THE COMPLETE GUIDE TO SELF-PUBLISHING COMICS

How to Create and Sell Comic Books, Manga, and Webcomics

Comfort Love & Adam Withers

WATSON-GUPTILL PUBLICATIONS

Berkeley

Published in the United States by Watson-Guptill Publications,
an imprint of the Crown Publishing Group, a division of Random House LLC,
a Penguin Random House Company, New York.
www.crownpublishing.com
www.watsonguptill.com

WATSON-GUPTILL and the WG and Horse designs are registered trademarks of
Random House LLC.

The Dreamer © Lora Innes; Mice Templar © Michael Avon Oeming and Bryan J. L. Glass;
Paradigm Shift © Dirk Tiede; Dresden Codak © Aaron Diaz; Guns of Shadow Valley © Dave
Wachter and James Andrew Clark; Gronk © Katie Cook; Random Veus © Jeffrey Cruz;
Mouse Guard © David Petersen; The Victories © Michael Avon Oeming; Delve into Fantasy
© Del Borovic; Girls With Slingshots © Danielle Corsetto; Molly Danger © Jamal Igle and
Company; The God Machine © Chandra Free; Skyward © Jeremy Dale; Wee Introduction
© Riley Alexander V; Gronk © Katie Cook

Library of Congress Cataloging-in-Publication Data
Love, Comfort, 1980–
The complete guide to self-publishing comics : how to create and sell your comic books,
manga, and webcomics / Comfort Love and Adam Withers.
pages cm
1. Comic books, strips, etc.—Authorship. 2. Comic books, strips, etc.—Publishing.
3. Comic books, strips, etc.—Marketing. 4. Self-publishing. 5. Web publishing.
I. Withers, Adam, 1981– II. Title.
PN6710.L68 2015
741.5023—dc23 2014035025

Trade Paperback ISBN: 978-0-8041-3780-5
eBook ISBN: 978-0-8041-3781-2

Printed in China

Design by Daniel Lagin
Cover artwork by Comfort & Adam, with Del Borovik and Corinne Roberts

10 9 8 7 6 5 4 3 2 1

First Edition

DEDICATION

This book is dedicated to our parents for supporting us in forgoing a normal life in favor of a career as storytellers. To the teachers who inspired us not only to love learning, but to want to pass it on. To our students, the guinea pigs on whom so many of our crazy ideas about comics and comics creation were tested. And to our editor, Patrick, for taking a chance on a little husband-and-wife team.

This book wouldn't have been possible without our friends and peers who gave us their time and knowledge, contributing the many sidebars you'll find within. This tome is what it is because of their generosity, and we're deeply thankful for it.

CONTENTS

Introduction 1

1. CONCEPT 5

What Are You Making and Why? 6
Research 10
Designing Characters 13
Designing Your Setting 21

2. WRITING 27

Anatomy of a Comics Script 28
The Writing Process 31
The Writer's Trinity: Plot, Story, and Character 36
How to Write Dialogue 46
Life as a Writer 49

3. DRAWING 57

Anatomy of a Comics Page 58
The Drawing Process 62
Creating Interesting Pages 66

Bringing Characters to Life 76

Life as an Artist 82

4. <u>COLORING</u> 89

Introduction to Color Theory 90

Getting Comfortable with Photoshop 95

Coloring the Page 101

Special Effects 113

Life as a Colorist 125

5. <u>LETTERING</u> 131

Understanding Lettering 132

Getting Comfortable with Illustrator 136

How to Letter a Page 141

Sound Effects 155

Life as a Letterer 167

6. <u>PUBLISHING</u> 171

The Modern World of Publishing 172

Print Publishing 178

Digital Publishing 188

Distribution 194

7. <u>MARKETING</u> 199

You Are Your Product 200

Targeting Your Audience 203

Mastering Your Web Presence 207

Conventioneering 214

Afterword 225

Thanks and Gratitude 227

The Adventure Continues Online 229

Index 230

INTRODUCTION

THERE'S SOMETHING MAGICAL ABOUT COMICS. THE unique blend of words and pictures to tell a story captures the imaginations of people of all ages, genders, and nationalities. No matter who you are, there are comics for you. No matter the style or substance, whether you read them online, make weekly pilgrimages to the comics store, or thumb across the brightly colored spines of the comics at your local library, sequential art draws you into its world. Call them manga, call them webcomics, call them whatever you like—comics are comics wherever you go.

We were children when comics got their hooks in us—Adam at six years old, Comfort closer to thirteen. Our eyes were opened to something so new, so different; we changed as human beings. We wanted to be storytellers. We wanted to create new worlds, new characters, to reflect our experiences, hopes, fears, dreams, and ideals. We wanted to draw, we wanted to write; we wanted to make comics.

Maybe you have a similar story. Many do; it's one of the magical things about comics. Many love music, few start to play. Many love movies, few become actors. But so many people who love American comics, manga, or webcomics start thinking up stories of their own, even if only for a little while. Comics inspire us to imagine, and that is one of the most wonderful things a

medium can do. Imagination is among the greatest powers we humans possess, and comics encourage this thoughtful daydreaming as good, or better, than anything else.

We wrote this book because we felt we had to. Knowledge must be passed on. Passion must be shared freely. We feel that the spark that a great comic ignites in people to create stories of their own should be fanned into a flame. Now is the time! Be not afraid of the perils of striking out on your own. This is the golden age of the self-publisher. It has never been easier, cheaper, or more convenient to make comics, publish comics, and build an audience.

WHAT THIS BOOK WILL DO

We have self-published comics since 2008. Each of us has been teaching comics since 2002, and we travel the country presenting panel discussions and seminars on making American comics, manga, and webcomics. We both write, we both draw, we both color, we both letter—we do everything but physically print the books. We want to share what we've learned and hopefully help people avoid some of the mistakes we made when we started out.

This book is the ultimate "nondenominational" guide to making comics. Whether you love American comics, Japanese manga, or webcomics, this book is for you. We'll mostly refer to them all as "comics" going forward—as a blanket term to cover all the different formats and styles. In the pages ahead, we'll address some of the finer points for each style, and we'll also include sidebars from some of the most talented professionals in each field to support those points. Pay attention to all of them! Just because a particular pro tip might come from a webcomics creator doesn't mean it won't apply to your manga. We think all kinds of comics creators can learn from one another—American artists and writers have been influenced by manga for decades, and Japanese creators have been doing the same with Western art and storytelling styles since Walt Disney started making cartoons. And webcomics? Welcome to the future, kiddies—in no time at all, everything is going to be a webcomic. The digital age has permanently changed the way comics are being made and read, and it must be a part of your strategy from now on.

We will teach you how to take the skills you have and go from somebody who talks about making a comic someday to somebody who publishes comics *right now*. This book is for those hobbyists ready to go pro who still think they need a big fancy publisher's permission to do so. Stop waiting for permission and start making comics! Your time is now; the only thing standing in your way is *YOU*.

WHAT THIS BOOK CAN'T DO

This book isn't about how to draw or how to write—there are a lot of good books out there on those topics. A few of those titles are truly exceptional. If you don't know how to write, we can't change that. But we *will* show you how to refine a concept, turn it into a story, and then turn that story into a comics script. If you don't know how to draw, this book isn't going to change that. It *will* show you how to take your drawing skills and use them to draw better comics pages.

This book is about professionalism. It covers how to make a job out of your hobby, and it requires you to bring your own determination and hard work to bear. A lot of people out there just want to doodle around in their sketchbooks and get paid. *That ain't happening, buddy.* Success goes to those who work hardest, work longest, and turn lucky breaks into career stepping stones. This book can't show you an easy way to make comics because making comics isn't easy. In some ways, it's the hardest job you'll ever do.

But if you're like us, if you're somebody who has the heart and mind of a storyteller, then making comics can become the most rewarding job you'll ever have. There will be challenges, and it will be disheartening at times. Maybe even miserable. But at the end of the journey, you'll have created something only you could have made, and that matters.

Make comics. C'mon—let's get started.

Comfort and Adam

1. CONCEPT

ALL COMICS BEGIN WITH A CONCEPT. WHAT'S YOUR book about? Why do you want to create it, and what will make it worth reading? While it is tempting to jump ahead and start writing scripts or drawing pages, it's better to take your time in the early stages. *The Uniques* is our superhero comic, and was our first venture into self-publishing, and we spent six years building the concept before we drew a single page; six years working out the entire story, the major arcs, the characters and what their individual arcs would be, how the setting worked—everything we could think of that would inform the decisions we made starting from issue 1.

In this chapter, we'll walk you through the steps for putting together the initial concept for a book. We'll cover how to work out that initial idea and hammer it into a road map for your series. We'll go over the formatting issues you'll want to keep in mind while planning what the end product will look like, and cover the basics of character and setting design, along with the things we do to add more depth and intrigue to the people we create and the worlds they live in. Remember, concept design is the foundation upon which you will build your entire comic. The stronger the foundation, the more resilient and sound the final story will be!

▲

What dangerous secrets lie within the package? Any small, seemingly mundane moments from your life can be the genesis of a new story concept.

All comics start with an idea. The idea might be big or small, fully formed or just a kernel of something that will develop over time. To nurture and shape that idea, worth reading, you have to start with two deceptively simple questions: (1) What is your comic about? and (2) Why is it worth making?

What Are You Making?

Likely the number one question asked of any writer is *Where do you get your ideas?* People read something great and wonder how that author came up with it. A lot of people think, right or wrong, that they're one great idea away from being a "real writer." If only they could learn how authors get their ideas, they'd be halfway to the finish line!

The truth is ideas come from everywhere and anywhere. One of the greatest inspirational tools you'll ever utilize is your own life and experiences. Any mundane thing can be the starting point for a story. The mail runs late and you miss a package: what if you were a journalist and that package held secret documents from an inside source in the CIA? Because you missed it, the postal worker holding the package becomes a target of some counter-spy organization or something . . . it all spirals out from that moment.

The story doesn't have to have a complicated plot. Many brilliant works of fiction are based on the real lives of ordinary people. Heck, there are quite a few brilliant works of *non*fiction in comics. Just look at books like Craig Thompson's *Blankets* or any of the comics from Harvey Pekar to see how great writers can take stories from their daily lives and make gripping comics from them.

Of course, there are other ways to get ideas. In our daily lives, we consume a plethora of media. Movies, TV shows, books, and comics—all are fertile ground for developing your own new ideas. One of our favorite brainstorming techniques is to take a story we thought was done poorly in film or TV and ask how we could fix it. Alternatively, we look at trends in movies and TV, themes that keep coming up over and over, and ask ourselves, *Why is that trend getting so big? Is there something of value in there that's worth exploring?* Or, if we find the story to be genuine crap, *Is there a way a new story could rehabilitate it?* We all like to complain about movies, shows, comics, and the like. This is your chance to put your money where your mouth is! Instead of complaining about what bad stories there are, create something better yourself.

Without ideas, you'll never have a comic. Activate your brain, and keep it active all day long. Think of everything in terms of story. Look for things around you that could become stories of their own. Develop a way of looking at life through a more creative lens so that you can imagine ordinary things in extra-ordinary ways. Once you've got something you feel is really special, that's when you're ready for the next big question . . .

Why?

It isn't enough to have an idea. You also have to know why it's worth making, and why it would be worth reading. Your answers to those questions will determine everything about how you build the concept for your story. The why can be as simple as "because it would be really fun!" If so, you now enter a situation where

◄ Study your media! You are no longer a passive consumer of entertainment; you are an analyst. It's your job to understand why something works, why it doesn't, and how to incorporate that information into your own work.

DIRK TIEDE: REFINING AN IDEA

Now for the fun part: taking that rough nugget and polishing it into a real story concept. You need to flesh out three key things—the characters (who), the setting (where), and a rough plot (what)—so you can start writing an outline.

It's time to brainstorm! Start collecting ideas you can use to flesh out these three things. It helps to create an idea notebook so that you can jot them down in one place. Maybe you're already brimming with ideas, but if not, look around for inspiration. Mine your obsessions. Do some research. Borrow from mythology. Steal from the classics. Look up who and what inspired your heroes. For instance, when George Lucas created *Star Wars*, he was inspired by old pulp science fiction (setting), Joseph Campbell's *Hero with a Thousand Faces* (plot, mythology), Kurosawa's *Hidden Fortress* (characters), and World War II movies (feel and style).

Anything and everything can be grist for the mill, so cast your net wide. Take your time if you need to, or pour that overflowing mass of ideas right out onto the page.

Dirk Tiede
Creator of *Paradigm Shift*
paradigmshiftmanga.com

No book appeals to everyone equally. Have an idea of the type of audience that would most enjoy your story so that you can target them from the earliest stages of concept design. ▶

your goal is to create the most fun comic you can imagine. FUN IN ALL CAPS! Maybe your answer is deeper; you have something you want to say about life, the world, or the human condition. Your approach will differ from the "FUN!" guy's, but both approaches are equally valid.

We've talked a good bit about drawing inspiration from other stories, but now that you know what your influences are, you need to make sure your comic isn't just an imitation of something else. What will set it apart from the things that inspired it? If all you're doing is creating a different version of Wolverine or Dragon Ball, why should we bother reading your comic instead of just buying more Wolverine or Dragon Ball comics? Inspiration and influence are one thing, but be sure you aren't just making a clone or being a copycat!

Ideally, we all want to make stories that mean something to somebody. We want our stories to make people feel something. What do you want to make

readers feel? What emotion do you want them to have as they finish your comic and set it down?

Start thinking about your audience: who they are, what age, what gender, what background, and so on. The more clearly you can visualize who you're creating for, the better you can decide how to shape your story to have the exact impact you want. This isn't pandering, and we aren't suggesting you give up your creative integrity for sales. But the more insular your creative focus, the less compelling to others your work will likely be. Find your audience, and take the time to truly understand them. This knowledge will guide you to making a story that's equally fulfilling for you and them.

What makes people love stories? Look to the ones you've seen and read that have meant the most to you. What movies have really grabbed you? What books have impacted you? Now ask yourself why. What was it those authors did that caused you to have that reaction? It works in reverse, too: When you've hated a story line on a TV show, why didn't it work for you? What were the specific things that bothered you, and why did they affect you in that way?

When you're a storyteller, you can't afford to be a passive participant in media. Actively analyze and examine the media you consume, ask questions, and seek a deeper understanding both of those stories and of yourself. The better you know yourself, the more you'll be able to understand your emotional responses to the things you watch and read. Soon you'll start anticipating those responses, and then you're just a short jump from being able to actively create them for readers of your own stories.

PRO TIP

MICHAEL AVON OEMING: HOW A CONCEPT GROWS

The inspiration for *The Victories* came out of going to therapy when I was going through some high-stress times. I found that art was a way in which I channeled anxiety into a sense of control. That meant the thing I loved most, my art and making comics, came out of my own anxieties. I bring them with me or escape from them every time I draw. I thought that was a great inspiration/origin for my hero, Faustus, to struggle with. I also learned how much my mother's life has left an impact on me. She was very loving, but also very tragic.

I spent years working on my writing, mostly concentrating on structure, the Hero's Journey, even took the *Story* seminar with Bryan Glass. But I had a pretty quiet life, working on comics and art every day since I was thirteen. So when it came to "write what you know," I thought I was void of experiences. I hadn't had much experience with relationships, parties, jobs, fights, travel, finishing high school and college—you know, all the stuff writers write about. I thought I had nothing to bring to comics other than my love of fantasy and my imagination. Going to therapy was a real eye-opening experience, and I suggest any writer do it if he or she can. You learn not only about your own motivations, but of those around you and your creations'.

Michael Avon Oeming
Creator of *The Victories*
Cocreator and artist of *Powers*
oeming.tumblr.com

◀ Once, something you read inspired you to be a storyteller. Now you can be that inspiration for another person.

RESEARCH

The old saying is "Write what you know," but nobody knows everything. Nobody expects you to be a fighter pilot before you can write about fighter pilots, or that if you're writing a story about cops in the 1920s, then you yourself had to have been one. For these situations, you'll have to do some heavy research to make sure you know enough about the subject to create a reasonable facsimile in your stories. Readers who know much about the topics you're writing about will be put off if the book is too far from reality. Some suspension of disbelief is expected, but too much and they'll quit on you.

The objects on the left are drawn without reference. Those on the right were drawn using reference. The small details make a big difference in how your drawings look!

▼

This goes equally for writers and artists. Writers need to know their subject to write it well, but artists have to know a huge amount of things as well. How did cops in the 1920s dress? What did the cars look like? What are the details of a modern fighter jet? Research is invaluable for any comics creator, and it can be pretty fun.

The Basics

Researching your story can be simple or complicated depending on the story, what you need to know, and how deep you want to go. At its simplest, research involves tracking down books (preferably nonfiction), articles, and the like at a library or online. Subjects like historical periods, major wars, various national military forces; presidents, kings, and other heads of state; cars and drivers; musicians; and more will frequently have in-depth websites devoted to them.

When dealing with the Internet, always make sure you have a credible and real source for any information before you take it as accurate. Don't just take the author's or website owner's word for it. Look for direct quotes from original sources or multiple corroborating sources to back up your facts. When books or magazines are cited as reference or sources, try to get copies to read for yourself. The original source is almost always more useful than secondhand quotations or summaries. And if you're not sure where to look or where to find these things, a local library will likely be filled with helpful librarians willing and eager to help you.

◄ Rigorous research into eighteenth-century fashion and architecture was invaluable for drawing *The Dreamer*, a book about a girl who, when she dreams, lives during the American Revolution. (*The Dreamer* by Lora Innes, published by IDW)

For firsthand sources, nothing beats talking to actual people. If one of your characters is a scientist, why not find real live scientists you can talk to? Not only will they be a wealth of information for your story, they can also give you ideas about how people in those professions talk, which will help when the time comes to write dialogue. If you can't find anyone to talk to in person, hit up web forums, Facebook, and Twitter feeds to find people with whom you can connect. Let them know you're doing research for a comic you're writing, and you'll find many professionals are happy to help. After all, it's nice to talk with somebody who genuinely cares about what you do and wants to hear all about it.

Crime writers will often arrange ride-alongs with police stations, going out with an officer in a patrol car for a day. The wealth of real-world information isn't limited to a single genre of storytelling. Depending on what your comic is about, maybe you could spend some time at a local firehouse, or have a tour of a research laboratory and talk to some of the people there. Speak with museum curators or history professors or *anybody* who could have even tangential connections with your subject. If nothing else, maybe they can connect you with somebody who will be able to help you more.

If It Isn't Real, Fake It!

Sometimes researching your subject is trickier. Maybe you can't get much firsthand information because you're writing about prehistoric times or the Dark Ages. Then there are things that don't exist and never have: aliens, magic, or spaceships that can travel to distant star systems with the ease of a guy taking the bus to work. And there are other things that, by their very existence, change the course of human history to the extent where normal research can only give you a small piece of the picture. Who knows, maybe you're creating an entirely new world from scratch, and it has no history to research in the first place. In these cases, you're going to have to use what real-life experience you can get to make these bizarre and impossible concepts believable for your audience.

In these situations, look at what you *can* use, and work from there. What real-world facts, people, and events can you look at to help inform the fictional world you're creating? Knowledge of human biology, culture, and technology can help you make more interesting and believable alien species. Knowledge of the Dark Ages can help inform a classical fantasy story. Even small pieces of real-world information can give your fiction a firmer grounding—like a character who does impossible, fantastical things, but has a day job as a mechanic in a believable auto repair shop full of supporting characters who feel real and believable.

In *The Uniques*, we deal with a world in which people with superhuman powers have been around since the 1930s. We wanted to have the existence of these powers change the way history unfolded in believable ways, so we did

lots of research. We looked at geopolitics, law and the judicial process, the history of various national powers in the twentieth century, and so on. Once we had enough data, we could make educated guesses about how people with superhuman powers might have reshaped history as we know it.

At the end of the day, all stories are about people. If the characters in your story feel like real people with thoughts and emotions that the audience can understand and relate to, it won't matter if you fudge some of the other details. Readers don't believe a man can fly because you got the science right—they believe he can fly because they believe in the man himself. Give readers characters they can care about—characters who think, feel, and act in believable ways—and those readers will cut you a lot of slack with their suspension of disbelief.

DESIGNING CHARACTERS

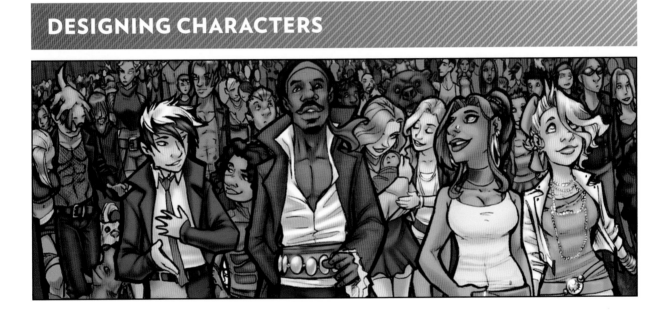

Characters are the most powerful and important things in your comics, hands down. Manga, webcomics, and American comics stories of all stripes live or die by how much readers attach themselves to the characters. Sometimes they do so because they feel a character is "just like me." Sometimes it's because the character is more aspirational—somebody they *wish* they could be. Other times, characters have that indefinable "cool" factor that draws people to them. The best villains can range from relatable characters that we understand and pity to such detestable foils for the heroes that we can't wait to watch the conflict between them unfold.

The importance of character creation in your comic cannot be overstated. Fortunately, for all the same reasons people love reading about characters of all

While *The Mice Templar* features a large cast, Karic is the clear protagonist. His journey is central to the plot and is at the heart of the story. (*The Mice Templar* by Michael Avon Oeming, Bryan J. L. Glass, and Victor Santos, published by Image Comics)

types, creating new characters can be one of the most fun parts of the comics-making process.

Character Concept

The process of building comics frequently begins with the characters. Creators will have a vague idea of a story they want to tell and then jump into figuring out who the book is about, spending quite a while focusing on them. The better you know your characters, the more easily everything else will start to fall into place.

To begin, you've got to know the concept behind each character. There will usually be one or two central characters, the protagonists, who are the entry points into the story for your readers. They'll be the ones who go through the most growth over the course of the comic and who will frequently emerge as the "stars," even in a large ensemble cast. These are your Luke Skywalkers, your Monkey D. Luffys, your Frodo Bagginses and so on.

Who is your protagonist? They *tend* to be more ordinary types—average (or *seemingly* average) people thrust into wild situations unlike anything they've encountered before. Even if they're used to adventure and danger, they probably aren't ready for what's coming for them in *your* comic. If you already have a rough idea of what kind of story you want to write, think about what kind of role you need the protagonist to fill. Is he a fish out of water? A bitter old cynic? A hot-shot know-it-all? What does your story require, and how can your protagonist fill that role?

With that worked out, flesh out a supporting cast by looking for holes in the abilities or personality of your protagonist. In the manga *Naruto*, Naruto himself is a wide-eyed, goofy kid full of hope; Sasuke is the bitter, determined boy with the dark past. Naruto isn't a very skilled ninja to begin with and knows little about the world around him; Kakashi is a ninja master who's as worldly as Naruto is ignorant. Naruto may be the main character, but the supporting cast can balance Naruto's personality and provide skills and knowledge he lacks but that the audience needs to know about. By Naruto asking questions of and being challenged by the others, the audience learns along with him.

Getting into the Details

When it comes to working up a backstory for your character, there's no such thing as going too far. The more you know about where your characters came from, what motivates them, what they want, and what they fear, the more you'll be able to anticipate how they would react to the situations you put them in, and thus the easier they become to write.

To create good characters, you have to understand human psychology. You have to study people, their actions, their behavior, what drives them and motivates them and makes them react—good or bad—to things happening around them. Just like artists have to study the world with their eyes so that they can draw a more believable world, writers have to constantly listen and analyze and seek to understand and sympathize with all kinds of people. That's important, since you'll write good and bad characters and have to be able to write even people you would normally detest in a relatable way. Remember, the best foes for your main characters are always ones that have something sympathetic about them, something in their nature that we can understand and relate to, even if we still hate them and desperately want to see them beaten in the end.

The more complex your characters are, the more interesting they are. It's easy to write basic archetypes (the big brute, the sarcastic intellectual, the sassy tough girl, the sinister politician, and so on), but archetypes are the character equivalent of a cardboard cutout: one dimensional and not all that interesting. You need to know your characters inside and out so that you can express, in the story and through the plot, the nuances and complexities that make your characters more than just a collection of clichés. Throw in personality traits for your

▲ You might expect the big guy to be tough or domineering and the pretty girl to be more aloof or serious. Going in the opposite direction makes them more interesting by adding layers to their personalities beyond the stereotypes.

◀ In "man vs. nature" stories, it can be difficult to make the environment feel like a captivating antagonist. Doing things like giving names to storms or using a recurring element such as a wolf can help give a "face" to nature itself.

Bold Sir Simon eventually defeated the castle, but facing a *person* rather than a building would have been a more interesting conflict for the readers to experience.

characters that seem opposite to their physical appearance (a big strong guy who gets all silly and gushy around animals and children; a beautiful bombshell who's a socially clueless goofball). Let the audience spend a while thinking the character is a certain kind of person, then drop a surprise revelation that changes everything they assumed before. That smarmy ladies' man is actually interested in the fellas. The devil-may-care hot-shot who rushes into battle isn't brave or heroic—he's literally suicidal. Suddenly the audience is asking questions about these characters, interested in them all over again in entirely new ways.

These guidelines also apply to villains. The protagonists of your book are only as interesting as the people who work against them (the antagonists). If your antagonists are flat, bland characters without much to set them apart, then the whole conflict becomes boring. But the more interesting and challenging the villain, the more exciting the adventures of the hero become.

This applies equally to stories that aren't about battles and grand adventure. Love stories need antagonists, too, and those antagonists still have to be dynamic and interesting. Even in the case of "man vs. nature" stories, the environmental antagonist must be a character unto itself. You have to handle the animals, natural phenomena, and other oppositional elements in such a way as to make them come alive for the audience and take the role of the "villain" in the story, with all the charisma and personality that requires.

If your protagonists are opposed by an organization, army, or other large group, you'll want to create one or two recurring antagonists who can represent that group to the audience. The Avengers fighting hordes of alien warriors is fun enough to watch. But the Avengers battling Thanos or matching wits with Loki? *Those* are exciting conflicts! People can be charismatic and exciting in ways organizations have a hard time matching. A struggle against a person will often feel more relatable and immediate than a struggle against a group or idea or other not-really-human *thing*.

When you've got a pretty good grasp on the nature and motivation of your characters, it's time to ask some hard questions about them to help nail down their psychology. The great writer Greg Rucka has a list of questions he answers for his characters before he starts as a way of getting to know the people he's writing during his concept process. We've put together a handy list of twelve questions we like to answer for every major character in all of our stories. Some came from Rucka's list, some from other lists, others just because we like to ask them. The answers we come up with not only enrich our understanding of the cast, making it easier to know how they would talk, interact, and react to events as they happen, but they also sometimes help us come up with ideas for stuff to do in the story, allowing the characters to drive the plot rather than the other way around.

TWELVE QUESTIONS FOR YOUR CHARACTERS

1. What is the character's name? Does she have any nicknames? What did/do her parents call her?

2. What does the character look like? What does he *wish* he could look like? What one thing would he change about his appearance if he could?

3. Who are the character's friends and family? Who does she surround herself with? Who is she closest to, and who does she wish she were closest to?

4. Where was the character born, where does he stay, and where does he think of as home?

5. What makes this character happiest? Is there anything she thinks would make her happier than that?

6. What makes this character angriest?

7. What would this character consider his greatest achievement?

8. What does this character consider the most overrated virtue?

9. When would this character be willing to lie? Is there anyone she could never lie to? Is there anything she could never tell the truth about?

10. What is the thing this character needs most? What's the core need that might drive him above and beyond everything else?

11. What is the character's greatest fear? Has she ever told anybody? Is there anyone she would absolutely *never* tell?

12. What is the thing that happened to the character early in his life that made him believe something untrue about himself? What is the lie he believes, and how has he shaped his persona in response to it?

Bonus Round! What is the character's deepest, darkest secret—the one thing she would tell nobody?

The thing to remember about writing characters is that they're as varied and relatable as the people out in the real world. The more time you spend trying to peg down human behavior, the more stuff you'll discover about people in general and yourself, specifically. You want to learn and grow as a person so that the people you create can be as deep and real as humans can be rather than just a bunch of clones of yourself wearing masks and pretending to be different people. As Leon Surmelian said in his great book *Techniques of Fiction Writing*, "[Human personality] is a universe in itself, and we are strangers even to ourselves. Characterization requires self-knowledge, insight into human nature . . . it is more than impersonation."

Designing the Look

When it's time to come up with what your characters look like, keep three concepts in mind at all times: personality, simplicity, and utility.

Personality means that your characters' design should tell us something about the kind of person they are. From the dangerous ranger in black to the Wall Street tycoon in the expensive suit to the powerful superhero in the billowing cape, the way characters dress is the way they want to be seen by the world. Characters (and, through them, you the creator) try to show the kind of person they are through their dress.

Use little details to portray quirks in characters' personalities. Maybe the big, broad-shouldered tough guy with the heavy rifle, torn sleeves, and camouflage pants also wears small, delicate eyeglasses and a religious symbol on a necklace. Those little touches can totally change how a reader perceives a character. Look for anything you can use, from costuming to body type, to cue readers in to what sort of character this is.

Make sure that every character's face is distinct. Don't draw the same face for everybody and just change the hairstyle! You'll also want to vary the characters' body types. It's sadly typical for artists to draw all men a certain way and all women a certain way. The world is full of a diverse range of body types. Embrace that and your comic will provide a much richer experience for your audience. Your pages should be full of the same range of physical attributes that you see in the world around you in terms of ethnicity, weight, personal hygiene, fashion sense, and more. In the end, remember this: a character whose body type and facial features look just like every other generic "hero" character out there will never be as interesting as one who breaks the mold.

Simplicity means you should try to say everything you need to about a character using the least amount of detail possible. For one thing, it saves your drawing hand. You're making a comic; whatever you design here you'll have to draw for panel after panel, page after page, issue after issue. You don't want

By adding some small details—the eyeglasses, pipe, and necklace—this character has become more than just a plain military archetype.

Even if using a more animated drawing style, you should strive for distinct faces for your cast of characters. In *Paradigm Shift*, Dirk Tiede uses face shape, ethnicity, age, and demeanor to differentiate his characters. (*Paradigm Shift* by Dirk Tiede)

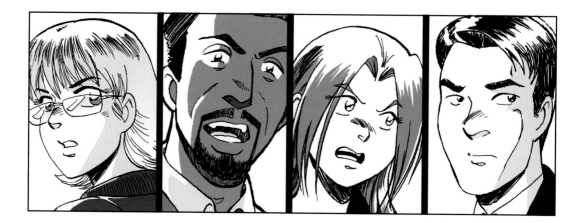

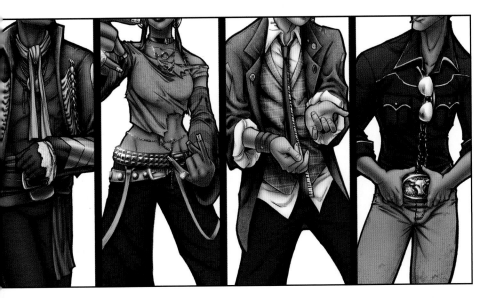

In *Rainbow in the Dark*, music was a big influence. Each major character was designed to reflect a different genre/era of music. (*Rainbow in the Dark* by Comfort Love and Adam Withers, published by Comfort and Adam)

to design costumes so elaborate that your hand breaks from repetitive stress injuries. Additionally, you want your characters to stand out and have immediate and lasting impact on readers—the most iconic designs are usually the ones without too much extraneous detail. Look at Superman's classic design—simple, clean, with one primary color, one secondary color, and an accent color. It's powerful, distinct, memorable, and gives an impression of him and the world he exists in right away.

Ordinary clothing still abides by the rule of simplicity. Neo's black trench coat in *The Matrix* was so iconic that that trench coat has become the de facto uniform for every Neo-esque character since. Ichigo Kurosaki and the Soul Reapers from the manga *Bleach* primarily wear simple black kimonos with white accents—a powerful and striking look, with room to slightly individualize how the uniform is worn by each character. For stories with ordinary people engaging in an ordinary world, look for ways to dress them that will let them stand out from the rest of the bystanders on the street without requiring tons of unnecessary detail.

The question becomes this: What is necessary detail and what isn't? For that, we go to the rule of utility. In a nutshell, the rule of utility means that everything you put on a character should serve a specific function. It can be a practical function or a function of showing personality, but everything you draw should be there for a reason.

Don't cover your character in stuff unless he needs it. Even with soldier, inventor, or future-warrior type characters, it's a bad idea to start adding pockets and pouches just for the sake of it. Don't give characters harnesses or utility belts or thigh pouches unless you know they will actually *use* those things in the story. Always ask whether your characters *need* the stuff you're putting on them or not. Be wary of designs that get so busy that nothing stands out. You want your characters to be defined by their traits, not their clutter.

PRO TIP

TERRY MOORE: DESIGNING CHARACTERS WITH PERSONALITY

My favorite thing as a boy was to listen to my dad tell stories about growing up in a small town where everybody seemed to be "a real character." His descriptions of friends and high school pals were concise, but accurate. With one quick profile, an image came to mind. Then a poor decision was detailed, the chaos that ensued and the hilarious consequences described. I laughed because I saw the characters and events through the words of my dad. I can't recall the exact words he used, but I will never forget the characters my father described. So, don't labor over clever words because they are soon forgotten. I can't quote any of Agatha Christie's Poirot stories, but I know that brilliant, eccentric little man intimately. It's the character that endures, not the words. Write that way.

Terry Moore
Creator of *Strangers in Paradise*, *Echo*, and *Rachel Rising*
terrymooreart.com

When designing Scout for our comic *The Uniques*, we figured out every gadget in his belt and harness first. This helped the design and gave us ideas for scenes to use in the book. After all—if he had all that cool stuff, we wanted to make sure he had chances to use it! (*The Uniques* by Comfort Love and Adam Withers, published by Comfort and Adam)

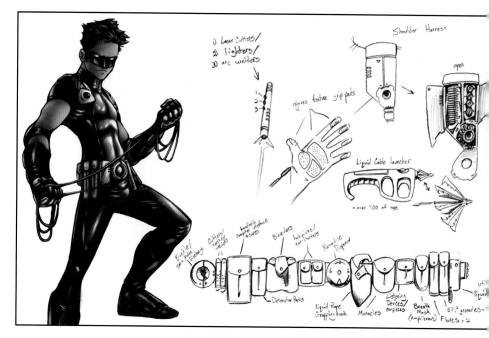

Nobody wants to look at this type of cluttered costuming, and you don't want to have to draw it page after page either.

Think of one feature or ability for your character that you think should be the focus of her visual design. Maybe it's a superpower—she shoots eye-beams or has big wings or something. Maybe it's an item of clothing, like a cherished necklace or unique jacket. Maybe it's a physical feature that stands out like exceptional muscles or something about her hair or long legs or arms. It could be a feature that she wants to showcase, or one you want to draw attention to as the designer. Once found, build the design so that it emphasizes that feature. The utility in this case is working to focus readers' attention where you want it to go without distractions.

Tech is one place where extra detail is almost always going to make it better. When working with giant robots, mecha, or armored suits, remember that they look the coolest when you really dig into the sci-fi elements. Comparing the old-school way of drawing power armor (just another kind of skin-tight clothing with a couple of techy details) versus the newer style (highly detailed and technical), the new school takes the cake hands down every time. Study actual heavy weapons, tanks, fighter jets, and so on, for ideas on what practical features to add and how to make them work for your design. Utility still applies—try to make sure that all those extra bits and bobbles actually *do something*!

The better you know your characters, the better design you'll create. Whenever you run into trouble, go back to the core questions: Who is this person, how would she want to present herself to the world, and what about her look or feel do I want to make sure is clear to the reader? If those remain your central driving foci, you'll come out fine in the end.

No matter how well you render old-school comic-booky power armor, it won't look as good unless you get into the details.

DESIGNING YOUR SETTING

Characters may be the most important part of your story, but without a living, breathing world to inhabit, they'll feel at best like twinkling stars in a flat, empty sky. Just as a hero is only as good as the villain he opposes, your characters also need an interesting setting to function in for the story to feel grounded in a world the reader can connect with and understand. Verisimilitude—the appearance or semblance of truth—is key to suspension of disbelief. For your readers to buy into your story, there has to be enough of a feeling of reality that they'll accept what you're telling them. The setting is a big part of that.

A common phrase you might hear bandied about when people talk about stories is "the setting was like a character." It sounds like a neat thing to strive

The setting of Nephilopolis is every bit as important to the story as the characters in the webcomic series *Dresden Codak*. (*Dresden Codak* by Aaron Diaz)

for, but what does it mean? In short, it means the setting of your comic has as much thought, detail, and personality as the characters who inhabit it. Gotham City in *Batman*, Nephilopolis in Aaron Diaz's *Dresden Codak*, or even real-world Toronto in Bryan Lee O'Malley's *Scott Pilgrim* are all superb examples of settings that become as central to their comics as the characters themselves. So let's talk about how you make that happen.

Details Matter

The more specific you can get with your setting, the better off you'll be. Using unique details can help distinguish your location from more generic sites. They don't have to be big details, but make sure they matter. The streets of Flint, Michigan (where Adam grew up), are so pitted with potholes that they look like somebody went along the roads with a pickax. Saginaw Street downtown is still laid with old bricks. If you go to Louisiana, however, the main streets in the city of Baton Rouge are mostly made of concrete instead of asphalt. Little things like these change the way a city looks in a subtle way that readers might not realize they're noticing, but their brains still catch.

If you're creating a new setting from scratch, use details from real-world places to build a believable city all your own. In *The Uniques*, much of the story is centered in the fictional city of Madison, Pennsylvania. We spent some time

in the state, in cities like Pittsburgh, Philadelphia, and Reading, and did research on the state to glean details we could use to make Madison feel like it was part of that whole. Understanding the economics of the state, just how much of it was blue collar industry (steel, coal, automobiles, and mining), and that the average income is under $40,000 a year gave us a sense of the kind of place Madison would be. We looked at the architecture to see the kinds of buildings to populate the streets with. We noticed how much of the landscape was rolling hills, so Madison has a lot of ups and downs on its streets.

Use specific locations by name. Street names, business names, whatever—using them feels more real than speaking generically. Because comics are visual, you should avoid directly using the trademarked logos and imagery of chain restaurants, food products, drinks, and so on. But you can get around that, too. In *The Uniques*, you'll frequently see characters drinking Tasty-Cola or eating Bay's potato chips. The logos are designed to recall familiar brands, but we avoid legal problems from using trademarked images without permission.

So have your characters reference Cotton Street or Hancey Avenue. It seems like every city in America has a Martin Luther King Jr. Blvd., so add one to your imaginary city. Consider having your characters grab a bite to eat from Paulie's or Big Mouth Bassey's. You can come up with names for everything, and name every character inside. Then you can start having your cast revisit these

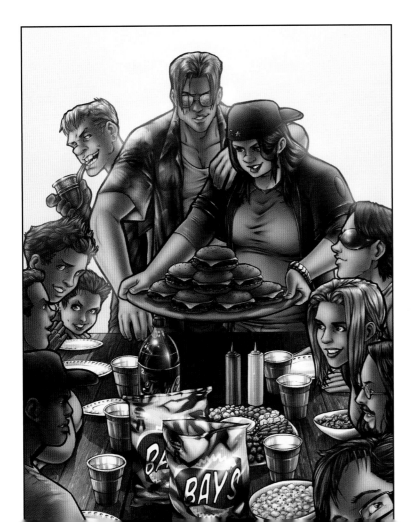

◀ The characters of *The Uniques* sitting down to a meal in an homage to a classic Norman Rockwell painting. Note the logos created for the food and drink. They make the scene feel more real by adding an extra level of detail to the setting. (*The Uniques* by Comfort Love and Adam Withers, published by Comfort and Adam)

For many familiar with the Western genre, a saloon gives an immediate feeling of mood and tone, exemplified in the webcomic, *Guns of Shadow Valley*. (*Guns of Shadow Valley* by Dave Wachter and Jim Clark)

places, and you'll find your audience looking forward to seeing Paulie, the kindly goofball owner of Paulie's Italian Subs. This is how one-off locations become part of a living, breathing world.

Artists, use specific visuals. What kinds of cars would be on the streets? What kinds of clothing are in fashion? And if that's in fashion, what kinds of clothing are worn by people who can't afford to be fashionable? What specific architectural styles accompany each region of the city? Details are as important in the way a setting is drawn as they are in how it is written.

Using Setting to Create Mood

The location of a scene has a lot to do with the feeling of that scene. Consider a shot of a man standing over a body. We don't yet know any context for the scene, only that he's looking down and the body on the ground doesn't appear to be moving. In one version, they're on top of a green hill under a bright sun, white clouds billowing by, a gentle breeze blowing leaves on the trees. In the other version, they're in a darkened alley, rain pouring down, a rat gnawing open a sack of trash nearby, graffiti scrawled on the aged brick wall. You need to have a variety of locations in your setting where you can take your characters to get these scenes to work the way you want and to increase the impact of given moments.

This is something you will develop over time, but as you're coming up with ideas for scenes, ask yourself where in the city or region you've created that scene could take place to enhance the mood. You might wind up creating a new location in your city to facilitate a grimy shootout, or a city park for a romantic meeting, or an ancient, marble-pillared courthouse for a dramatic speech on its wide steps. Even in a story set in nature you might need a clearing in the forest for a scene under the moonlight, or a huge pine tree with limbs hanging so low the protagonist can rest for a night under the needles, safe from the rain or snow.

When taking everything together, you get a series of settings that are exciting to read about. They feel like genuine, "lived-in" spaces, which makes

the people you create feel more genuine by proxy. A strong setting is memorable and can help your story last in the minds of your readers long after they've finished your comic.

▲ A good comics artist is as invested in bringing his backgrounds to life as he is his characters, such as in *RandomVeus*—where the settings had to be just as varied and random as the name of the book implied. (*RandomVeus* by Jeffery "Chamba" Cruz and Leonard Bermingham, published by Udon Studios)

PRO TIP

YALE STEWART: USING SMALL SETTINGS

Some say "familiarity breeds contempt," but with settings, familiarity's often your best friend.

Using settings that people are familiar with—schools, malls, offices, or a variety of other similar places—can help you sidestep extraneous exposition defining that location, as readers will already have an understanding of the purpose and workings of that locale. The amount of information you'd need to provide is on a sliding scale, however. Using "elementary school" as your setting requires less information than something as general as Los Angeles.

It's important to note that due to this familiarity, these places can very easily become boring and redundant. When setting your story in a more generic location, it's very important to fill that location with very strong characters. An office is a boring place to work, and most office stories have been told. The characters that populate that office, however, are unique to your story, and will provide the reader with something to latch on and relate to.

Settings are backgrounds. Characters always go in front of them.

Yale Stewart

Creator of *JL8* and *Gifted: The Great Party*
Contributor to *The Legend of Luther Strode*
yalestewart.deviantart.com

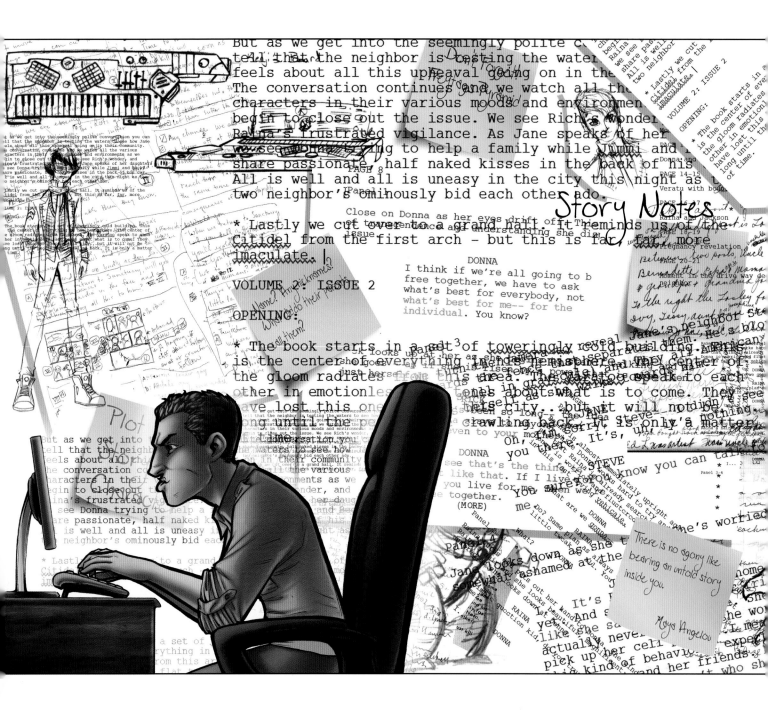

2. WRITING

WRITING: **WHEN THE CONCEPT BECOMES REAL** for the first time. It's the act of taking all those ideas you've put together and compiling them into an actual story that anyone can read and understand. We simply can't overstate the importance of strong writing in comics. Make no bones about it; the story is the most important part of your book, no matter whether it's in the American or Japanese style, published on the Web in whole, in part, as strips, whatever. If your story isn't gripping, you'll never last. Yes, the art should be equally strong, but always remember, the best comics unite great art *and great words*!

In this chapter, we'll break down our writing process and describe how to build your script up in stages; just like an artist's rough layouts help produce better final artwork, your scripting drafts will give you a stronger story. We'll also talk about what you'll need to know to be a professional writer, and how to be a good collaborator, working with your artist to produce better work in a happier, more rewarding partnership. By the time you're done reading this, you'll be a better writer and an able team leader!

ANATOMY OF A COMICS SCRIPT

Before setting out to write your script, you should probably know what one looks like and how to put it together. The following is pretty typical for comics in general. As with everything, you may find slight variations that work better for you, but so long as all the necessary pieces are in place and you (and your editors and proofers and artistic collaborators) can easily read what's intended, you'll be fine.

Script-Writing Programs

If you're looking to make the writing process a bit simpler and smoother, look into software made specifically for writing scripts. Many professionals use a program called Final Draft; it's easy to use, and while designed for writing screenplays, it also works exceptionally well for writing comics. There are many other similar programs on the market, and quite a few freeware programs as well. A simple Google search for "Free Script Writing Program" will turn up several fine options for you. In addition to full programs, there are a number of plug-ins or templates you can use for word processors like Microsoft Word that will do a similar job.

The benefit of a script-writing program is that it will do most (if not all) of your formatting for you, producing very attractive, easy-to-read scripts with very little effort. That makes them huge time-savers, and anything that saves you time and makes your work look and read better is a no-brainer.

The Script Format

You want to make your scripts as easy to read and follow as possible. That's doubly important for you if you have other artists who will work from your scripts. If your artist can't follow your intentions on the page, you won't see everything you wanted in the artwork you get back from her. The good news is that this formatting is very simple, and you'll only need to get a handle on a couple basics that will carry you through 99 percent of the process.

Here's a breakdown of the basics of how our scripts are put together:

```
[1] RAINBOW IN THE DARK: VOL. 2 ISSUE 3

    Lose

    By Comfort Love and Adam Withers

[2] PAGE 1

[3] Panel 1

[4] We see a close up shot of Donna placing the ring she found in
    the last issue onto Raina's finger. It's quite possibly the
    biggest, most colorful, gaudy ring one could ever win from a
    vending machine. But no one can deny how fabulous a prize it
    is.
                            [5] RAINA
                     Aw, baby... I love it!
```

1. Series name, issue number, title, and byline.

2. Page number: should be in ALL CAPS to set it apart from the panel numberings.

3. Panel number.

4. Panel description: explains what's happening in the panel, including location, characters, character actions, background actions, important props, or other items in the panel—whatever you want to see needs to be spelled out for your editors, proofers, and the artist.

5. Character name: always appears above dialogue and always in ALL CAPS. Sometimes you'll have someone speaking who isn't a major character. You don't have to name these minor speakers. JANITOR, NINJA, WAITRESS, and so on are all fine. If several of them appear and speak, number them. PIRATE #1, PIRATE #2, and so on.

Those are all the basics you'll need to use, but there are a couple more details that crop up from time to time.

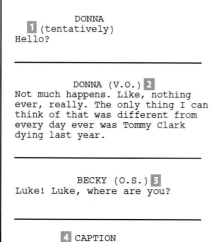

```
              DONNA
     1 (tentatively)
Hello?
_____

              DONNA (V.O.) 2
Not much happens. Like, nothing
ever, really. The only thing I can
think of that was different from
every day ever was Tommy Clark
dying last year.
_____

              BECKY (O.S.) 3
Luke! Luke, where are you?

_____

         4 CAPTION
September 26th, 1996
```

1. Parentheticals: used to give minor emotional details about how a character speaks her lines. These should never be long sentences! All you'll ever need is a word or two to communicate something specific about a character's delivery in that moment.

2. Voice over (V.O.): used when a character speaks or narrates from some unknown place. On the finished page, voice overs are lettered in caption boxes.

3. Off screen (O.S.) or off panel (O.P.): used when a characters speaks and is heard by others on panel but isn't actually in the panel.

4. Caption: used when you need to give information to the audience, but nobody actually speaks out loud. Examples include time, date, locations, and so on.

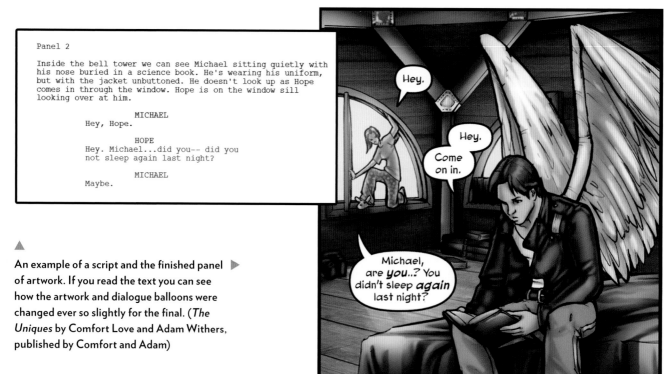

```
Panel 2

Inside the bell tower we can see Michael sitting quietly with
his nose buried in a science book. He's wearing his uniform,
but with the jacket unbuttoned. He doesn't look up as Hope
comes in through the window. Hope is on the window sill
looking over at him.

              MICHAEL
     Hey, Hope.

              HOPE
     Hey. Michael...did you-- did you
     not sleep again last night?

              MICHAEL
     Maybe.
```

▲

An example of a script and the finished panel ▶ of artwork. If you read the text you can see how the artwork and dialogue balloons were changed ever so slightly for the final. (*The Uniques* by Comfort Love and Adam Withers, published by Comfort and Adam)

There you go! You're ready to write a script—or at least you know how one should look. We're only just getting started, though, so read on!

THE WRITING PROCESS

Artists are generally comfortable with the idea that a drawing starts with a rough sketch that is refined over time into a final illustration. But writers can fail to recognize the need for the same process in their own work. Writing begins as a sketchy draft—a broad layout—that you then carve into a final script. In this section you will find a tried and true method to approaching that process.

Working from Big to Small

By the time we sit down to write, we already have a pretty solid idea of what a given issue will be about. We've worked it out over time, discussing the story back and forth on walks or while cooking meals together, until we're confident we know the plan. When we're ready to write, we start by jotting down a broad overview of the issue's plot, just to get all the ideas down onto the page.

Next, we break that up into scenes. Our scene breakdowns look like this:

A script breakdown from *Rainbow in the Dark* functions like an overview of the issue, with page counts for each scene.

▼

```
PAGE 1                                    PAGE 8-9

Open with Veratu                          Mom and neighbor at gas station

PAGE 2-3                                  PAGE 10-13

Jane and Rick fight again and Donna       Donna and Dad with jewelry box
comes to the house.
                                          PAGE 14-15
PAGE 4-5
                                          Veratu with bouncing ball and other Veratu
Kenji and the others at the wall - worried about monsters
getting in.                               PAGE 16-17

PAGE 6-7                                  Raina and Jackson

Luke and Becky with pregnancy.            PAGE 18-19
```

This step gives a sort of road map for the issue. Looking it over, we know if all the planned content will fit into a single issue and how much room we have for individual scenes within that issue. As writers, the most consistent problem we have is overwriting. We take too many pages to do things, use too many panels per page, and prattle on in dialogue when half as much would do just as well. A lot of the scriptwriting process is designed to prevent overwriting and to find how to say things in the best (and tightest) way possible. As you work, do your best to spot your own weak points as a writer. Make adjustments, as we did, to the methods you use to try to avoid the pitfalls you most often find yourself in.

Learn to properly budget your time so that you can accomplish everything you need to for each issue, chapter, or strip. It's a far easier task if you develop discipline as a writer now rather than writing for pages only to find that you need to cut half of it in order to avoid exceeding your page count. Remember, it's much easier to add to a scene when you find you've got more room than it is to cut stuff when you've written too much.

Once all the scenes are laid out, go back and break the script down panel by panel. Again, this is about trying to budget space and plan the pacing of

This page from the first issue of *The Uniques* ▶ has so many panels that the action gets garbled and confused. The panels get so small you can hardly tell what is happening! We thought we were being clever with this layout, but the end result is too cluttered and confusing to work. (From *The Uniques* by Comfort Love and Adam Withers, published by Comfort and Adam)

scenes. This time it helps the artist as much as you. A comics page can only fit three to six panels comfortably, give or take, depending on the amount of dialogue or action. Working out your panel count keeps you from overburdening the artist, so he can have enough space to draw the pretty pictures that will accompany your words.

In these panel descriptions, write as much as you think the artist will need to know so he can give you what you want. Paint a picture for him with your words; anything that is important to you to have in the artwork must be made clear so the artist won't miss it. Some people go "full Alan Moore" in their scripts, emulating the acclaimed writer by creating multiple detail-laden paragraphs for every panel of every page. Others leave it more to the artist's discretion, sticking to minimal necessities and trusting their collaborators to elaborate in their drawings. It's up to you, and you can always change your writing style as you get comfortable with your artist.

```
PAGE 1

Panel 1

We open the issue with a shot of the Acropolis. It's vast and      *
endlessly ominous, and as gray as anywhere else in the gloom.      *
It looks like a large city, the only notable difference is         *
that there are several huge towers of a similar style to the       *
Citadel (from issues 1-3) arranged through the skyline. Tall       *
dark buildings dot the horizon as the sun rises on a new day.

                    OTHER VERATU                                   *
              Speak to us, supplicant.                             *

Panel 2

A Veratu stands on a balcony looking over the Acropolis as a       *
cleaner lumbers out into the light of the morning. A mist          *
still hangs in the air as they speak. This is NOT our "lead"       *
Veratu, but another of their kind. He will have some kind of       *
visual cues to make that obvious, but for now we'll just call      *
him "Other Veratu."

                    OTHER VERATU
              You have witnessed the deviations                    *
              of one of our own; the warping of                    *
              our doctrine.                                        *

                    CLEANER
              Yes. My former master, he plans to                   *
              take back the wayward city on his                    *
              own.                                                 *

Panel 3
```

Here's an example of a full script for *Rainbow in the Dark.* You can see our different edits at work; each time one of us reads through, we make revisions in different colors, so the other can easily see what's changed when doing the next pass.

Finally, once the page-to-page, panel-to-panel work is done, fill in the dialogue. Bingo, bango, boffo, you've got yourself a script there, buddy. Or, rather, you've got a first draft. But your first draft is garbage. Sorry, it is. Nobody's first draft is perfect. You've got to write, rewrite, and rewrite again to hammer that puppy into shape. We never start artwork on a script with less than three to four drafts. We'll even revise it again when we do our lettering.

Take your time. Make it good. No . . . *make it great!* The saying goes that it's *possible* to do good work under the gun, but you can't do *great* work unless you can take the time to revise and refine. Once the script is done, go back through and give it a read. We promise you'll start wanting to adjust things as you go. Then give it a day or so and read it again. Be merciless! Question

everything, trust nothing, and always look for the best way to say a line or to build a scene. Then, eventually, you'll be finished.

Second Opinions

You've done several drafts of your script, but is it any good? You can't answer that question. You're too biased, positively or negatively. We're talking to you too, writers who hate everything you do! You need fresh eyes to read your script and give you opinions. We have a large group of prereaders (sometimes also called beta readers), editors, and proofreaders we trust to go over our scripts and give us feedback: men and women, young and old, multiracial, multitheological, and from a wide range of social and economic backgrounds. Their diverse backgrounds and experiences mean we get a wide range of opinions about what we've written and how it works (or doesn't).

One of the major advantages of having a diverse set of prereaders goes back to the idea of authenticity we talked about earlier. You are likely to be writing about characters from different backgrounds—backgrounds you don't share. If you're somebody who grew up in a loving, middle-class Caucasian suburban home, you might not have an immediate knack for writing about a poor, orphaned Hispanic kid growing up in a rough border town—or, for that matter, a wealthy Tokyo businessman living in a super-high-rise apartment. If you can find editors and prereaders who have *something* in common with your characters that you don't, even if it's only a small connection, they can point out

Get feedback from a diverse range of people. Their different backgrounds give them unique perspectives that can help your writing feel more genuine. It may not always be positive, but on the whole, it will always be valuable.

when your writing feels genuine and believable and when it doesn't. Trust us, if your characters aren't recognizable to the people out there in the world they're supposed to reflect, it will hurt the reception of your comic. Best to find out and make changes early rather than find out too late.

Finally, pick people you trust whose opinions you respect—people who won't just tell you how awesome you are, but who will challenge you and make you think hard about what you've written and how it could be improved. Steel yourself and listen, really listen, to what they're telling you. Not everything has to be used, and sometimes your vision for what your story needs will conflict with the taste or sentiments of one of your editors, proofers, or prereaders, but if you keep hearing the same things over and over then you probably need to address those problems.

Making Changes

In his 1914 lecture *On Style*, Arthur Quiller-Couch said that writers must be willing to "Murder your darlings." This means that no matter how much you love something you've written (your "darlings"), you have to be willing to cut them out if they hold your story back. There is no scene, no line of dialogue, not even a character that is so perfect that it's worth keeping if it hurts your story.

In a worst-case scenario, you have to be ready to scrap everything and start over if the results aren't good enough. When we finished the first issue of *The Uniques*, despite all our careful drafts, we had a good friend and prereader sit

We had planned to include this character in *Rainbow in the Dark*. He was wild, rough, and funny but had no real part to play in the story. We took his role and divided it up among the other characters (who actually had important roles in the story) so that they would have more screen time.

▼

us down and explain how the whole thing was a mess! He actually had Post-it notes with all the plot points jotted down and laid out in order, then reorganized everything to show a better flow for the comic. We wound up tossing much of what we'd written, reorganizing the order of events, and starting over. The result was a much better issue, and we were so glad we did it.

We had an entire character slated to be part of the main cast in *Rainbow in the Dark*, but as we got deeper in plotting the comic we realized he didn't add anything to the story. He was cool and fun, but his presence held the story back. By removing him, the characters who really mattered to the story got more room to shine.

Don't be afraid to cut anything that holds you back. You can always save it for later, copying the cut text into a document where you store all the great ideas you had that didn't work out in other scripts. Somewhere down the road, you may have a spot where it fits perfectly. Or maybe not. But nothing need be wasted just because it doesn't work right now. Thus, the BIG question becomes, how can you tell what should and shouldn't be cut? Well, fair readers, move on to the next section to find out!

THE WRITER'S TRINITY: PLOT, STORY, AND CHARACTER

You can break down a tale into three basic parts: the *plot*, which consists of the events that happen in the narrative; the *story*, which is the underlying theme or themes happening on a deeper level throughout the tale; and the *characters*, the people to whom all of this happens. Every scene you write should do something to propel the plot, the story, or the development of the characters. The best scenes can accomplish more than one of these goals at a time.

These broad categorizations are helpful ways for breaking up the development of your comic, by focusing on each piece in turn. What is your book about? What are the deeper ideas and concepts you are trying to convey through these events? And who are your characters, what is the arc they are on, and how do they change and grow over the course of your tale?

Plot

In simplest terms, the plot is what your book is about: the series of events that lead you through the story. Aristotle said that plot was the most important element of a story—even more important than characters! The importance of a solid, interesting plot cannot be understated.

Arthur Quiller-Couch also said that there were only seven plots in the history of storytelling. And he's pretty much right! At its most basic, plot doesn't deviate very much. Here's what you've got: man vs. man, man vs. nature, man vs. himself, man vs. God, man vs. society, man vs. machine, and man vs. destiny. Pretty much all the books you've read, the movies or TV shows you've seen, even a lot of the music you listen to will fall into one of those categories. So don't worry if you feel like your plot isn't original enough—nobody's is! What's really important is how you tell the tale, not that it's one nobody's ever read before. If the details of your plot are interesting, intricate, engrossing, or exciting, that's what'll set your idea apart and make it stand on its own.

All that aside, a narrative plot can be broken down into five very basic parts: exposition, rising action, climax, falling action, and resolution.

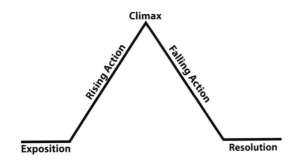

Gustav Freytag, a nineteenth-century author created this pyramid to describe the general flow of most stories. It begins with exposition, gains intensity through the rising actions, reaches peak tension with the climax, and then the conflict ends through the falling action and eases into the resolution.

Exposition is the opening, the setup, the events that explain where the characters started and how they wind up getting involved in your tale as it unfolds. The *rising action* is when conflict is first introduced and the characters have to do something about it in order to overcome whatever barriers you've just thrown in front of them. The *climax* is the moment of greatest tension in the story. It's frequently the moment where everything in your tale comes to a head and the characters are in the greatest danger. All success or failure hinges on

actions taken in that moment. The *falling action* encompasses the final events in resolving the conflicts of the story. Perhaps the main nemesis has been defeated, but your heroes still have to escape the burning building or drive off the wolves or bring down the shield generator so their allies can arrive. Finally, the *resolution* covers the last moments of the story, where we see how everything works out for the characters after the conflict is over.

It can help to write up a plot outline for yourself, where you simply jot down the order of events. It can be loose to start with, maybe only amounting to "Opening scene, something-something, big fight, the end." You might have specific moments you want to have happen at certain points of the plot, or you might just have general ideas. In whatever state your outline starts, having it is important because you can easily go back in and add to it as you flesh things out. Think of the plot outline as a loose road map, helping you remember where points X, Y, and Z are and exactly how you want to get from one to the next.

And it's very important that the sequence of events flows in a logical way. The most interesting tales are those in which the things that happen all relate to one another. Look at the individual events in your plot and ask, *Is this an "and then . . ." narrative or a "therefore/but . . ." narrative?*

"AND THEN . . ."	VS.	"THEREFORE/BUT . . ."
This happens		This happens
And then . . .		*Therefore . . .*
That happens		That happens
And then . . .		*But . . .*
Something else happens		Something else happens
And then . . .		*Therefore . . .*
This happens		This happens
And then . . .		*Therefore . . .*
The story reaches its ending.		The story reaches its ending.

Disney's *Sword in the Stone* (and, to a large extent, the novel *The Once and Future King* on which it is based) is an "and then . . ." plot. Merlin takes Arthur under his wing and then they turn into fish and then they turn into squirrels and then they turn into birds and then Arthur pulls the sword from the stone—*The End*. The events happen one after the other, but don't have any causative relationship

to each other besides the very tenuous "because he's training the kid" thread. You want things in your plot to happen *because of* the other stuff in your plot!

Compare the previous plot with that of *The Matrix*, which has a great "therefore/but..." narrative: Neo is a genius computer hacker who feels something is wrong with the world, therefore he draws the attention of Morpheus, but he also draws the attention of Agent Smith. Therefore Morpheus has to act more quickly, offering Neo the chance to leave the Matrix and enter reality, therefore Neo enters the real world for the first time and finds out he might be "The One." But he isn't actually that good, therefore Cypher doubts him and Morpheus's whole plan, therefore he accepts Agent Smith's offer to betray Morpheus. It continues on like that, with each piece of the story leading directly to the next in a logical, interconnected way.

As we like to say, some of the very best plots are those that "use every part of the buffalo." Events from the very opening scenes become critically important later on. The resolution or solution to the final conflict hinges on some item or piece of knowledge gained early in the plot. Every piece of the plot contributes to some other piece in a meaningful way. If you can weave a plot that's that tight, you're golden.

Story

If the plot of your tale is the series of events that happen, the story is the underlying emotional stuff that drives the narrative. The plot is what the book is about—the story is what it's *really* about. It can be tricky to get a handle on the

STORY VS. PLOT IN COMICS, MANGA, AND WEBCOMICS

	COMICS *Watchmen*	MANGA *Death Note*	WEBCOMICS *The Dreamer*
The PLOT is . . .	A murder mystery set against the backdrop of the possible outbreak of World War III.	A detective story in which two brilliant minds challenge each other for supremacy with the fate of the world in the balance.	When she sleeps, a teenage girl has strangely realistic dreams of being in the American Revolution.
The STORY is . . .	A group of former superheroes slowly realize that sometimes, to be the hero, they have to become the villain, and must decide what compromises they will refuse to make.	Given ultimate power over life and death, a young man makes himself a god and, in trying to serve the greater good, becomes the ultimate evil.	Torn between two worlds, a girl must decide where she stands, and she discovers there are things in life worth fighting for.

difference, so consider this example: the plot of *Star Wars* is about a galactic civil war, but the story of *Star Wars* is that of an orphan boy who discovers his father is the greatest evil the galaxy has ever known, and in redeeming his father he saves himself.

Every good narrative has something going on beneath its surface that adds extra depth and interest to its plot. You want your book to be about something, even if that something is as simple as what it means to love somebody or what it takes to be a hero. The story doesn't have to be complicated to be good; even simple stories can be moving and meaningful.

There are a couple of ways to approach what your story will be and how you can deliver it in your narrative. One is the use of theme; the other is by delivering a moral or sermon. Themes deal with larger, broader issues and ideas, whereas a story with a moral or sermon tends to focus on one big idea that is built up to throughout the rest of the tale. Both types of stories work equally well in different situations, and can often cross over each other (a story about a theme that delivers that theme as a sermon, a story with a sermon that is broad enough to encompass a number of smaller ideas).

Themes are broad hypotheses that encompass many smaller ideas. "Love conquers all," "life is beautiful," or "war is more complicated than good vs. evil" are all common themes that include a lot of concepts and theories all working toward one broad hypothesis. The comics series *The Walking Dead* by Robert Kirkman, Tony Moore, and Charlie Adlard is a story about the themes of the cost of survival, the value of relationships, what it means to be human, and the nature of society and community. Every plot arc is designed to showcase and further these themes in large or small ways. Even the characters themselves are built so that their story lines build these themes, and in resolving the personal struggles of these characters, the creators of *The Walking Dead* present aspects of their themes to the audience.

Themes have the advantage of being broadly applicable. At its core, the theme behind the *X-Men* comics is one of outsiders rejected by society who nonetheless try to help humanity while trying to earn the acceptance they deserve. That theme can apply to a wide range of people, from teenagers who feel like their thoughts and feelings aren't taken seriously by adults to people struggling against racism, bigotry, or religious persecution—basically anyone who has ever felt like they weren't accepted because of some factor they couldn't control. All of them can find something to attract them to the themes *X-Men* explores. This is a large part of the reason why these characters have remained so popular and relevant since their inception—the search for acceptance is universal.

Morals or sermons are typically more narrowly defined, and a story will usually have only a single moral to deliver. Traditional fables and fairy tales often conclude in this manner. Where themes are broad concepts, a moral will

say something more specific and concrete, like "the American drug war damages the lives of everyone involved." Also, while themes are broad enough that they're rarely called out specifically in the writing, morals are often stated explicitly somewhere. That's why they're sometimes called sermons, because at some point a character will speak a line that essentially tells the audience what the story is about, like a preacher delivering a sermon to her congregation. (Consider Stan and Kyle's little speeches at the end of so many episodes of *South Park*.)

If you're writing a story around a central moral or sermon you want to deliver, odds are you want the audience to agree with it (or at least accept the possibility that it could be true). To do this, you have to ensure that your plot

The moral of the *Frog Prince* is that you shouldn't judge a book by its cover. It's a brief story that gets to the point, and every piece of the tale reinforces its sermon, encouraging the audience to consider more than appearance when judging a person. ▼

and characters deliver plenty of evidence to back you up. If you have a character who has taken an oath of nonviolence in a tale for which the moral of the story is that violence isn't the answer, you'd better not have her readily killing off enemies to resolve conflicts without there being major consequences. If you want people to believe your sermon is true, make compelling arguments in your story to win them over, and don't let your plot or character actions undercut your ultimate message.

Writing a story around a moral can be very rewarding, but very dangerous at the same time. The fanbase you can build around a story with a sermon that people can rally to is tremendous, but anyone who rejects or can't believe in your sermon might feel that the story has turned them away. The bigger your "big idea" is, the more risks you take with the moral—the more you'll need to be prepared for potential backlash. But be brave! Trust that you can find an audience that will be as excited to discover your message as you are to deliver it.

Character

The scenes you write can develop characters in a couple of ways. The first way, and the one most connected to your plot and story, is through each character's narrative arc. A *narrative* or *character arc* is the way a character grows and changes over the course of a story. The events that unfold, the challenges you craft in the plot, all need to have an impact on the characters. If they don't— if characters go through the entire story and don't learn anything or have any personal growth—then they become flat characters, or ones without arcs. If the main character or characters are flat, then their adventures feel meaningless. Even if the conclusion of the story sees the main character returning to the same life she had before, she must have learned something or grown somehow as a person, or the audience will feel like your tale was pointless.

When writing, character development can help you move the plot forward. Each time a major plot event occurs, the very next thing you should ask yourself is *How would my characters react to this?* The choices they make and the direction they choose to move determine where the plot goes next. Once you get the hang of it and really come to know your characters well, you'll find that each action from your antagonist occurs in reaction to something the protagonist has done, which will in turn drive the protagonist to take further action and cause the antagonist to react yet again.

The point is that characters are the axis around which the entire comic turns. When people read comics, it's generally the characters that draw them in and make them care. While readers may delight in the plot and story that you deliver over the course of weeks and months, it will most likely be the strength of your characters that gets them hooked. And it will be those characters who

In one stunning moment in the first issue of *Mouse Guard*, your whole perception of Liam changes and you realize how tough he, and the rest of these mice, can be. (From *Mouse Guard* by David Petersen, published by Boom/Archaia)

have to keep them hooked long enough to start finding out what your long-term plans are.

So, when planning a comic, make sure you spend extra time developing your core characters, and stick with a small enough group, so that each can easily get the face time needed to make an impact. If your cast is entertaining enough, you can hook readers whether you release a graphic novel once or twice a year, or just a few panels a week. Once readers are hooked, you can keep them for whatever your bigger plans might be.

The other way you can develop character in your comics is more subtle, but it is a constant factor. Every time characters speak, you build their personalities. Every line of dialogue is another opportunity for you to clue the audience in on what sorts of people these characters are. Whether it's through humor or some particular kind of dialect used when speaking, some quirk in the way they phrase their words, there should be something in how they talk that reveals deeper truths about their characters.

The way this moment plays out gives important cues about who the character, Metatron, is as a person, at the same time as it moves the plot forward. (From *The Victories* by Michael Avon Oeming, published by Dark Horse Comics)

PRO TIP

DANIELLE CORSETTO: BUILDING CHARACTER IN WEBSTRIPS

Whenever I introduce a new character to *Girls with Slingshots*, I think about how that person would introduce him or herself in real life. Often we do what my friend Michael calls "sending your representative"—presenting an ideal version of ourselves to a new acquaintance in the hopes that they'll like us more. The same goes for most fictional adult characters (kids, on the other hand, tend to wear their entire personalities on their sleeves, God love 'em).

As we get to know characters over time, their flaws will slowly come to the surface—like the process of an acquaintance becoming a friend. Sometimes a character will surprise even you, the creator, by developing a personality you didn't expect! Let it happen; your characters will develop their own voices regardless of your original plans. Letting characters' motivations guide your writing can lead to interesting plots that you never expected. They may also lead you to research something you weren't familiar with before, in the interest of writing the developing characters more believably.

Danielle Corsetto
Creator of *Girls with Slingshots*
girlswithslingshots.com

This happens all the time—you're likely already doing it yourself, you just don't recognize it. When something terrible happens and your character responds with a glib, humorous retort, you're building character through dialogue. When something wonderful happens, and your character responds with a sardonic "We'll see . . ." you're building character through dialogue. When your characters speak in a scene, always ask yourself if there's some way you can phrase their dialogue to reveal something about them. It's easy to say broad things, whether funny or serious, dry or goofy, dim or clever. It's the greater writer who can slip surprises and secrets into dialogue, something the audience won't realize was important to the comic until later on.

Let's look at a way you can build plot, story, and character in one scene. Suppose you're writing a book about a young cop who's been transferred to a police precinct plagued with corruption in a district overrun with crime and hopelessness. You could craft an early scene in which the rookie and his older partner respond to a domestic disturbance call. While the rookie cautiously approaches the house, attempting to speak with the quiet, shaking wife, his partner marches in and grabs the husband. Handcuffing him to a stair rail, he proceeds to pummel him and threaten him. Taking his wallet, he gives it to the woman and tells her to go to her mother's house as he and his shocked partner leave.

The rookie is furious and challenges his partner. It ends with this exchange:

In one short moment, you can move forward the story, plot, and character simultaneously.

That one small scene does a number of things. It establishes your plot, showing the by-the-book rookie cop and his bitter, brute partner in a crooked city. It establishes story: the struggle of a good man in a hard situation, the struggle for righteousness in a place that has no respect for the righteous. It establishes both of your main characters and what they're like, as well as what their relationship to each other will be.

But there's more. This scene could be just the beginning; it could plant a plot development seed, if the woman turns out to be important to the book later on, or if this action gets the cops in trouble with Internal Affairs. It could lead to story developments if you wanted to make a whole comic that spoke about abusive relationships—the husband and wife are obvious examples, the brutish cop bullying his young partner is a slightly less obvious one, but there's also the relationship between the police and the people they're meant to serve and protect. You could use this scene to develop a story about how good people trying to stop monsters can become monstrous themselves.

Finally, this scene could lay hints about character beats for later. The brutish cop sure was protective of the wife . . . what if she turns out to be connected to him somehow? Or maybe he himself used to be an abusive husband before his wife and family left him, and he channels his regret and anger at himself outward into people he meets who remind him of the person he used to be.

HOW TO WRITE DIALOGUE

Comics writers are a lot like screenwriters: most of what they write won't be read by their audience. All that descriptive text and panel-to-panel stuff will get turned into artwork. While you decide the narrative arc, people won't read it—they'll see it. The only thing you write that is read directly as text on a page is the dialogue. For this reason and more, dialogue is the most important thing you'll write in terms of how the audience appreciates your contribution to the story they're reading.

Dialogue Defines Character

We've frequently said (and probably will again, at length) that character tends to be the most important thing in your overall story. People who love your characters will most likely love your comic. Create characters entertaining enough and audiences will love your writing even if your plot is weak. Just ask J. J. Abrams or Kevin Smith: characters with enough personality and heart can trump everything else. Character is defined in many ways, but it comes down to this: how a person acts and talks.

The way your characters express themselves will determine a huge percentage of what the audience thinks about them. A character could be a detestable jerk, but if they have witty and charming dialogue then people will love them. A character might be a selfless paragon of goodness, but if they've got stale, boring dialogue, readers won't care.

Note the angry father referring to "your" son while the soothing mother says "our" son. Little dialogue beats can say a lot about characters and their relationships. (From *Delve into Fantasy* by Del Borovic)

There are always a number of ways to say something. How a character speaks reflects his personality and changes how people think of him. Make sure each of your characters has his or her own way of talking. ▶

PRO TIP

SCOTT KURTZ: FINDING A CHARACTER'S VOICE

Your story IS your characters. You can have a story dripping with plot, but if your characters aren't well defined it will be boring, which makes giving each character his or her own "voice" so important. Readers should hear your characters in their mind and be able to distinguish them. When writing your dialogue, ask yourself, *What does this character want from this conversation and what's their relationship to the person they are speaking to?* Well-defined characters will start to "suggest" their own dialogue the moment you place them in a situation or pair them with another character. It sounds crazy, but well-defined characters can tell *you* what they're going to say next. Once you know the characters, ask yourself, *How do they sound?* Try reading the dialogue out loud, and listen to yourself. Does it sounds like a group talking or does it sound like a crazy person talking to himself? You know what, it's best to avoid this exercise in public places!

Scott Kurtz
Creator of *PVP, Table Titans,* and *How to Make Webcomics*
pvponline.com
tabletitans.com

The most important thing is to give characters dialogue that reflects their individual personalities. Writers call this having the characters "speak with their own voice." No two people will use exactly the same kind of words or phrasing. A teenage dropout won't talk the same way as a middle-aged bank teller. Older people will frequently use older slang and reference pop culture that basically nobody remembers; younger people will frequently make little sense to anyone even a few years older than they are.

There are a lot of ways to say any given phrase. Look at how one person asking another, "Would you like to have lunch together?" (in the image above) can reflect personality just through how they say it.

Part of the problem for many writers is that it's too easy to master one way of speaking and have every character talk like that. You easily wind up with a cast full of diverse faces all speaking exactly the same way. Look at the movie *Juno*—while the dialogue was very clever and fun to listen to, every character in that film tended to sound alike. In our observation, nobody had his or her own means of expression; it was just the same sarcastic banter from every mouth on the screen. No matter how entertaining that dialogue may be, it doesn't make sense for all characters to express themselves the exact same way. Your characters need to talk the way real people talk! Some clever, some sharp, some snarky, others dull, others slow; professional or casual, uptight or relaxed, poetic or plain, dramatic or practical—human beings talk in a billion different and amazing ways.

LIFE AS A WRITER

Being a writer in comics is a difficult proposition. We won't beat around the bush, here: this is generally seen as a visual medium. When people think of comics, they often think of the art. They think of the characters. They think of the movies, for goodness' sake. They don't always think of the writers. Some superstars emerge who make such big names for themselves that people remember them—writers like Neil Gaiman, Stan Lee, and Akira Toriyama. Most of the time, though, the comic itself will be better known than the person who writes it.

If you're a writer-artist, that isn't as much of an issue for you. You know how to draw and you have a skill that will give you an edge in terms of gaining fans and building a reputation. If you're someone who can't draw, you will need to build a team that can carry you to victory.

The Team Leader

The writer is usually the one who comes up with the idea for a comic. This makes you the leader of your team of collaborators, and puts most of the responsibility for the success or failure on your shoulders. You will be the person in charge of publication, marketing, distribution, press, and keeping the rest of the team going. When there are problems in any area of production, you'll be the one who has to take charge of getting them resolved. You are, in short, the most important person when it comes to the comic's long-term success.

But first, you need to build your team. The number one question we're asked when we travel and give our seminars and lectures is *How do I find an artist?*

As team leader, the writer must wear many hats. Be prepared for the ~~horror~~ *joy* of being in charge.

JON LOCK:
BUILDING YOUR TEAM

The first comic I ever made was the result of a collaborative effort. Having realized at quite an early age that I was never going to cut it as an artist, I instead took on the role of writer while two of my childhood friends assumed the art duties.

Years later, as I pursued my dream of making comics, I again found myself in need of an artist to bring my scripts to life. My break came when I posted an advertisement on the "Help Wanted" forums at digitalwebbing.com. This effort put me in contact with the incredibly talented Ash Jackson, who would go on to be instrumental in defining the look and feel of my comic, *Afterlife Inc.*

In exhibiting at comic book conventions, I gained invaluable experience and made many friends who would later contribute art to my stories. Always be willing to put yourself out there and make connections. You never know what exciting collaborations may come about as a result of chance encounters. No creator is an island, and there are few things greater than working alongside friends.

Jon Lock

**Creator of *Afterlife Inc.*, *Orb*,
and *99 Swords***
jonlock.com

There are a lot of people out there who want to write comics, but finding a partner to collaborate with is very difficult. Finding one who is reliable and dedicated can be even harder.

We recommend pursuing a two-pronged approach of searching the Internet and networking comics conventions. When online, peruse websites like DeviantArt where masses of artists congregate. At conventions, wander the Artists Alleys, and see and talk to the people there. Find artists with a style you like, who aren't already established talent (people who don't already do steady work on comics), and who have pages of comics art (generally found in their online galleries or in a portfolio at their table, if at a convention). That last one is important, since you want to work with somebody who knows how to draw comics! Just because an artist is amazingly talented doesn't mean she'll know the first thing about creating comics pages. If she doesn't have pages on display, ask her if she has any samples for public viewing. If she doesn't, look elsewhere.

Strike up conversations with artists. Comment on their work, let them know you like what they do, and try to build a relationship over time. Don't jump right in and immediately tell them you want them to draw your book! Get to know them a bit, and let them get to know you. A collaboration is a delicate thing; akin to a marriage, it takes time, work, and commitment, and isn't something to enter into lightly.

Scour the Artists Alleys of comics conventions to find people who are ready to make comics but who haven't been snatched up by big publishers yet. ▶

WRITER ARTIST

◀ While the quality of their work is equally important in the success of a comic, the plain truth is that artists will always carry a vastly heavier workload than writers.

PRO TIP

LINDSAY CIBOS AND JARED HODGES: WRITING AS A TEAM

For us, the key ingredients to successful collaboration are trust, compromise, and playing off each other's strengths to make the best work possible. After developing a concept and discussing the basic plot, characters, and thematic elements, one of us will take the lead role of building the overall story structure for the project. From there, we alternate making passes over the manuscript, adding ideas, and fleshing out the story. Sketches of characters and other visuals happen as well.

Sometimes we'll have a disagreement about the story's direction, a character's motivation, the visuals, and so on. This is an important part of the collaboration process! Be open with your teammate about what is and isn't working. Challenging one another's ideas can be tense, but it can also invigorate boring writing and pinpoint problems or areas in need of finesse. If there's something one of us feels strongly about keeping, we back it up with reasons for why it's essential to the story; if we can't come up with a convincing argument for it, we reassess and change it!

Lindsay Cibos and Jared Hodges
Creators of *Peach Fuzz*
and *Last of the Polar Bears*
Artists on *Domo: The Manga*
jaredandlindsay.com

Eventually, ask for a commission. Request something that requires a little back-and-forth between you and the artist. Nothing too complicated or tricky, just something to see how the artist works with your direction. If she can't do a commission for you, she can't do your comic. After that, you might try to arrange a short five-page story. Five pages aren't a lot, but they're enough for you to gauge the artist's professionalism and how your relationship will work. Again, if the artist can't do five pages, she can't do a whole comic.

There is, of course, the matter of compensation. Here we have to pause a moment to tell you a hard truth you have to accept: your artist is in demand. You are not. This is an artist's market. A new comic will sell based almost entirely on its art, and artists know this. You will not get an artist of any skill or quality to commit to a full miniseries without offering some kind of compensation.

This is fair. We are both writers and artists, and believe us when we say art is far, far more time consuming. It takes at least a day to draw a single *page* of comics art, while we can write an entire twenty-eight-page issue in just a couple of days. Heck, even if you've been working on this story for years, you were probably able to keep a regular job during that time. When you ask an artist to work on your book, you are effectively asking her to give up her entire life for months or years to make your dream a reality. Offering a percentage of the profits is expected, but doesn't count as real compensation. Few comics make much money in the beginning (or ever, in some cases), and even a huge cut of profits might not amount to much. Eighty percent of zero dollars is still zero dollars. For the same reason, offering a share of the rights of the book is expected, but won't be enough.

We also know, as do most artists, that few people have the money to fund an entire comic independently. So the question becomes this: How *do* you

TOM PINCHUK: RESPECT YOUR TEAM

Have you, as a creator, ever wanted to be somebody else's rubber stamp?

No? Not ever? Gee . . . neither have I. And no one on your creative team will ever want to be, either. Remember this at every stage when you're making a comic.

The "finished script" is just the starting point. I turn it in with the expectation that it'll evolve according to what the rest of the team contributes. Certainly, it's important to have a clear creative vision, but being amenable to your collaborators' choices is just as important.

Make your panel descriptions as detailed as necessary, but always leave the penciller, inker, colorist, and letterer room to do their thing. Sometimes, what they send back will be exactly what you pictured. Other times, it'll be radically different. Sometimes, it'll be worse. Other times, much better. This is an artistic dialogue, not a lecture. Keep the discussion open.

Give your team creative license. Encourage them to spitball ideas. Respect their talents. By the end, you'll have a far more vibrant and exciting comic.

Tom Pinchuk
Writer of *Max Steel*
Cocreator and writer of *Hybrid Bastards!* and *Unimaginable*
tompinchuk.com

compensate your artist for her work beyond her fair share of the rights and profits of the material? For this, we recommend the barter system. It works. Ask yourself if you have any skills to offer your artist as payment. Could you do her taxes? Mow her lawn? Build her website? Work on her car? What can you offer that isn't money but that will still make it worth the artist's while?

Once the collaboration begins, expect headaches. Again, this is a relationship and relationships will experience ups and downs. In the end, it's all about communication. As the team leader, it's your responsibility to keep a cool head when things get stressful. There will be miscommunication, misunderstood emails, conversations where something is taken the wrong way, and these will all lead to mistakes in the project. Stay calm and remember that everybody wants this comic to succeed. Your artist might be just as new at this as you are, and her inexperience might lead to confusion or frustration. Look for how you can smooth things over peacefully and keep the ball rolling while making sure the team doesn't lose too much time in the process.

Always keep the word *compromise* at the front of your mind. The two of us frequently argue over our stories, and those arguments can get heated if we aren't careful. We aren't always perfect at this teamwork thing, but time and again we find that, when we stop fighting for our own way and try to find a third option, it turns out better than either of our original ideas. If you run into a seemingly intractable situation, step back and ask what *everyone* needs. What is the core need they have that their idea is designed to address? And then, once

All the struggles of collaboration are worth ▶ it when you hold that finished masterpiece in your hands. It's a truly wonderful feeling.

everyone has said their piece, try to work together to formulate a new idea that can address everyone's needs at the same time.

It's hard work being team leader, but someone has to do it. Be the bigger person. Be the cool head in the fire. Be the calm center of the storm. Be the one who gets everyone's butts in gear and keeps the project going through its ups and downs. You'll be the hero of the project.

The Writer/Artist

Your life will not be easy, friend. You are going to have to work long, long hours to make your comic a reality. Don't take the quick, easy path and skimp on your scripting to get to the art faster—write out the entire script in long form before drawing a page for each issue. No matter what you think, it will improve your work. Sometimes writing can give you ideas you wouldn't have had while drawing. Sometimes you make massive mistakes while drawing that could cost you days of work to correct; whereas if you'd written it out first, such mistakes could have been caught and corrected in minutes. Just because you can draw doesn't mean you get to skip any steps.

PRO TIP

THOM ZAHLER: LEADING A TEAM OF ONE

Keeping yourself motivated is a challenge. It's hard to keep yourself working when you can also hear your couch calling your name. It's harder still when there's no one imposing a schedule on you.

It's your responsibility to manage yourself. Figuring out what works is key. Do you write better in the morning? At coffee shops? Do you draw better with a cup of coffee? Don't fight it; figure out what you can use to quickly get your brain into "work mode."

Find a reader or readers if you can, people you can show your in-progress pages. It's good to find someone who will be disappointed when you don't produce new work. Excuses are harder to make when you have to say them out loud.

And, above all, be realistic. I can write and draw a page a day, but that has to be a clear day. Eventually, your water heater will break, you'll catch the flu—something will happen to throw off your schedule, so put some padding in it.

Thom Zahler

Creator of *Love and Capes*
Writer/artist on *My Little Pony* microseries
thomz.com

◀ There will always be people who think that, since you're an artist, you can't also be a "real" writer. Aspiring writers might say things that are unintentionally offensive. Let it roll off your back—they're just hoping you could lend your talents to their stories. It's a compliment!

The biggest problem you'll have, as we've stated, is funding. Usually, the writer is kind of the patron of the project. She finds some way to compensate everyone or offer some kind of carrot on a stick to keep things moving. You'll have nothing, which can force you to work another job and thus have even less time to work on your art. But have heart! As the writer/artist, you also have the rare gift of complete creative control! Then again, complete creative control is a double-edged sword. You'll need editors, prereaders, and other second opinions even more than other creators because you haven't got a team of cocreators to help build the comic and bounce ideas around, looking for the best ones.

Learn this quickly: if your art is any good, you'll never be respected as a writer. Well . . . not for a long time. All the focus will be on your pretty pictures, not your story. Other writers out there will think that you're just waiting to abandon your comic and draw theirs. After all, you're an artist! Not a *real* writer like them! It's frustrating. Conversely, you might be highly respected as a writer, but your artwork will be totally ignored. It happens less often (again, comics are a visual medium, so art is almost always noticed first), but it's still frustrating to work so hard on something and only receive partial credit for a whole job.

Someday you could be great enough ▶ to carve a place in history alongside the great writer-artists.

You carry a lot of responsibility. You can't slack on your writing, or you'll quickly be labeled "an artist pretending to write." You can't rush your art half-heartedly, or you'll be seen as "a writer pretending to draw." You won't be able to produce work as fast, so your books will release less frequently and thus have a harder time holding people's attention. This means you'll have to work harder at marketing and traveling to conventions, which will further restrict the amount of time you have to finish your art.

But if you can manage to master your craft, be a truly great writer, AND be a truly great artist, you will enter a very elite pantheon of cartoonists who are universally respected by writers and artists alike. Mike Mignola, Bill Watterson, Osamu Tezuka, Frank Miller—these are the names of creators other comics pros wish they could be. For all the work you'll endure, all the hardships and struggles and long, rough days and nights, your friends and peers will envy and respect you. It's a good feeling.

3. DRAWING

ART IS WHAT SEPARATES COMICS FROM NOVELS. Sequential art—using images arranged in sequence to tell a story—is a different kind of illustration than any other. You carry a heavy responsibility as the artist of a comic; the early success of your book rests largely on your shoulders. People won't reject the first issue offhand because the writing is poor, but they will frequently refuse to try a first issue because they don't like the art. It isn't enough to make beautiful illustrations. You also have to tell a story! We believe comics to be among the most challenging fields an artist can attempt because you have to flex muscles no other artist needs to use.

In this chapter, we'll show you how we draw pages. We won't teach you how to draw—there are a lot of great books out there to teach you that. Instead, we will focus on showing you how to use your drawings to tell a story that a reader can follow and enjoy. We'll also talk about how to draw characters that feel real and believable to your audience and that come to life on the page. Finally, we'll get into what you can expect as a professional comics artist and how to work with your collaborators to have a more fulfilling experience.

▲

An early sample page of Adam's. The panel layout is nearly unreadable.

Comics pages are fascinating pieces of art. Each panel is an illustration unto itself, yet all the panels on a page must work together as a singular whole. It's kind of like a collage—a piece of art made up of smaller pieces of art—and yet, the comics page also has to have a narrative flow that tells a clear story from left to right, top to bottom, the same way text is read here in the Western world.

The nature of sequential art makes comics a unique art form and a medium for storytelling unlike any other. There is no story comics can't tell, and the merger of pictures and words in a sequence on the page allows us to tell stories in a way that no other medium can.

What's on the Page

Let's look at what goes into a comics page so that you can know what you're dealing with. These are the most common features that any given page of comics art will have.

1. *Panel*: The images drawn inside borders. The fundamental building blocks of all comics. How you lay out the arrangement of panels on a page determines everything about how your comic is read and interpreted by your audience.

2. *Panel borders*: The frames or edges around the panels. Sometimes panels are created without borders and use the *gutters* (see page 59) to separate one panel from another.

Page 2 from *Rainbow in the Dark* #5 (*Rainbow in the Dark* by Comfort Love and Adam Withers, published by Comfort and Adam)

PRO TIP

JENNIE BREEDEN: USING AN ONLINE FORMAT

If you post your work online with updates daily or weekly, one drawback is that you must show something happening in each post. If you read a print book, it can take a whole chapter for the story to get to a point. But if your readers wait twenty-four hours or more between pages, you have to hold their attention and get them to come back for the next "episode." The upside of digital work is that you can turn on a dime.

You get real-time feedback from your readers as your story unfolds. Digital readers are generally a tad more forgiving of style changes than print fans.

You can develop your style as the story progresses and your readership will develop along with you. Never let your perceived lack of ability hinder you. Use the digital field as a playground to learn and develop your skills.

No one thinks they're ready; you just have to do it and you'll learn along the way.

Jennie Breeden

Creator of *The Devil's Panties* graphic novel series
thedevilspanties.com

3. *Gutters*: The space in between panels. Where the real action of a comics page happens. Where the reader performs the work of filling in the spaces between what happens in panels. The space between panels can be infinite. You can have a panel with cavemen hunting prehistoric creatures followed by a panel of skyscrapers and businessmen, or a two-panel sequence of a hand slowly opening and closing. It's up to the reader to bridge the gap of time, whether millions of years or milliseconds.

4. *Bleed*: When an image runs off the edge of a page. When an image bleeds off of every edge of the page (and thus has no panel borders or gutters), it's called a *full bleed*.

Special Panels

Certain kinds of panels deserve special attention. They serve specific functions and are so common as to be standard across virtually all types of comics.

Establishing shot: A panel that establishes a scene, setting up who the reader is watching, what they're doing, where they're doing it, when it's being done, and possibly why, is called an *establishing shot*. These panels are necessary to keep the reader oriented to what's going on and where it's happening. Every page should have at least one establishing shot, and every time you change locations, you need a new establishing shot to show it. If you change locations four times on one page, you need four establishing shots on that page. You never want to let the reader get confused as to where the scene takes place.

Inset Panel: When one panel is drawn completely inside the borders of another, it's called an *inset panel*. They can perform a number of functions, such as showing an expression or reaction from a character who otherwise wouldn't be seen by the audience, drawing special attention to a particular action happening at the same time as events in a larger panel, or delivering a punchline to a joke set up in the larger panel. Inset panels can get tiresome or even annoying if overused, so try to use them sparingly and only when they are the best way to accomplish a storytelling goal.

Splash page: When one entire page is taken up by a single image, it's called a *splash page*. When one panel takes up two-thirds or more of a page, it's called a *splash panel*. When one image takes up two whole pages (instead of just one), it's called a *two-page splash* or *double-page splash*. Artists frequently use them to open an issue "with a bang" or to wow readers with a big reveal, a cool action shot, or some event so large in scope it needs an entire page (or two) to show it all.

This one panel gives a lot of information. We can see where we are (dingy computer lab). We also see the main characters and get a sense of what they might be like. (From *The Uniques* by Comfort Love and Adam Withers, published by Comfort and Adam)

▼

This inset panel allowed us to spotlight one of the fighters on the wall, giving some personality to the battle cry and ensuring the reader knows where the cry is coming from. (From *Rainbow in the Dark* by Comfort Love and Adam Withers, published by Comfort and Adam)

A splash page stops the reader with a sudden, huge burst of art in the face. (From *Rainbow in the Dark* by Comfort Love and Adam Withers, published by Comfort and Adam)

▲

A simple thumbnail sketch, shown at approximately its actual size.

Artists are frequently an impatient lot. Paradoxically, many are willing to procrastinate for long periods, and then rush through the process of preparing their work so that they can get to the final, polished drawing as quickly as possible. Just as writers have to be willing to work through several drafts—refining their scripts into their perfect form, artists must also build their pages with a series of sketches and revisions to find their best ideas.

The process we use when drawing comics may seem like it adds a lot of time to our workload, but in fact, it saves us tremendous amounts of time! By slowly working up rough drawings and tightening them into final drawings, we not only reduce the amount of mistakes we make (and thus time spent fixing them), but we also get to work with confidence, knowing that the pages we're drawing are the best versions we could come up with.

Thumbnails and Final Roughs

The process of drawing comics pages begins with *thumbnails*. These are small, super-rough sketches that serve to get ideas out of your head and onto paper so that you can know if what you're planning will work as a page or not. Frequently, there's an invisible wall between thought and execution; the plan in your head for how a page will work can turn out to be really difficult to actually draw.

Thumbnails serve a few important mechanical purposes. First, comics art requires each panel to function on its own while simultaneously contributing to a coherent page. Your final pages will be drawn at least two-thirds larger than the size at which they're printed, either because you're drawing on larger paper

or zooming in digitally to get crisp details. That's much too large an image for you to see all at once. You can only focus on the small piece of the page right in front of you, which makes it hard to gauge how the rest of the page fits together. By drawing small thumbnails, you can see the whole page at once and instantly know how well all the panels work both individually and as a unit.

The difficulty of seeing the whole piece of art at once affects other aspects of illustration as well. It's far easier to look at the proportions of your characters at a small size and tell whether they look right. Doing wild poses with your figures becomes much simpler when you can sketch it out loose and quick at a smaller size. It's also easier to see any problems with the perspective used to draw your backgrounds and characters—with a single glance, you can see if the buildings, cars, trees, figures, and so on are all receding in space correctly.

Finally, thumbnails prevent you from becoming too attached to your ideas. You might get halfway through a drawing before realizing you could have done something much better. However, if you start right on the final page, then you will have already spent the better part of a day drawing it. Having put that much time in, you might not want to start over, even if you know you could have drawn something much better. If you only spend a few minutes drawing a thumbnail and it isn't working, it's no sweat off your back to go back and try again. You can draw a dozen thumbnails or more in the time it takes to rough in one final page. Since the time investment is so small, thumbnails make it easy to get creative and take risks by trying different types of things.

There are several ways to approach thumbnails, but we're going to show you two of the most commonly used methods in comics. We'll call the two

◀ If you can't see the whole image at once, you might not realize what mistakes you're making until it's too late.

PRO TIP

JANE IRWIN: THOSE WHO FAIL TO PLAN, PLAN TO FAIL!

Everybody loves a good storyteller, someone who can take even the most boring narrative and make it interesting. In comics, the storytelling process begins with thumbnailing. In many ways, it's the most important step, because no amount of flashy penciling or beautiful inking can save a page that's a visual mess. Remember, you're not just figuring out how much action can fit on one page, you're also explaining the story to your readers, balancing dialogue, camera angle, facial expressions, and movements until you have just the right mix of narrative, pacing, and mood.

I brainstorm potential ways to tell the page's story by doing several quick sketches, each about the size of a playing card, until I get one that finds the sweet spot between subtlety and clarity. I then develop the page from there. Investing in this step may even save time and effort—frequently, thumbnails capture much more emotion and spontaneity than tighter drawings, and you can blow them up on a computer or photocopier and "lightbox" them into your final pages.

Jane Irwin
Creator of *Vögelein: Clockwork Faerie, Vögelein: Old Ghosts,* and *Clockwork Game: The Illustrious Career of a Chess-Playing Automaton*
fierystudios.com

Doing thumbnails of the same page in completely different ways forces you to get more creative and may draw out better ideas than from a single attempt. ▶

PRO TIP

FREDDIE E. WILLIAMS III: DRAWING DIGITAL THUMBNAILS

Creating page layouts digitally is using the most versatile tool for the most important (and intimidating) step of comic book creation, as you can explore any angle, pose, or composition that occurs to you— encouraging creativity and increasing speed!

You can even "bank" unused ideas and poses along the way, saving them for later. For example, if you realize the awesome punching pose you've drawn isn't right for that page, you can save it in an "unused poses" folder to use later. This way, no idea is wasted and you can feel free to try anything while not being bound to use any poses or layouts that don't work for the page you're drawing.

Make sure you're still working to master your drawing skills alongside your digital skills, not expecting your illustration software to do your job for you. It's a lot to learn up front, but it will benefit you greatly in the long run!

Freddie E. Williams III
Writer of *The DC Comics Guide to Digitally Drawing Comics*
www.freddieart.com

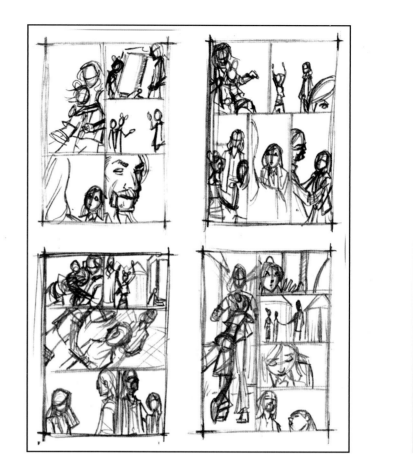

approaches tight thumbnails and loose thumbnails. *Tight thumbnails* are small enough to fit about four on an 8½ by 11-inch page and have a higher degree of crisp detailed drawing, while still being finished quickly. Tight thumbnails work well for people who are adept at drawing really tiny.

If you have a harder time drawing that small, you may prefer *loose thumbnails*. These are drawn far smaller than tight thumbnails, with at least nine on a page, but are very sloppy and rough with very little detail. Tight thumbnails usually have enough detail and cleanliness to be enlarged and drawn over with final lines immediately. Loose thumbnails usually need to be enlarged only slightly (Comfort likes to go up to 6 by 9 inches) to add the details and tighten the sloppy thumbnail layout into a final rough.

Either way can work, or you might find another option that fits your style better. What's important is that you take that time to get your ideas on paper and make sure they work, and do so in a way that isn't taking too much time. As you work up your thumbnails, focus on making sure your figure proportions are correct, and that your perspectives all line up properly. When moving to the final rough stage, remember that this is your last chance to fix any and all

PRO TIP

DAVE WACHTER: PREPPING YOUR OWN DRAWINGS

You've drawn the page, but you're not finished yet! Time to scan that masterpiece and get it ready for the next step on the production line. (And you want to make sure you do it right!) Invest in a big scanner. Most comic art is drawn large, so buy an 11 x 17 scanner. You can find a good one these days for under $300. It's worth it for all the time you'll save. Scan at a high resolution, at least 300 dpi. Once scanned, clean it up. Get the file ready in an art program, like Photoshop. Straighten the image, trim it to the proper size, and clean up any errant marks or smudges. If working with inks, adjust the image to get your blacks black and your whites white. When you're done, be sure to save it in the proper file format, usually a tiff.

If you're working with a publisher, be sure to ask them for their guidelines—each publisher can have a different set of rules. Ask the next person down the production line, whether it be the inker, colorist, or a production person, how they prefer to receive the files. The easier you make it on folks, the more they will want to continue working with you. And in this biz, relationships are key.

Dave Wachter

Creator of *The Guns of Shadow Valley*
Artist on *Breath of Bones: A Tale of the Golem* **and** *Night of 1,000 Wolves*

◀ Comfort uses the loose thumbnail method to go from quick, sketchy thumbnail to a final page.

construction errors in the drawing before your final lines go on the page. Working hard at creating structurally sound final roughs will make your final drawings easier to do, more fun to work on, and better looking by far.

The thumbnail process is where you'll figure out the layout of the page, but this step isn't just about the art! Something many inexperienced artists forget is to leave space for the word balloons. Eventually, you're going to hand these pages off to a letterer, and if you pack your panels too tightly with art, there won't be any room for words to be added. In the beginning, it can help to draw in where you think the balloons will go, ensuring you've left enough room for them. As you gain more experience, you might not need to do that as much, but it's a good idea in the beginning.

When you've got a rough layout you like, whether by working straight from tight thumbnails or by enlarging and cleaning up loose thumbnails, you're ready to add your final lines. This is where your style will come out and shine—let yourself have fun with your art. If your final roughs are up to snuff, you won't have to worry about basic anatomy or perspective stuff anymore. With luck, you should be able to lose yourself in the joy of drawing, confident that everything is where it needs to be, and thus free to enjoy the best part of drawing comics.

CREATING INTERESTING PAGES

Now that you have the mechanics of drawing a comics page down, it's time to talk about what goes into good-looking comics, manga, and webcomics. Much has been written about how to be a better artist. Very good books exist that detail all the ins and outs of figure proportions, clothing and drapery,

PRO TIP

MARK MORALES: WHAT AN INKER BRINGS TO THE TABLE

To me, there are two main things that any good inker brings to the table. One is the addition of a feeling of depth to the page through the use of various line weights, textures, and spotting blacks. For example, just by adding a somewhat heavier line to foreground elements in a panel and a thinner line to the background stuff, the inker can help trick the reader's eye into believing that the panel exists in three dimensions.

The second important thing is the addition of clarity to the page. No matter the style of pencils, from superslick to very rough, the goal when inking the page should be to do so in a way that makes the images read clearly to the viewer. Despite many great advances in coloring these days, it still works better when the final black-and-white inked page can stand as a finished piece of work before colors. It also helps the colorist make choices that will add to the look of the page.

Mark Morales
Inker on *Avengers vs. X-Men*, *Thor*, and *Infinity*
markmorales.deviantart.com

perspective, and so on. If you want to draw better, there is a veritable smorgasbord of great material out there to inform you, not to mention vast piles of web pages, Pinterest collections, and Tumblr feeds devoted to artist reference and tutorials.

So, we aren't here to tell you how to draw. Instead, we've come to teach you how to draw *sequential art*. While it's relatively easy to find a wide array of training tools for basic drawing skills, finding people who can help you make better comics pages is much harder. Much of what we know we learned by going to comics conventions and talking with professional artists, showing them our portfolios, and listening carefully as they detailed how badly we stank and in which particular ways we could improve. Pagecraft is an art form unlike any other. We're going to focus on the most important points—the things that, if you get the hang of them, will quickly improve the quality of your pages many times over. Learn these tricks and you'll become a better sequential artist, no matter what your style of drawing may be.

Controlling Time and Impact

One of the biggest jobs of a comics artist is controlling the reader's perception of time and delivering an emotional impact through use of visuals. The size, spacing, and placement of panels on a page determine how important the per-panel action is, and how quickly the reader takes in that information and thus

◄ **All three of these sets of panels show the same events, but use time in different ways. The expansion or contraction of time has a huge impact on how events affect the reader.**

how much time the action seems to take. Learning to manipulate these elements is essential for getting the desired impact.

Let's talk about time first, as it can be the trickiest to wrap one's head around. The perception of time in comics is a tough thing. On the one hand, we're looking at static images, and we naturally assume static images contain no passage of time. On the other, dialogue balloons and captions indicate that at least as much time is passing as it would take for a person to say those words. So, on a subconscious level, comics readers are taught to consider time as flexible and relative. It's your job to help the reader figure out just how much time passes in a panel, and from one panel to the next.

The artist has two primary ways for controlling the perception of time: panel size and gutter width. In simple terms, the larger the panel is, the longer it takes to absorb the information inside it, and thus the more time it seems to encompass. Similarly, the wider the gutters between panels, the more time seems to elapse between actions. To put it another way, the more time it takes in "real time" to read the information in the artwork, the more time it seems to take in "comics time" for those actions to occur.

Manipulating the readers' sense of time can allow you to control their levels of excitement. Small, tightly placed panels feel like rapid, intense actions, as in

The layouts here use two small panels to set ▶ up a big moment. The small panels move quickly; then the large panel slows down and increases the impact of the scene. This trick works equally well for action and drama.

an action movie when a scene cuts rapidly from one punch to the next. Big, expansive panels slow the action down to one big moment. Mixing small and large panels can re-create a bit of the cinematic style popularized by directors like Zack Snyder (director of *300*, *Watchmen*, and *Man of Steel*) characterized by superfast, intense action, suddenly halted by big, slow-motion impact moments. In this way, space does for comics what time does for film.

Controlling time can also control drama. By forcing the reader to slow down as you build to a climactic moment in the story, the tension rises and excitement grows. This leads us to the idea of creating resonance with your art. Obviously, the content of the panels has a lot of power, making the reader feel something. When your characters are broken down and crying, hopefully that has an impact. But you can also use the layout of the page itself to drive home that emotion.

Tight, narrow panels feel claustrophobic. Wide, expansive panels feel tranquil. Widescreen, rectangular panels feel cinematic. These effects change depending on the panel content—those same wide, expansive panels can also feel terrifying if the imagery inside tells the reader it's a scary moment. However, it's worth noting whether or not what's happening on the page is reinforced by both the content of your panels and the layout of your pages.

The easiest thing to remember is that panel size tends to denote importance. Readers will view the smallest panel on a page as the least important moment, and vice versa with the largest panel. If you've got a really important shot on a page (the hero is wounded, the fiancé wants to break up, the shark attacks the boat, the space station explodes, and so on), then it should probably get the biggest panel on that page. The size of your panel almost always denotes importance.

When examining a script, identify which moments absolutely must have the most amount of space on a given page. Build your layouts from that

◀ The small panel works well enough, but the bigger panel makes the moment of hitting that ball seem much more significant and explosive.

▲

The Smash Cut!

▲

The Teaser!

understanding, and you'll develop a "hierarchy of impact" where the most important beats get the most valuable real estate on your pages.

How to Use Establishing Shots

On page 60, we explained that establishing shots were panels used to give a lot of data to a reader in one image—the who, what, when, and where of a scene. But did you know that the placement of that establishing shot is just as important? Where you put the establishing shot on the page can totally change the impact of the panel and the page as a whole. The artist Jim Calafiore opened our eyes to this concept many years ago, and it was one of the biggest "Aha!" moments for us. Shown here are three examples of how rearranging the panels of a page can totally change the way the page reads. We won't change any of the art or the panel shapes or sizes, just their placement. We'll start with the "smash cut."

Smash Cut: This is the conventional delivery of an establishing shot, placing it as the first panel on the page. *Smash cut* is a film term, but it basically means from one page to the next, you immediately reveal the new scene. This layout puts all the necessary information up front, so the reader knows what's going on from the start. The rest of the page slowly builds on that knowledge, adding tension and emotion to the information the establishing shot started with.

Teaser: This time we open with panels that have little context. They're clearly showing significant moments, but the readers don't know what's happening!

The Slow Reveal! ▶

By opening with emotional information instead of concrete visual data, you build tension. The establishing shot becomes a big reveal. It can be an "Aha!" moment of revelation, or an "Oh NO!!!" moment of nervousness for the characters, or even a big, heroic "Yay!" moment as something wonderful happens. The rest of the page can then build on that reveal, taking the tension that's built and then released and using it to leave the readers with a strong emotional connection to the moment as they turn the page.

Slow Reveal: In this example, the establishing shot is the very last panel. The page seems to very slo-o-owly reveal information to the reader, building an ever-increasing feeling of dread with every panel. It starts bad. It gets worse. Then it gets even worse than that. Then you end with the artistic equivalent of a punch to the reader's gut.

These are by no means the only ways to place an establishing shot, and you can use those we've shown to create different moods or feelings than we've done here—all of which shows how much the emotional impact of a moment can change depending on when you give the reader that big reveal. You'll also notice that the bulk of the detail work on a page is found in the establishing shot. That's not an accident!

Details are important. They can mean the difference between a reader simply recognizing a place or thing, and the reader getting a feeling about that place or that thing. It's about giving the things you draw real character. An empty room with clean walls and closed windows doesn't have any personality. It's the things we put in our rooms that make them feel like ours.

Say the script you're working on gives this description: "Jim walks into his apartment." Pretty simple idea, and there are a lot of ways you can approach it. Here's the most direct way:

◀ A standard beginner's approach to drawing an environment. It uses few details other than the most basic items necessary to communicate the idea of a guy's apartment.

The example on the previous page certainly gets the job done; anybody who looked at it would think "That guy is walking into his apartment." Mission accomplished. But in this take, the artist misses an opportunity to create a real space with personality and character. Here's another way to do the same thing:

The same panel with more personality ▶ makes the image more interesting. It says something more about the kind of person this is just by adding a few more details to the establishing shot.

In the example above, you have a lot more little details that say things both about the apartment itself and its occupant. Heck, it could have gone even further, adding loads and loads of little details all over. You don't want to go too far, though. Save your hand the strain, and focus on the details that will do the job best!

Go back and take another look at those page examples we showed you before. Go on, we'll wait. Okay, did you notice that all the panels *other* than the establishing shot had no background at all? The beauty of an establishing shot is that, by adding all that detail in one big panel, the audience remembers that information and will fill in the blanks themselves elsewhere. The more work you do making a great establishing shot, the less background detail you need to worry about for the rest of the page. Obviously, we aren't talking in absolutes, and you'll need to evaluate the needs of each panel, but generally the extra work you do in the establishing shot actually saves you time in the long run.

That's a nice metaphor for the entire artistic process, isn't it? More work in one area can save you tons overall. Just something to keep in mind.

Moving the Camera

When you're the artist on a comic, you're like the director of a movie. You're the one moving the camera as you "film" the actors—deciding what images the audience sees. When you're reading a comics script and planning your page

layouts, try to imagine the entire space of the scene as if you were physically there. Now, think of the panel like the lens of a camera. Where can you set up that "camera" to get the most interesting shot?

It's important that your art keep the reader engaged. That seems obvious for action sequences, for which you naturally assume that the panels and page layouts must be exciting and dynamic, but it's perhaps even more important for "talky" scenes with lots of dialogue. While those scenes may seem more low-key, remember that your reader should never feel bored. When the average person turns a page of comics art and comes to a page covered in lots of dialogue balloons, it can frequently induce a bit of a groan. Inwardly, he's thinking, *This page will be more work to get through than the more "fun" pages.* Your job is to make the art entertaining enough that it keeps those readers happy and interested even when (goodness forbid) they have to read a lot of words.

When drawing pages, there are a couple of soft rules to help ensure you're keeping your layouts dynamic and interesting. We use the term "soft rules" because they aren't absolutes; however, they should be obeyed when you can. Soft Rule #1: Never use the same angle twice on the same page. The difference from panel to panel can be slight, but it needs to be noticeable. The angle you choose to show an image from has a big impact on the drama of that moment. The blander the angles you choose, the less drama there will be. Look at the brief sequence of panels below:

▲

This is a good example of strong, straightforward storytelling, but are the angles as dynamic as they could be?

It's certainly a workmanlike approach, and it gets the job done. You can tell what's happening, and it's exciting enough, doing what it needs to. But then, any time you're drawing action there will be some basic level of excitement simply by virtue of the action unfolding in panels. Compare that sequence with the one that follows, showing the same events but using different, more dynamic angles:

PRO TIP

ADAM WARREN: DRAWING EXCITING ACTION

Never miss out on the chance for character "acting" during action sequences. Vivid facial expressions of rage, fright, or alarm in a fight scene not only show that the heroine is invested in the action, but show that the *reader* should be, too.

Use panel shape to force the reader's eye along the line of motion. Horizontal, panoramic panels are ideal for sweeping moments of "side-to-side" action, indicating clear cause and effect; just remember that the cause (a blaster firing, say) should be placed on the panel's left side to precede the effect (a robot subsequently exploding) at right. Vertical panels work equally well for accentuating downward motion, such as a character or object falling; the longer you extend a vertical panel, the more pronounced the vertiginous effect.

Always err on the side of clarity by ensuring that the reader can visualize where the characters are placed relative to each other, within the context of their battleground's environment. Rule of thumb: "Reset" the action scene's setting once per page with a shot that clearly reestablishes the combatants' positions.

Adam Warren

Creator of *Empowered*
Artist on *Dirty Pair* and *Gen13*
twitter.com/empoweredcomic

As with the previous image example, this ▶ image tells the story. But the use of more dynamic panels creates a sense motion and intensity that the other set lacked.

Notice how much more exciting this version looks. Notice how much more impact the action has, how much more tension there is in the movements of the characters. By looking for the best angles and keeping them varied from panel to panel, you create a significantly more entertaining sequence. The same is true for dialogue scenes. When reading the script for a two-person dialogue sequence, it is easy to come up with a panel sequence like the one below:

As with the action sequence, this panel ▶ set does the job. But it's not always about simply doing the job; it's about doing it to the best of your abilities!

Again, it gets the job done in the most basic way. But you need to work even harder in dialogue sequences to keep the audience entertained. That doesn't mean you have to always use super-extreme layouts or wild and bizarre camera angles, but you should be much more dynamic than your first instinct might be. Let's look at those same panels from new angles in the example below:

See the difference? None of the angles ▶ are extreme, but sometimes just a simple movement of the camera can be enough to create the right amount of interest in your pages from panel to panel.

This second example changes everything! Suddenly, the scene has much more drama and intrigue. It also lets us bring up a good point: even without word balloons, your pages should be *readable*. Though we've added no text to these sample panels, you can still get a sense of what's happening. You can follow the action and interactions to read the mood of the characters. The best pages function almost as well without word balloons as they do with them.

As with camera angles, you want to vary the sizes of the figures and objects in your panels. Now here's Soft Rule #2: Never draw your figures the same size twice on a page. Again, the difference doesn't need to be drastic, but it should be noticeable. Varying the size of figures and objects extends beyond the panel-to-panel layouts and into the layouts of the panels themselves. By including objects and figures of multiple sizes even within panels, you let them take on a depth of space that makes your drawings feel deeper and more three-dimensional. By continuing that variation from panel to panel, you can make the whole page feel more dynamic and deep.

◀ The angles barely change in this sequence, but just by changing the sizes of the figures in the panels, it becomes more interesting to look at.

◀ Sometimes you should consider breaking the rules. Leaving the figures mostly static in this sequence creates a deadpan feeling to the art that helps enhance the humor.

Keep It Simple

Finally, it's worth noting that the worst thing a comics page can be is confusing. It is easy as an illustrator to get excited about layout designs and artistic flourishes, wild panel shapes, figures breaking panel borders, and how you're going to blow people's minds with your creativity and cleverness. The problem is,

if readers can't follow what's going on, then you've failed. They have to be able to read the page! What's the point of a comics page so artistic and creative that nobody can tell what's going on?

Odds are you're just getting started drawing comics—you've got some artistic heroes and at least a couple of them do some pretty wild things with their layouts that make you "ooh" and "ahh." But you aren't ready to do what they do yet. First, you have to get good, and then you can get clever. You have to master being a storyteller, and then you can experiment with layouts. You need to know and understand the rules before you start breaking them. That way, you're breaking them for a specific reason, to create a specific effect, and not just because you don't yet know what you're doing or (even worse) are just trying to be avant-garde for the sake of your own fanciness.

When in doubt, just remember that Western audiences (who we can only assume this book is being read by—including you, aspiring manga creators!) read from left to right, top to bottom. Look out for any spots where your pages might require people to break those guidelines, either reading something from right to left, or going from the bottom of the page back to the top. It isn't part of our natural flow, so readers aren't likely to do it with your page layouts. That can lead to readers who are confused or lost. Remember, once you've lost the reader, you've failed at your job.

BRINGING CHARACTERS TO LIFE

There's more to drawing characters than just shapes and proportions. The characters you draw need to have a feeling of life. It's easy to create illustrations of characters that are technically superb in craftsmanship and execution, while also utterly lifeless and boring. It's the same as comparing a wax sculpture to a human

being; even though a wax sculpture is still much more realistic looking than a mannequin, it doesn't feel any more alive than the hunk of wax it really is.

So the question is, how do you breathe life into your drawings so that the characters come alive on the page and become real people? The answer lies in how the characters move, how they show emotion through their faces and postures, and how they interact with one another.

Expressive Faces

How faces are drawn is the number one most important thing to keep in mind for drawing characters that feel alive. When human beings feel things, we tend to show it. Sometimes we're extremely expressive, sometimes we try to keep a cool exterior, sometimes we actively show the opposite emotion on our faces from what we're actually feeling inside. If we experience something and show absolutely no emotion about it, either we'll appear heartless or the experience will seem to have had no meaning to us at all. Drawing expressive faces is essential for reflecting both the personality of the characters you're creating and for creating convincing drama on the page.

The nice part is that drawing expressive faces should be fun. That's really the entire point—you should have a good time drawing these characters! When they're screaming, wailing, cracking up with laughter—those should be fun things for you to dig into and exaggerate in your drawings. Don't be so busy trying to make your characters look "cool" that they wind up stiff and lifeless. Start making faces at yourself in the mirror and learning how your face works.

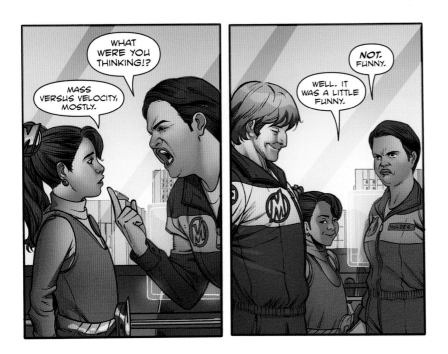

◀ The joke wouldn't be half as funny without the expressive faces in panel two. (From *Molly Danger* by Jamal Igle, published by Action Lab Comics)

Not only do emotion sheets help you develop your skills in drawing emotive faces, they also help you learn your characters and how to draw them consistently through a range of expressions. When doing an emotion sheet for multiple characters, you have to question how different people express different emotions. Here you can compare the faces of Telepath and Quake from *The Uniques* (right and left respectively). It was important for us to know what emotions he would hide compared with her, or at which times she might be less expressive than him.

Don't just look at how your features move, but notice how they move in relation to one another. When your mouth opens wide, look at how that affects your eyes and your nostrils. When you raise your eyebrows high, look what happens to your cheeks. Learn to feel the muscles of your face moving around. You might not be able to see every detail of how an expression changes your face, but you can feel it, and that feeling can help you spot small changes you can use in your drawings.

In the beginning, you might want to go extreme with your expressions. Really push the boundaries of what you can get away with on the most over-the-top emotions—terror, despair, madness, mirth—those feelings that are usually

accompanied by the biggest screams or the loudest laughter. Then slowly wind those down to less dramatic versions of those emotions—worry, depression, stress, humor.

Practicing drawing different emotions is also a great time to practice drawing your characters so that they always look like the same people every time you draw them. Getting your characters' faces to look consistent can be a difficult skill to develop, so why not kill two birds with one stone? A fun exercise creators of all types use for mastering both abilities is an emotion sheet. Make a list of different emotions, and draw one character's face over and over with the facial expressions she would make when feeling those emotions. Keep in mind that people feel emotions and express those emotions differently. One person might show sadness in a very different manner from another.

It's worth talking about manga iconography here and its use of symbols to emphasize emotions. Examples are the throbbing vein to indicate anger or the sweat drop to show embarrassment or exasperation. Sometimes, artists use entirely different styles for drawing characters in these comedic moments. Called *chibis,* these exaggeratedly cutesy drawings are like a comic artist's version of the old spit-take gag—a sudden change in style to emphasize a kind of reaction. They're a classic convention of manga artists, and while they can work within certain styles, they can utterly derail others.

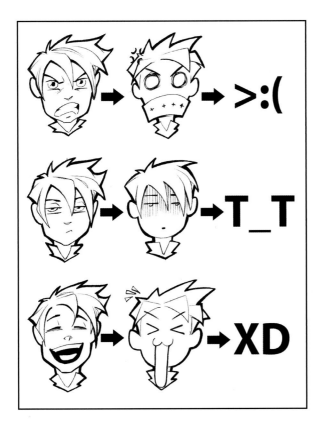

PRO TIP

SVETLANA CHMAKOVA: WHEN TO GO CHIBI

Chibis are a huge part of what drew me to manga—besides being almost painfully adorable, expressive, and much easier to draw than the full-figure character—they are also a powerful visual device for lightening up the mood of a scene or getting a side point across quickly. Every creator finds her own way to use manga's rich emotive symbol vocabulary, and while my personal opinion is that you could never have too many chibis, it's worth noting that sometimes they can disrupt a narrative if used too glibly.

For example, a dramatic death scene where the entire group of characters mourns for their fallen friend may be best suited for treatment with somber full-figure versions of your characters, and the addition of chibis would signal to the reader that this scene is not THAT serious and dramatic, after all.

You could theoretically set up effective drama with chibis, if you tell the entire story in chibi form; otherwise, it's best to not give conflicting mood cues to your readers.

Svetlana Chmakova

Creator of *Dramacon* and *Nightschool: The Weirn Books*
Writer/artist of the *Witch & Wizard* manga adaptation
svetlania.com

◀ Ultimately, exaggerated chibiness is little more than an emoticon. Truly great creators know when to use these—and when not to—for humor and effect. Be cautious though; it's all too easy to start leaning on these emoticons as a crutch.

JERRY GAYLORD: GETTING ANIMATED

I always say it's important to stay loose. Be free with your sketches and ideas. Many young artists will look at professionals' work and just see the final cleaned-up art and think that all great artists sit down and masterpieces flow right out of their pencils. The truth is every great artist I know starts with a million sketchy lines and doodles before she comes up with the finished piece. Be brave enough to throw down a crazy line. Remember, none of it is permanent and you can always start again. A lot of creativity comes with the courage to experiment.

You'll find that the more you loosen up and use squiggly lines, the easier it will become overall to create the images you have in your mind. It's my opinion that artists that don't embrace a loose underdrawing tend to have a more stiff finished piece. The presketch really allows you to have an advanced look at what you hope the finished piece will be. If things aren't working out, you can see it from an early stage in your art and prevent hours of frustration.

Jerry Gaylord

Artist on *Fanboys vs. Zombies*, *Loki Ragnarok and Roll*, and *Sonic the Hedgehog*
thefranchizelive.com
thefranchize.deviantart.com

When roughing in your figures, exaggerating their movements and posture makes them feel more alive and active.

Remember that these chibi faces are essentially no different from slapping an emoticon on somebody's face. It's as if you just typed :) on your drawing to show that the character was smiling rather than just drawing them with a smile. When working in a highly stylized, animated art style, these emoticons can enhance the humor elements of the comic. If you're telling a more serious story, or using an art style more grounded in realistic proportions and details, these emoticons run the risk of pulling a reader out of the story.

At the end of the day, in a moment of true human emotion, emoticons are no substitute for drawing a great face. If you draw a face that looks truly grief-stricken, do you really need tear waterfalls exploding like hoses from the eyes? If you draw a face that is clearly boiling with rage, is it improved by a big rubber-stamp of a throbbing vein? It's for you to decide. Give your art a hard look, and see which answer works best for you and your comic.

Body Language

Expressiveness doesn't only function from the neck up. Your whole body expresses emotion, mood, and character—how you sit, how you stand, how you walk. When you talk, do your hands move? When you scream, do your fists clench and shake? This is the language of the body, and it's every bit as useful as the face is for showing expressiveness and personality.

We can boil bad body language down to a single word: *stiffness*. Do your characters look stiff when they move? You want to create a fluidity of motion! Let's compare a few examples of boring poses to some poses with character:

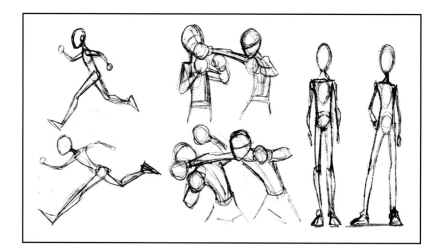

When laying out a figure, it can help to use an action line to set up the flow of the pose. The *action line* consists of one or two quick lines that run through

the approximate center of a figure's layout. Let's look at those pose examples again, but this time with an action line overlaid onto each of them:

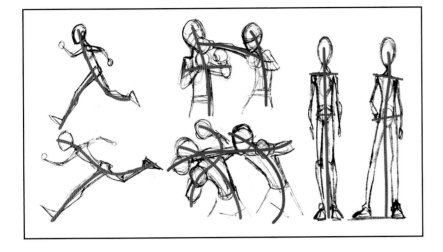

Note how the "bad" poses use primarily straight, stiff action lines and the "good" poses use action lines with more curve and swoop to them. Curving lines feel more natural and comfortable, more expressive and emotive. Straight lines feel mechanical—too perfect, almost robotic. When figuring out how to pose a figure on the page, using the action line is a helpful place to start.

As with every other aspect of drawing characters, you want their personality to take the lead so that it can shine through in every image. Every character's body language will be a little different. Some people are confident and walk with swagger and intensity, while others keep their heads down and hope not to be noticed. Some are bold and brassy; others couldn't care less. Changing how people carry themselves can change everything about how they're perceived.

The first time you see characters, you draw a lot of conclusions about what sort of people they are just from the way they stand and present themselves. That's an important phrase to keep in mind: the body language you choose is the way the characters *present themselves* to the world. It reflects their psychology and sense of self. Use that to guide you in making your artistic choices.

When multiple characters interact, each action from one should lead to a reaction from the others. It's obvious that one person punching another will cause the person getting punched to react, but it's also true of almost all human interaction. When one person says something funny, the others won't just smile; their body language will reflect their attitude. When three people talk and one asks an uncomfortable question, one of the others might adopt a challenging posture while the other might recoil slightly in embarrassment.

Examine all the characters in every panel you draw, whether they're in the foreground or background, a main character or little more than human scenery

◀ The more curved and swooping a figure's action line is, the more dynamic the pose will be.

▲
This entrance made by Quake and Singe pretty clearly delineates the differences between their personalities. Their body language reveals their attitude. (From *The Uniques* by Comfort Love and Adam Withers, published by Comfort and Adam)

Every time you draw your characters, it's another chance to show their individuality through body language, expression, and attitude. (From *Rainbow in the Dark* by Comfort Love and Adam Withers, published by Comfort and Adam)

in a crowd shot. All should have something in their posture and body language reacting to the world around them or the thoughts within them. This will enhance every aspect of your art. The acts of heroes are even more stunning when the people around them react accordingly. The shock of a sudden revelation is even more shocking when all the characters in earshot respond both facially and bodily to the news.

Learn to create expressive, living characters and they will be even more beloved by your readers. The story you tell with those characters will have much more impact, the events will be much more meaningful to readers, and your work will be more personally satisfying.

LIFE AS AN ARTIST

It's no great surprise that comics attract a large number of kids to the idea of becoming an artist. How many of you out there reading this book first started drawing comics at a very young age? And here you are now, looking to make a career out of a lifelong love for this little hobby.

The good news is you live in a great time to become a comics artist. You don't have to worry about many of the headaches of past generations—from decades when old technology required you to jump through a lot of annoying hoops just to get the picture you drew to look like it's supposed to when it prints. Now you can just draw, scan, and send. Presto! You can draw digitally on a tablet or monitor, your concepts instantly transferred to an electronic medium that lets you seamlessly blend drawing, painting, and graphic design in one interface in a fraction of the time it used to take.

The bad news is that, while you love drawing, this is still a job. Nobody will pay you to doodle in a sketchbook. There will be days when you hate the work. There will be mornings when you wake up, look at the pile of work ahead of you, and wish you were doing anything else but drawing for a living. Great artists are not defined by how well they draw the things they love drawing, but by how well they draw the things they *hate* drawing! The difference between the hobbyist and the professional is the ability to act like a professional and do the job right, do it promptly, make the sacrifices the work requires, and stick it out no matter how hard it gets.

The Modern Professional Comics Artist

Getting started as an artist is hard work. In times past, there were art studios where big-league artists and newcomers worked together and learned from one another. These studios are mostly gone or have moved to online groups that meet up once in a while at conventions. If you wanted to work for Marvel or DC, you could cut your teeth on a selection of anthology books or backup stories they published. But these too have become exceedingly rare. There seem to be fewer and fewer ways to break in and learn the craft.

The legendary comics writer Mark Waid used to talk about a trinity of ideal characteristics for artists in comics: draw great art, meet your deadlines, and be a great person. As long as you mastered two of the three, you'd be able to find work—but not so much anymore. Things have changed so much that it can feel like many publishers have a new trinity: deliver on incredibly tight deadlines, do what they say when they say it, and work super-cheap.

Globalization has not left comics untouched. It's possible to hire foreign art studios to produce dozens of pages a day for less than any artist living in an industrialized nation could ever afford to match. Publishing—not just for comics, but all print media—is a struggling industry, and publishers need to cut costs wherever they can to stay profitable. Even many of the publishers themselves don't like it, but that's the reality they have to deal with.

But hold out hope! There's a reason this book is about self-publishing! You don't need those publishers to be able to create and release comics to the world. You can draw your own, or hook up with a writer and his team to create comics

Drawing comics can be exhausting work. Be ready for some long nights . . .

JEREMY DALE: HITTING DEADLINES NO MATTER WHAT

It's ironic that I write this section at the same time that, for the FIRST time, I find myself missing a deadline.

Here's the main point: at no point should you ever miss a deadline, kids.

If "your word is your bond," then what does that mean for the professional creator? Your ability to hit your deadline is your bond—it speaks to your professionalism (or lack thereof). I have many, many friends that miss deadlines like it's a professional sport. In every case, it has dramatically hurt their options in future gigs. Even the biggest artists and writers in comics who miss deadlines often find themselves offered less and less work over time—and it takes a lot of time, attention, promises, and work to get even a sliver of that trust back from editors.

Even worse, it jades your fanbase—in some cases, for life. I've seen A-listers fight for their lives to outlive that one project that was continually late.

Bottom line? Don't miss the deadline! It's just not worth it.

Believe me—I'm living the reality of this as we speak!

Jeremy Dale
Creator/artist of *Skyward*
Artist on *G.I. Joe* and *Kapow*
(Marvel Comics)
jeremy-dale.com

as a group. The benefit is that you can do the projects that mean the most to you in the way you want to see them done. The tradeoff is you won't have a regular paycheck. But, to be fair, with the publishing industry in the state it is—knowing where your next paycheck is coming from is an increasingly rare luxury.

You have to sacrifice a great deal to be a professional comics artist. Look around your home and ask, *How much of this stuff do I need?* Look at a list of things you want to buy and ask, *How much of it is important to me?* Professional artists, especially in the early days (the first ten years or so, on average) don't get to buy new electronics or be early adopters of pretty much anything. You probably can't afford a house, so get used to renting for a while. Living in a big city is pretty expensive, even if you've lived there all your life. Can you make enough money as an upcoming artist to stay? Is it really worth it to spend the money to do so? It's a difficult choice to make, but choosing a smaller area where you can live cheaply and attend a lot of conventions can help you survive. You don't need cable if you have the Internet (thanks, Netflix) and you don't need a big-screen HDTV and you don't need a Playstation AND an Xbox AND a handheld device AND a smartphone. Get over the stuff and the things you *think* will make you happy, and realize that the quality of your life is about more than what you can buy and own. We can't purchase anything without checking our budget first, but we're stupid levels of happy because we make comics for a living. Nothing beats that.

You'll probably need to maintain a day job for a long while. This will make life harder for you, because drawing comics pages takes a lot of time. You can't

All those material possessions? You don't ▶ need those. You just need your artist's tools. And maybe this paddleball game . . .

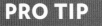

Learn to balance your dual lives. Sure, you're a mild-mannered fry cook by day. But by night . . . you're a digital dynamo!

afford to come home and use the "I'm too tired from working my day job" excuse to get out of doing your art. Realize that you are in fact working two jobs, and when you get home you're stepping into your other "office." Work hard at your drawing by night and your *whatever else* by day until the drawing can become your day job. We may sound harsh here, but this is the level of dedication you need to find professional success.

You'll need to attend conventions, maintain a presence online through multiple social media outlets, and generally do everything we're gonna talk about in chapter 7, even if all you do is draw. As an artist, you could be in high demand. This only happens if you build up a portfolio and a cult of personality that makes you an attractive option for creative teams looking to hire an artist for their books.

Artists are lucky in that they can always sell their original artwork, make prints, or sell commission sketches at conventions or online. For those reasons, you have many options for generating cash while working your way up the ladder. The downside is that you always have to manage yourself as if you were a one-person show, even if you're part of a team. No matter how many others you work with, you won't get anywhere if you aren't constantly building your own stock and building excitement behind all your projects. It all sounds like a lot of work, and it is, but the benefits are enormous. As you become a better one-person business, you'll find the extra work gets easier and only broadens the range of rewarding professional work you can do.

PRO TIP

TERRY AND RACHEL DODSON: WORKING AS AN ARTISTIC TEAM

Early in Terry's career, he became part of a studio in order to get on a good work schedule. When the two of us started working together, we decided to work at home, as having *both* of us there makes sure we get to work and get stuff done, just like in a studio! The obvious advantage is it's great to have someone else around to get feedback/second opinion on something— mostly on how a drawing looks, but also talking about upcoming projects, ideas for covers, and so on.

Obviously, you need to respect the space/privacy/mood of the other person to make it a happy working environment. We both enjoy listening to watching radio, podcasts, music, movies, and so on while we work, so we try to steer our studio entertainment into compromising territory to ensure a happy working environment. We work in the studio but are about twenty feet from each other, so we can hear each other but aren't breathing down each other's neck. It's nice to go, "Hey, what do you think about . . ."

Terry and Rachel Dodson
Artists on *Uncanny X-Men*, *Wonder Woman*, and *Marvel Knights Spider-Man*
terrydodsonart.com

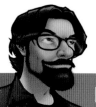

DAVID PETERSEN:
AN ARTIST AND A WRITER

It wasn't a preplanned decision to be both writer and artist when I started telling stories in comics. Filling both roles came out of the necessity of wanting to get my work out while not having the luxury of waiting to find the ideal writing companion to depend on. Both jobs came rather naturally as I muddled through the process of figuring out how to tell a story, and I found the two roles inseparable.

Every choice in making comics is storytelling, from the wording to the font the comic is printed in, from the the size of a panel to the details on any page. Art choices can bow to the written word and other times art overrides the use of language—it's a symbiotic balancing act. I think in both terms—art and word—when I create my stories, sometimes getting ideas out visually, sometimes in text. And while having full control of both roles is a great deal more work and responsibility, it is even more gratifying.

David Petersen
Creator of *Mouse Guard*
mouseguard.net

Take your job seriously, and act like a ▶ professional. This job can and will get hard sometimes, but that's no excuse to slack off.

Working with Your Writer

Earlier we told writers to respect their artists and the work they'll do, but that wasn't meant to inflate your ego as an artist. *Treat your writers well!* Earn their respect. Earn their trust. You want to know one of the biggest reasons why publishers are hesitant to take on young American talent? It isn't the cost and it isn't the skill—it's because they've been burned so often by young artists who fail to meet their obligations or act in totally unprofessional ways.

You have a lot to prove, people. If a writer is expected to provide some kind of compensation for your work, you are expected to provide that work to the best of your abilities and beyond, in a time frame that is, at a minimum, respectful and reasonable. Earn your keep! Be worth the investment! Not just because it's the path to being a decent human being, but because there are tangible rewards.

Writers are not, by and large, unreasonable people. They want you to work on their projects because they respect your work and think you will enhance their ideas. When you're reading the script, you might have some suggestions for how to approach the pages. Maybe you have an idea for a slight panel adjustment to get a bigger impact, maybe you think rearranging the beats of a scene will lead to a better flow of visual information on the page—share that! But start

A relationship built on mutual respect takes work and trust, but the rewards are huge.

small, little things here or there, to see how open your writer is to such feedback, and start building trust.

The more you deliver, and the better it looks, the more willing the writer will be to listen to any ideas you might have. Prove yourself enough, reveal enough interest and love of the comic you're working on, and maybe the writer will invite you to have input on the story itself—where the characters are going and how they're developing. A true collaboration is a beautiful thing, but it requires that all parties feel safe with one another. You have as much responsibility in building that trust and confidence as the writer does. Don't take for granted that an artist's value to the success of the book means you are *personally* valuable. There are a lot of young artists out there who would love a chance to work on a great project. If this is a comic you want to work on, step up and treat it like a real job.

Respect yourself enough to invest your all in any work you do—no matter how big or small—and respect your partners enough to deliver on your promises. (*Over*deliver whenever you can.) Treat your collaborators the way you want to be treated first and see how it changes the nature of your relationship for the better! In the words of novelist Laurence Sterne, "Respect for ourselves guides our morals; respect for others guides our manners."

PRO TIP

TAKI SOMA:
TAKING CARE OF YOURSELF

It's easy to lose yourself and live in a bubble as an artist, but you pay the price if you're not nice to the body that lets you create. I've done my share of going to doctors and physical therapists, due to lack of prevention, which is the key to staying healthy in any given lifestyle, is it not? I've injured my wrist, forearm, elbow, and neck, all from drawing. And I'm the one paying the piper. I'm now, and probably will be for the rest of my life, cemented in a long and what feels like an arduous set of stretches for these parts of the body. But that's okay, I don't require surgery and I don't suffer pain as long as I'm vigilant.

Work out at least every other day. And by that, I mean vigorous cardiovascular activity for forty minutes or more as well as strength training and stretching. It's time-consuming and takes a lot of will and discipline. However, it pays off in mind, body, and art for me. Maybe it can for you, too.

Taki Soma

Creator of *You'll Never Die . . .*
Cocreator of *Rapture*
Co-artist of *The Victories*
takisoma.com

4. COLORING

COLOR HAS AS MUCH POWER TO DETERMINE THE tone and style of a comic as pencils do. A good colorist creates depth and space, brings mood and emotion through lighting and contrast, gives objects their texture and feel, and is responsible for all those dazzling special effects shots. Colorists can elevate good pencils to greatness or drag them down. You can make a comic shine, make it gritty, and with every choice you make, you directly impact how readers will interpret the art they see.

Yet color is also one of the most overlooked aspects of comics art (next to lettering, see chapter 5). People often incorrectly think of a colorist's job as akin to a kid with a really neat coloring book and a digital box of crayons, but it's so much more than that. In this chapter, we're going to show you how to color, as well as give you some tips on how to give your color a bit of its own character.

The way color is used and the style in which it's applied here give *The God Machine* a unique look and feel—helping it to stand out among its competition. (From *The God Machine* by Chandra Free, published by Archaia) ▼

First, realize that color is just the way our eyes perceive light bouncing off objects. Virtually every aspect of color has to do with the nature and color of light, and the way our eyes work. Like nearly all aspects of art, the path to color improvement begins with training your eyes to notice all the subtle things happening around you.

There's a science to the way color works. It has rules, and centuries of painters have worked to catalog these rules for others. It's called *color theory*, friends, and it's a subject whose study can and should last a lifetime. We're going to give you a primer on some of its most important elements, but we highly recommend going out and learning more whenever, wherever, and however you can.

Color Terms to Know and Understand

You're going to need to know some vocabulary before we can get into the meaty stuff. Here are some terms to help you more easily understand the science of color.

Chromatic means something has color. *Achromatic* means it doesn't, or is neutral. Black, white, and gray are all achromatic—everything else is chromatic. Chromatic shadow and light use colors to create dark and light spaces instead of just black or white. Generally, unless you're working in black and white, you want to use chromatic light and shadow at all times.

Tone refers to how light or dark a color is. Using a range of tones creates a sense of mass; it's what turns that flat circle into a three-dimensional sphere. Tonal application varies from the sort of flat color used in simple animation to highly rendered painting.

Hue is the technical term for "color." Red, orange, green, blue, and so on are all examples of hues.

Contrast occurs when two areas have some visual difference. Higher contrast helps separate objects from one another, and adds depth to a picture. You can use tone to create contrast—the wider the range of tones from light to dark, the higher the contrast. You can also use hue to create contrast; a red apple in a gray world, a dark blue figure in a golden field. Any use of color to create distinctness also creates contrast.

◄ Here, colorist Steve Downer creates contrast with tone, hue, and saturation in order to separate the elements of the image and create a sad color mood for the image. (From *Skyward* by Jeremy Dale, published by Action Lab Comics)

Saturation refers to the intensity of a hue. The more color something seems to have, the more saturated it is. Pastel pink is low in saturation; neon pink is highly saturated. Black, white, and gray have no saturation at all—they have no hue.

Color Schemes

Color schemes are the different kinds of setups you can use when coloring an image. Have you ever seen an outfit with colors that looked good together, but you couldn't say why? Ever looked at a painting where people were given green skin, but it still looked fine? It's because of the artist's use of color schemes.

▲

Say hello to the color wheel, your ultimate color-selection tool.

The *color wheel* is a simple but effective reference for the range of colors out there. Invented by Sir Isaac Newton to show the natural progression of the color spectrum, the color wheel is a tool that artists now use to help in the construction of color schemes. Let's look at the different color schemes to see how they work, what they do, and how the colors are selected on the color wheel:

Monochromatic: Uses just one color, including ▶ gray scale. Easy to create, always balanced, and can be real moody if used right, but lacking in color/hue contrast.

Analogous: Uses colors that are next to each ▶ other on the color wheel. Usually has one dominant color with the others as accents. Easy to create, has more richness than monochromatic schemes, but doesn't offer much contrast.

Complementary: Uses two colors that are ▶ opposite each other on the color wheel. Offers more stark contrast than any other color scheme, but can be difficult to work with and maintain balance.

◀ *Split complementary:* Uses one main color and the colors on either side of its complement on the opposite side of the color wheel. Slightly less contrast than complementary schemes, but it has more nuance and can be a little easier to work with.

◀ *Triadic:* Uses three colors equally spaced from one another on the color wheel. Offers high contrast, and tends to be easier to balance than complementary schemes.

◀ *Tetradic:* Uses four colors on the color wheel arranged in two complementary color pairs. With more available colors, it has the most variety of the color schemes— but balancing so many colors can be tricky.

Color Temperature

You can break down colors into warm and cool hues. Warm hues are generally red, yellow, and orange; cool hues are blue, green, and violet. Every color has a warm and cool range—there are warm and cool reds, warm and cool blues. An object tends to take on the temperature of the light striking it, and its shadows will take the opposite temperature. So under a warm golden light, an object will

In the near image, the warm colors on the ▷ foreground figures make them pop out easily from the cool background. In the far image, the warm-colored figures still pop forward the most, even though they're in the background.

take on a warmer hue, but cast a cool shadow. Under a pale blue light, the object will appear cool and the shadow will be a dark, warm red or red-violet. Chromatic shadows will always look more awesome than just flat black, so use them as much as you can.

You can use color temperature to create space and contrast. Warm colors advance, drawing the eye's attention. Cool colors recede. If you have a scene in which the main focal point is warm and the rest of the image is cool, that focal point will pop right out at the audience. If you do the opposite and put a single cool object in a warm image, it will still stand out but the rest of the image will still appear dominant to the eye.

Atmospheric Perspective

Atmospheric perspective (sometimes called aerial perspective) is a term for the effect our planet's atmosphere has on objects viewed at a distance. In short, as the distance between you and an object increases, the object becomes less saturated and the details become more dull and faded, taking on the color of the background. This is why mountains in the distance start to look a faded blue rather than their natural color. It's why a huge billboard might not appear to have anything on it at all from a certain distance.

As a colorist, one of your primary jobs is to create a sense of space. You are the one who lets us know how distant the horizon is, how close the foreground is; you give us the idea that these pictures we're looking at have depth. Atmospheric perspective is your best tool for doing that when the panel you're coloring has a lot of distance from the foreground to the background.

In all images, you have three levels of distance, or *planes*, to work with—the foreground, the midground, and the background. In typical atmospheric perspective, the foreground is darkest and sharpest, the midground is medium and slightly hazy, and the background is lightest and the most faded. But don't be afraid to play around with it—you can change up those values for some interesting effects.

▲

The farther back you look in the background of the image,
the duller, grayer, and more indistinct the objects are.

GETTING COMFORTABLE WITH PHOTOSHOP

Adobe Photoshop is the comics industry standard for digital color. Photoshop
is also the program most other programs try to mimic. Therefore, if you learn
Photoshop, you can pick up and use just about any other program. However, a
lot of emerging programs are designed to work well for the sort of color we'll be
doing, so if you prefer using Manga Studio, PaintTool SAI, SketchBook Pro,
GIMP, or some similar program, these directions should be pretty easy to apply.

There are many versions of Photoshop, and more are being released all the time. Most of what we'll talk about will work with any version you might have.

The Main Menu

The main menu is located at the top of the program. Within its sections lie the operations and options you'll need to adjust, edit, and view your images as you work on them.

THE MAIN MENU

File Edit Image Layer Select Filter Analysis View Window Help

File	Pretty straightforward; basically the same options you'll find in any similar program. These include *New*, *Open*, *Save*, *Print*, etc.
Edit	Filled with simple editing options like *Copy*, *Paste*, and *Free Transform*. Also where you'll find things like *Photoshop Preferences*. You'll use this tab frequently.
Image	Where Photoshop starts to separate itself from your average programs. Where you'll control your *Mode*, *Image Adjustments*, *Image Size*, etc. This will be one of your MVPs for digital color.
Layer	Everything that has to do with your layers (see page 103) can be found under this drop-down menu.
Select	Contains a myriad of different image-selection options.
Filter	This may be the most entertaining drop-down menu of all, but it's also the most abused. You don't need the vast majority of these for digital coloring, but the ones you *do* use will be highly valuable.
Analysis	A drop-down menu of technical details.
View	Controls all the different ways you can view files in Photoshop.
Window	Here you'll find options to view any of Photoshop's helpful windows, including the Toolbar, History, Action, and Layers tabs, brush presets, etc.
Help	Takes you to the Adobe help page. (Often a Google search is more helpful.)

Windows of Importance

In Photoshop, there are a lot of windows (or "tabs") you'll have active on your screen that control many of Photoshop's different functions. Here are the four you'll want to have access to at all times, and why.

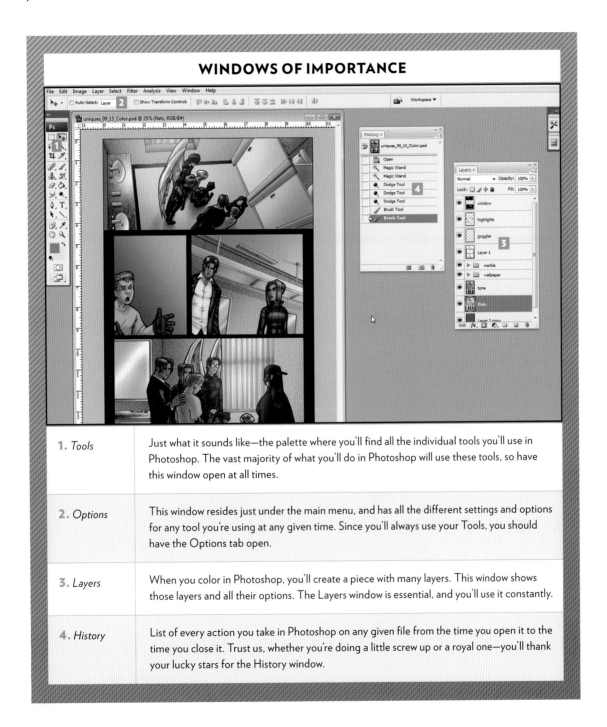

1. *Tools*	Just what it sounds like—the palette where you'll find all the individual tools you'll use in Photoshop. The vast majority of what you'll do in Photoshop will use these tools, so have this window open at all times.
2. *Options*	This window resides just under the main menu, and has all the different settings and options for any tool you're using at any given time. Since you'll always use your Tools, you should have the Options tab open.
3. *Layers*	When you color in Photoshop, you'll create a piece with many layers. This window shows those layers and all their options. The Layers window is essential, and you'll use it constantly.
4. *History*	List of every action you take in Photoshop on any given file from the time you open it to the time you close it. Trust us, whether you're doing a little screw up or a royal one—you'll thank your lucky stars for the History window.

JILL THOMPSON: USING TRADITIONAL COLOR

It doesn't matter what tool you use to make full-color comics. All the rules of color and composition apply. Use the white of the paper as your lightest light . . . don't overrender everything. It will flatten your composition out and make everything dull. There must be depth in your panels. Cool colors recede, warm colors pop. What else draws the eye? White, black, and typeface. Your brain will always want to read a sign. So, if that's not what you want people to focus on, make it illegible. Your focal point should be the most important part of your panel. If your background is highly detailed, make your focal point more graphic, and vice versa. This will help the reader's eye flow the way you intend it to! Limited color palettes can look like full color!

Jill Thompson
Creator of *The Scary Godmother*
and *Magic Trixie*
Artist on *Beasts of Burden*, *Sandman*,
and *Wonder Woman*
jillthompsoncreations.com

Tools of Interest

If you take a look at the Tools tab in Photoshop, you'll see that there are quite a few tool buttons to choose from. What's more, if you click and hold down, these buttons reveal more than one tool to choose from in a small nested list. As with everything in Photoshop, it's a lot to take in at once. Let's take a look at what you'll use the most for digital coloring.

PHOTOSHOP TOOLS

Tool	Description
1. *Move Tool*	Allows you to move selected pieces of your image around the page.
2. *Marquee Tools*	Used to make shaped selections on the page. If you click and hold, you'll see options for square-, round-, or column-shaped selection tools.
3. *Lasso Tools*	Used to make freehand selections on the page. Click and hold to select from three separate tools: the regular *Lasso tool*, which allows you to draw any selection shape you want (best used with a tablet pad or screen); the *Polygon Lasso tool* for making freehand selections with perfectly straight edges (works well with tablet or mouse); and the *Magnetic Lasso tool*—very messy and not a great selection tool.
4. *Magic Wand Tool*	Used to select whole areas of an image with one click. Selects based on tone and color.
5. *Crop Tool*	Used to select one piece of your picture and reduce the whole image to that single area.
6. *Brush Tools*	Used for painting and drawing. Of the tools available, you'll use the *Brush tool*, which allows you to paint or draw on your image with various brushes of all shapes and sizes, and the *Pencil tool*—which does the same thing, but with sharp, pixelated edges.
7. *Eraser Tool*	Even though there are multiple Eraser tools, the main one is all you'll need.
8. *Paint Bucket / Gradient Tool*	The *Paint Bucket tool* fills an area with a flat color. The *Gradient tool* fills an area with two or more colors that smoothly transition from one to the other.

9. *Smudge Tool*	Used to blend or smooth an area by smudging it with a brush.
10. *Dodge Tool*	Grouped with the *Burn tool* and the *Sponge tool* (which you may or may not find uses for), so it can be tough to spot initially. Makes an area lighter, brighter, and more saturated.
11. *Shape Tools*	These tools create various shapes. The two shape tools we use most are the *Line tool* and the *Custom Shape tool*.
12. *Color Picker*	This shows the currently selected foreground and background colors. By clicking on them, you can select a different color to paint with.

Key Commands

When creating your comics, you must constantly strive to improve your speed and efficiency. Learning to use the power of key commands is one of the best ways to improve both, allowing you to access tools, tabs, and options with a single press of a button instead of moving your cursor around and clicking on a bunch of menus. Here are the ones you'll use most often:

PHOTOSHOP KEY COMMANDS (GENERAL)

New	Ctrl/Cmd + N	*Paste*	Ctrl/Cmd + V
Open	Ctrl/Cmd + O	*Paste Into*	Ctrl/Cmd + Shift + V
Save	Ctrl/Cmd + S	*Free Transform*	Ctrl/Cmd + T
Save As	Ctrl/Cmd + Alt + S	*Levels*	Ctrl/Cmd + L
Undo	Ctrl/Cmd + Z	*Hue/Saturation*	Ctrl/Cmd + U
Print	Ctrl/Cmd + P	*Merge Layers*	Ctrl/Cmd + E
Select All	Ctrl/Cmd + A	*Zoom In*	Ctrl/Cmd + Space
Copy	Ctrl/Cmd + C	*Zoom Out*	Alt/Optn + Space
Cut	Ctrl/Cmd + X		

PHOTOSHOP KEY COMMANDS (TOOLS)			
Move Tool	V	Clone Stamp Tool	S
Marquee Tools	M	Eraser Tool	E
Lasso Tools	L	Paint Bucket	G
Magic Wand Tool	W	Dodge Tool	O
Crop Tool	C	Type Tool	T
Healing Brush	J	Shape Tool	U
Brush Tools	B		

▲

Once you get the hang of the basics in
Photoshop, it becomes a much more
welcoming program.

When you color a comics page, just like when drawing, you have to build it up in stages. You don't want to jump right into final tones any more than you'd want to immediately start drawing final lines without roughing anything in first. When coloring, start with flats (see below), then build up the final tone, then add textures and special effects when it's all finished.

These are examples of the bare line art (above), line art with flats (below), and flats with no line art (bottom).

Flats

Flats (also known as color separations) refer to the layer of flat color with no shadows or highlights that's used to separate all the areas of color on a page—sort of like an underpainting for your digital color. Flats are used to select individual areas of color for doing your tone later, allowing you to work on specific parts of the page without worrying about "coloring outside the lines." They can also be used to make quick adjustments to problem areas later after all the tone has been applied. Want to change the color of somebody's shirt? Select it on the flats layer, go to the tone layer, and zip-zap, it can be swapped out in seconds.

Flats are the most important step in digital color. They can mean the difference between a page that takes days to finish and one that takes an afternoon. They don't just bring speed; they also add the ability to easily adjust a piece on the fly and make corrections as you go without having to completely reselect or recolor things every time you (or your boss) decide something needs to be changed.

Flats are easily the simplest part of the color process; however, they can also take quite some time and be the most tedious to complete. But, just as with drawing, putting in the extra work at the beginning will end up making the whole project much, much faster—and *better*—in the long run. Virtually

every professional colorist uses them, usually employing teams of flatters to get the job done. We ourselves have a squad of elite "Fightin' Flatsmen" who do our color separations. But we had to know how to do it ourselves first, and so will you! Don't worry—it isn't hard.

1. Open up your page in Photoshop. And make sure your Tools, Layers, and History tabs are all up. These are located in the Window pull-down in the top menu bar.

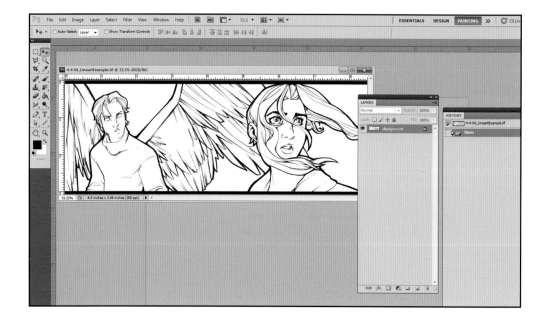

2. Go up to the Image menu at the top of the page and change your mode to RGB Color (a mode that builds color electronically). Even though printers all work in CMYK (a mode that builds color based on what ink can reproduce), many colorists prefer to work in RGB to have access to all of Photoshop's tools (some of which don't work on a CMYK document) and to maximize how well their work looks on the Web. If you get nervous about how your RGB image will look when printed out, you can turn on the CMYK Preview in the View menu.

3. Go to your Layers tab and drag your Background layer (the layer that has your drawing on it) down to the Create New Layer icon (it looks like a piece of paper with the bottom left corner folded). This will duplicate the layer so you'll always have a backup in case something disastrous happens. Don't assume it won't—mistakes can and will happen *all the time*. Rename the new layer *Line Art* by double-clicking its name. Naming layers clearly is really important so that you can easily navigate your file even if you get up to six or seven or fifteen layers.

Duplicate the Background layer and rename it Line Art, then add a new layer and name it Flats.

4. Hide the Background layer by clicking on the little eye icon on the left side of the layer. Then select the Line Art layer. Go to the Layer Mode menu at the top of the Layers palette (it'll probably say Normal right now) and change it to Multiply. This mode makes all white areas on a layer transparent and the blacks opaque. When you color on layers underneath it, it will show through the whites of the Line Art layer but not the black, kind of like crayons on a coloring book.

5. Make a new layer by clicking on the Create New Layer icon. Click and drag that layer so that it's between the Line Art and the Background layers. Rename the layer *Flats*.

6. Go over to your Tools palette and get two tools prepped before you start. First, grab your Lasso tool (or Polygonal Lasso tool if you prefer or are working with a mouse) and set the Feather to 0 pixels. Make sure Anti-Alias is checked off. We can't emphasize enough how important that is— *no* Feather, *no* Anti-Alias!

Set Feather at 0 (zero) pixels, and make sure ▶
Anti-Alias is checked off.

Observe the little dashed lines showing you
where your selection is. Or, if you'd rather,
you can click Ctrl/Cmd+H to hide them.

7. Now grab the Paint Bucket tool and give it the same settings (Feather 0,
Anti-Alias turned off). Additionally, you'll set the *Tolerance* to 1. You do
this to make sure that your flats will have a hard edge that will make select-
ing color areas easier and more precise, which is what your flats are for.

8. Okay, you're finally ready to start your flats! Take your Lasso tool (if you're
working with a mouse, the Polygonal Lasso tool is easier for this) and draw
around the area you want to fill in first. When you do this, make sure to go
right in the middle of the black line surrounding the object—not to the
inside or outside of it, but *right in the middle*. Doing this keeps the lines
between your selection areas hidden under the line art.

9. When the selection is done, choose the proper color for whatever area
you're working on by clicking the Foreground Color icon. This brings up
the Color Picker window. Move the side bar up and down to select the hue
(red, blue, green, and so on), and move the selector in the big box to get
the tone and saturation of the hue you like (light or dark, colorful or dull).
Generally speaking, you want to use a color that would be a good midtone
for the area you've selected—not too light, not too dark, just in the middle.
When you've got your color set, click your selection with the Paint Bucket
tool to fill it in. First selection: Complete!

Use your Color Picker from the Tools palette ▶
to choose your color.

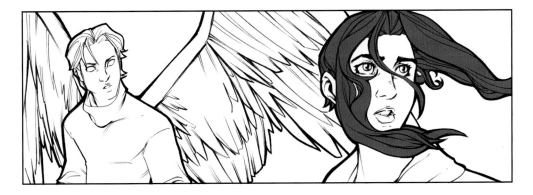

▲
◀ Select right through other color areas when making your selection.

10. Get your Lasso tool again, and select the next area you want to fill. When selecting an area, you can freely draw your selection lines through any area that has already been filled with a color. Once you have a color laid down, it works as a dam to keep out the other colors; provided its Tolerance is set very low, the Paint Bucket tool will fill right up to the edge of the colored area without coloring over it. This is also nice because it ensures that both colors butt right up against each other with no unsightly white areas in between.

◀ The Paint Bucket tool won't fill over existing colors.

PRO TIP

LAURA MARTIN: WORKING IN CHANNELS

Working in Channels is like working with masks while airbrushing, or painter's tape, or even a screen-printing screen. You usually work within an area by using a selection, but the selection is temporary and will disappear as soon as you deselect it. But if you save that selection as a channel, you can then reload that selection easily, any time you want. This is great for really intricate selections. You can also copy and paste your flats into their own channel. It's a quick and easy way to reselect large areas with the Magic Wand, even after that area has been airbrushed and rendered. Let's say you need to change the jacket color on a character who appears on four panels. Rather than going around each jacket shape with the Lasso tool (a time-consuming process), you can just jump to your Flats channel, choose the jackets with the Magic Wand, then go back to your coloring layer and adjust with Hue and Saturation. What a time-saver!

Laura Martin

Colorist of *Avengers vs. X-Men*, *Dr. Manhattan*, and *Uncanny Avengers* twitter.com/colorista

This is what your flats should look like with
the Line Art turned off. Each color butts
up against the other with a hard line. ▶

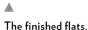

The finished flats.

11. . . . and that's it. Repeat as necessary until all the colors are filled in for the
page. It may seem complicated at first, but as you do it more, you'll begin
to understand how simple the process actually is. Once you've grown
accustomed to working with flats, you'll wonder how you ever did without
them. You'll marvel at how much time it actually *saves* you in the long run!
Now that the flats are finished, we can talk about how you use them as we
move into the next phase—adding tone to the page.

Adding Tone

With your flats done, you're now ready to jump into the tone. Tone is the bulk
of your color work, a combination of lights, midtones, and shadows that gives
your artwork depth, weight, atmosphere, and space. Different colorists apply
tone in various ways, but we're going to talk about the technique we use. This
technique incorporates elements of each of the prevailing comics coloring
styles, while still remaining both fast and detailed. Learning this particular tech-
nique to start will give you the tools you need to branch off into whichever style
of coloring you choose to pursue.

1. Start by clicking and dragging the Flats layer down to the Create New Layer icon on the Layers tab to duplicate it. Rename that new layer *Tone*. This new layer is where all of your basic coloring will take place; from this point on, you'll never touch your Flats layer again except to make selections. In fact, you might want to lock your Flats layer to make sure you don't accidentally color on it and damage it.

2. Before you start adding tone, choose an overall color tint for each scene. As we talked about in the "Introduction to Color Theory" section, the color of the light in a scene changes the colors of everything. Adding a tint to your Tone layer allows you to make the color reflect the light. In addition,

Copy your Flats layer by dragging the layer down to the **Create New Layer** icon, and rename it Tone.

Different color tints can help you set the mood as well as the time of day.

CARI CORENE: USING COLOR TO CREATE MOOD

When I work with color, I think about the desired mood more than what color a scene realistically is. So I use stage lighting a lot. *If It's Purple, Someone's Gonna Die* is a favorite book of mine on color usage.

Even though I work mostly with watercolor (an additive medium on a white canvas), I'm always thinking of my art as colors coming out of dark. It makes me establish value first, and then I layer color repeatedly around the light.

So, if I'm painting lush, lively, earthy, happy grass in shadow, I think of where the nearest light is, and then I paint a broad wash of green gradiating from that spot. Then I layer on some darker bluer green and some straight blue and brown for shadow.

But if I'm drawing someone dying on that grass, all bets are off. I don't care that the grass is green, I'm going straight to a sickly puce vomit color for that grass and the shadows are purple.

Cari Corene

Creator of *Door:Toilet Genie*
www.storyofthedoor.com

it helps differentiate every scene from one another. More variety of lighting colors adds interest and dynamism to your comic! Pick your tint wisely, and make sure to take into account the mood of your scene and what the light source is.

3. To make a color tint: Make a new layer and drag it above your Tone layer, but below your Line Art, and name it *Tint*. Use the Foreground Color selector to pick what color you think the light should be, and fill the whole layer

Set your Tint layer to Overlay ▶ mode.

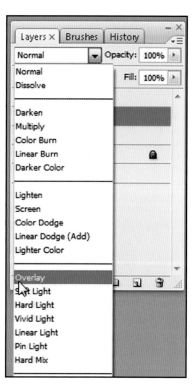

Change your tint color with the Hue and ▶ Saturation sliders.

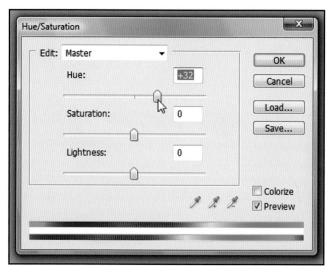

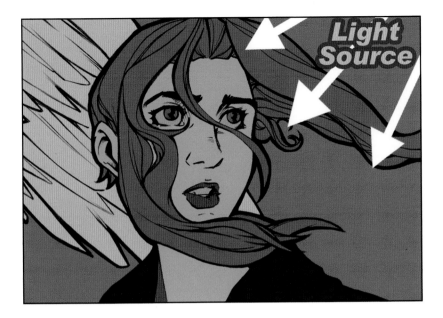

◀ Choose your light source before adding your tone.

with that color using the Paint Bucket tool. Now change the Tint layer's mode to Overlay. The Tone layer is modified pretty wildly by the chosen tint—maybe even too much! Go to Image>Adjustments>Hue/Saturation and move the sliders to adjust the color, color intensity, and lightness of the tint, if needed. When you're finished, you may leave your tint as a separate layer (just make sure to do all your toning with that layer turned off). Or, if you're confident with the color tint, feel free to merge the Overlay layer with the Tone layer by clicking Layer>Merge Layers.

4. Once your color tint is set, it's time to start the real coloring. First, you need to determine your light source. What direction does the light come from? Are there multiple things in any given panel giving off light? How bright is the light? These considerations determine where all your highlights and shadows will fall and how strong they'll be.

5. Get your Magic Wand tool and click on the first piece of the page you want to color. You'll see a scrolling dotted line around your selected area, but that can get really annoying. Hit Ctrl/Cmd+H to hide those dotted lines. The area is still selected, but now you're no longer in danger of having a seizure from watching those stupid lines (but you can hit Ctrl/Cmd+H again if you want to unhide the lines for whatever reason). If you need to select more than one area, just hold your Shift key and click the other areas you want selected. This way, you can color every instance of an object on a page; if there's a character in multiple panels, you can color his shirt in all the panels at once, instead of having to do the whole page one panel at a time. If your Magic Wand tool grabs more than just the one area you're trying to select, reduce the Magic Wand's Tolerance (in your Options menu at the top of the page). A Tolerance of 1 works just fine when you're selecting from your Flats layer.

PRO TIP

BRYAN J. L. GLASS: WRITING FOR COLOR

Color can be as effective a storytelling tool as line art, panel layout, or text. As color conveys mood and emotion, color notes in the script can set a tone and reveal emotion. Color often provides the subtext of a scene. Establish the intended atmosphere via a "downcast gray sky," the "warm orange glow of a fire," and so on, yet allow the colorist freedom to express their interpretation. If the specific color of an object, clothing, or locale is important, identify it: red sports car, yellow dress, blue tie. I strive to provide colorists with their own version of my scripts with such color indicators highlighted, as well as specific coloring notes that have often been inspired by the finished line work. A colorist is more than just a necessary cog in the production machine. Respect and communicate with them as part of the creative team.

Bryan J. L. Glass
Writer and cocreator of *The Mice Templar*, *Quixote: A Novel*, and *Furious*
bryanjlglass.com

6. Now the fun begins. Go back to your Tool palette and get your Brush tool. Pull down the Brush Type menu along the top of your screen and select a big, round brush with a soft edge. Then set your Opacity to 100% and your Flow to 8%.

Set your Opacity to 100% and your Flow ▶ to 8%.

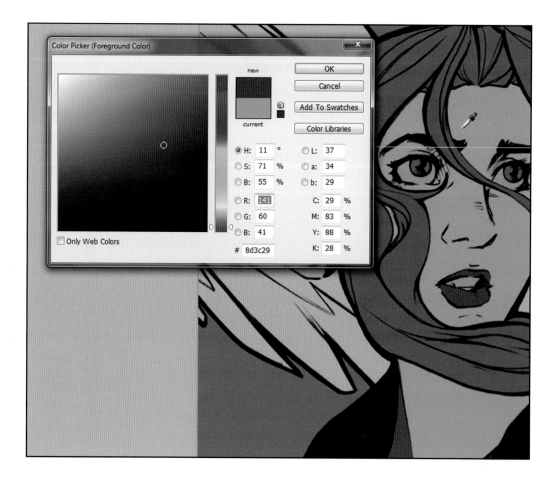

Click the Foreground Color selector and select the base tone of the area you're coloring. From there, you can choose your shadow color. ▼

7. To get the color you want, click the Foreground Color selector and click on the base tone of the area you're coloring. The cursor turns into an Eye-Dropper tool and auto-selects the color you click on. The base tone you laid down in your flats will now be the midtone of your color. We always start coloring by painting in the shadows, so with the Foreground Color selector, move the cursor from your base tone/midtone down to a darker shadow color. Make sure the shade you choose is dark enough to really give your

shadows some meat, but not so dark that there's too much contrast between midtone and shadow.

8. Brush in your shadows based on your light source. At first, use big, broad strokes with a large brush to lay in a base shadow; then use smaller brushes to add details. You can quickly change the size of your brush by using the bracket keys ([and]). You might need to take a second pass with an even darker shadow color to really make the image pop. But remember not to get *too* caught up in details. Let the line art be your guide. If the drawing is doing a lot of your job for you, don't overdo the color. If the drawing is tight and clean, your color should be as well. If it's loose and sloppy, feel free to get real brush-strokey and wild. Always try to apply your color in a way that complements the drawing and enhances it without overpowering or working against it.

9. When the shadows are finished, get your Lasso tool. In your Options, set Feather to 2 pixels and turn on Anti-Alias. Flats are supposed to have hard, sharp edges; however, when doing the final color, you want your selections to be slightly softer and more forgiving so that your tones blend nicely. Go to the Tone layer and select the areas you want to highlight. You're going to draw around the highlighted spots with the Lasso. Be sure to hold down the Shift key while selecting, so you can select multiple areas at once. It's going to take a lot of practice to get to where you can visualize exactly where to draw the highlights. For now, focus on where the light hits the object directly. Draw your highlight shapes to emphasize the form and contours of the objects where the light is striking them.

10. With the highlight selections made, click Ctrl/Cmd+H to get those scrolling marquee lines outta there. Then go grab your Brush tool—using another big, round, soft-edged brush. Select a lighter version of your base tone/midtone for the highlight. Lightly brush in your highlight areas from

▲

Always start with large brushes and work down to smaller ones. If you paint with smaller brushes all the time, your tone will get smudgy and splotchy. Don't be afraid of huge brushes!

▲

Select highlight areas with the Lasso tool.

◀ Once your selections are made, hide them and delicately brush in the highlights with a large, soft brush.

Finish the rest of the tone on the page a ▶ piece at a time. Now you're ready to add effects!

the direction the light is hitting. The idea here is to not completely fill your selections, just hint at their edges. Start really soft with a big brush so that the highlights don't get smudgy, getting stronger if you feel it needs it. Like your shadows, you can repeat the process using an even lighter color if you think the image needs it. Most objects won't be that reflective or shiny though, so you won't need more than one or, at most, two levels of highlights much of the time.

In a nutshell, that's how it's done. Repeat the process one object at a time until the page is fully colored. Remember, you can work with multiple objects of the same color at one time, speeding up your process. You may work on a scene that lasts for one page or for several. Most colorists get used to having five or more pages up and working on them at the same time. By coloring every instance of an object across all those pages at once, you can ensure the color will match for the whole scene. Don't be afraid of making this artistic endeavor into a bit of an assembly line in order to save yourself precious time and trouble. The ticking clock is your enemy! As your skills and technique improve, you can get fancier and add more flourishes to your pages, but in the beginning, you must focus on building a solid foundation. Make the issue's cover your coloring masterpiece, but color your pages at a brisk enough pace to get the issue done in time for the printer.

SPECIAL EFFECTS

Special effects are like the icing on top of your digital coloring cake. These are the glowing lights, the laser beams, the concrete textures on walls, the asphalt on the ground, the soft sunlight streaming through the window, the dancing dust particles glowing in a sunbeam. They're not necessarily essential, and it can be easy to overdo them. But when they work, when they really sing, special effects can mean the difference between a good page and a *great* page.

Special effects come in many different shapes and sizes, but we're going to break it down to five essential processes that you can use in various ways to make a number of different effects.

Glows

A *glow* can be anything from an epic energy blast from a superpowered character, to the light filtering in from a dingy window. If used correctly, a glow turns a plain-looking image into a majestic one. Creating a glow is a fairly simple process with nearly limitless applications. We'll start with some simple glowing eyes and then show you how broadly useful this technique can be.

1. Open up your image. For this exercise, anyone or anything with eyes will do; just make sure your image is at least 200 dpi (dots per inch) and 3 by 3 inches.

2. Set your page's mode to full color by selecting Image>Mode>RGB Color.

Any image with eyes will do for this exercise. They're an easy feature to make glow!

▼

3. Make a new layer by clicking on the Create New Layer icon on your Layers window.

4. Click the Foreground Color selector and choose black.

5. Fill your layer with black by using the Paint Bucket tool, or select Edit>Fill and fill with the foreground color (Alt/Option+Backspace).

Don't worry—all that black will be hidden ▷ momentarily.

6. Once your layer is filled with black, go to your Layers window and click on your Blending Modes menu and change the layer's mode to Screen. The black will disappear because the Screen layer mode makes all blacks transparent and all whites opaque.

7. Go back to your Foreground Color and select white.

8. Get your Brush tool and choose a soft-edged brush. Set your brush's Opacity to 100% and Flow to 8%.

Setting Layer Mode to Screen.

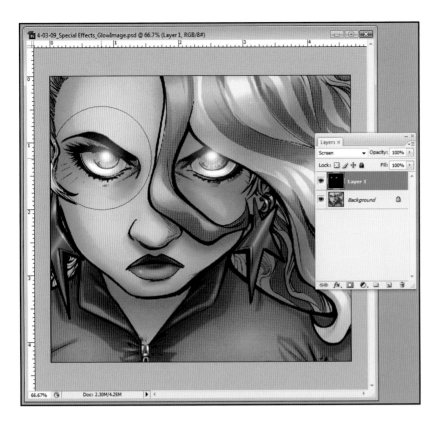

◀ Painting white glows onto the eyes with a large brush on the Screen layer.

9. You want to create a glow that's strongest in the center and fades at the edges. To more easily accomplish this, use your bracket keys ([and])to quickly change the size of the brush you're using. Paint your most intense white with a tiny brush in your subject's pupils, and then increase the size of your brush incrementally as you softly increase the glow size outward from that center point.

10. All right, this is the fun part. Click Image>Adjustments>Hue/Saturation (Ctrl/Cmd+U). This is another one of those windows we use all the time,

so get comfortable with it. Once the Hue/Saturation window pops up, click on the little box in the bottom left corner that says, Colorize.

11. Move your Hue and Saturation slider bars to get the color you want. Hue changes what color the glow will be; Saturation adjusts how bold and colorful the glow is. Voilà! You've just made your first glow in Photoshop!

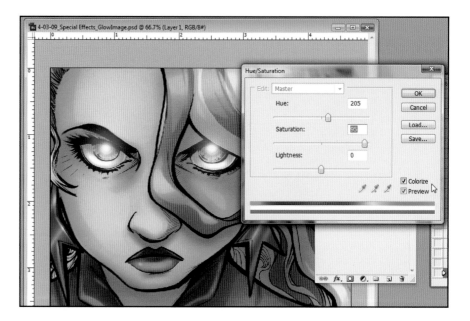

Adjust the sliders to get the desired color for your glow. ▶

Fades

Fades are used to create or enhance atmospheric perspective and to give more depth to an image. Conveniently, they are built off the same structural principles as the glows we just covered.

1. Open up your image. For this exercise, it's best to work with an image that has a clear foreground, midground, and background.

Here, the running children and tree are the ▶ foreground; the walking couple, playground, and distant trees are the midground; and the buildings are the background.

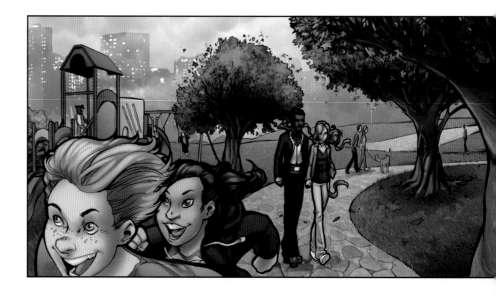

2. Make a new Screen layer, just like you did for the glows exercise.

3. Using your Flats layer, or if selecting by hand, use one of your Lasso tools (Anti-Alias turned off and Feather at 0) to select your background. Choose a gray with your Color Picker and fill this selected area. Do the same for your midground using a darker gray. Finally, leave your foreground fully black with no fade whatsoever.

Use the Levels command to adjust the contrast between lights and darks.

▼

4. Once all your sections are separated, you can use your Magic Wand tool to select each section individually. Then, using Image>Adjustments> Levels you can adjust the sections to get the right amount of fade from front to back. In the Levels window, you'll see a graph/mountain-range-looking thing with three arrows underneath. These control the image's Shadows/Dark tones (black arrow), Midtones (gray arrow), and the Highlights/Bright tones (white arrow). Sliding the black arrow toward the center darkens your darkest areas (making blacks blacker); sliding the white arrow toward the center brightens your lightest areas (making whites whiter). Sliding the gray arrow to the left makes your midtones darker, to the right makes them lighter.

5. Most fades look best when they have a slight color to them. You can colorize your fade as one piece or each tier separately by selecting Image>Adjustments>Hue/Saturation and selecting Colorize. Again, this repeats the same process used to colorize glows.

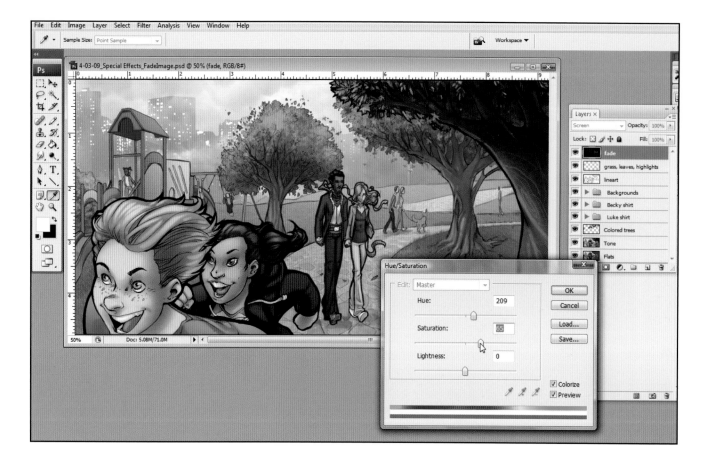

▲

Use the Hue/Saturation image adjustment and click on Colorize to give a slight color to your fade.

Blurs

The use of *blurs* helps you focus the reader's eye on what you want them to see. You can blur background bits to draw attention to the foreground, or vice versa to focus on the background. You can blur a little at the front and a little at the back, directing attention to an object in the middle. Blurs give your images an authenticity and interest, but you should use them sparingly or run the risk of having them become tiresome (both for you to create and for the reader to look at).

1. Open up an image to which you'd like to add a blur.

2. Hide any layers you're using for special effects by clicking the eye icons to the left of their layer thumbnails. Select the panel you want to blur with the Rectangle Marquee tool or the Lasso tool.

3. Flatten the rest of your image by selecting Layer>Flatten Image or Shift+Ctrl/Cmd+E.

Here, we will blur the monsters closest to us so that the focus shifts to the characters in the background.

4. Copy (Ctrl/Cmd+C) the area you have selected.

5. Go to your History window and move back to just before you flattened the image.

6. Go to your Layers window and click on the layer just below your effects and Paste (Ctrl/Cmd+V) your flattened image. Now you have a duplicate of the panel you want to blur sitting just under all your effects.

Be sure to turn on the Preview option in the Gaussian Blur window so that you can see how much you're blurring the image.

7. Select Filter>Blur>Gaussian Blur. Use your slider bar to obtain your desired amount of blur and press OK.

In Quick Mask mode, everything you paint red will *not* be part of the selection when you return to Normal mode. ▶

PRO TIP

STEVE DOWNER: THE GENTLE APPLICATION OF SPECIAL EFFECTS

Special effects in comics coloring is a catch-all term for anything a colorist applies that changes the artist's linework.

Less is more! Effects layers should be a "last resort" to create lighting or depth that can't be gained without altering the line art. It's best to get the effect you're after by using your color wisely under the line art.

Some things benefit from the use of special effects: magical effects, light sources (lamps, the sun, mystical glowing things), anything seen through a surface (glass, water, and so on), atmospheric depth (think fog, or mountains seen far away).

All these are just guidelines and not set in stone. Some projects call for an approach where no special effects are used or where every page is loaded. (Generally, the less heavy black shading an artist uses, the friendlier their lines are toward special effects, as the colorist makes more lighting decisions.) The more you create, the better you'll be at knowing when and when not to use special effects.

Steve Downer

Artist on *Dracula the Unconquered*
Colorist for *Edison Rex* and IDW's
Rogue Trooper
twitter.com/downersteve

8. Now you need to mask off the parts of the panel you *don't* want to have blurred. Using your Flats layer and/or your Lasso tools, select the area you don't want to have blurred. To make sure you have a tight selection, you can always use Quick Mask located just under your Color Picker on your Tool window (or just press Q to enter/exit Quick Mask mode). Quick Mask works by allowing you to paint areas into or out of your selection. Use the Paint Brush to turn things red and thus remove them from the selected area, and the Eraser tool to clear the masked areas, adding them to the selection. To exit out of Quick Mask, just click the Quick Mask button again (Q).

9. Click on *Select>Inverse* (Shift+Ctrl/Cmd+I) and go to the Layers window. Click the Add Layer Mask button on the bottom of the window. A layer

mask will appear that hides the part of the image you selected, leaving only the blurred part of the image. Odds are, the edges of the blurred image won't feel quite right yet. You can click on the layer mask (next to the layer thumbnail on the Layers window) and use a brush set to 100% black or white to adjust and fine-tune the mask to your liking.

Textures

Textures can add detail and visual interest or "realness" to various aspects of your image, from plaid shirts to brick walls to graffiti.

1. Using the magic of the Internet, track down some textures you would like to add to your image and save them to a Textures folder you make for yourself. Textures of just about anything can be found by doing a simple Google search, but you can't just use any picture you find without permission. You want to look specifically for free, open-source images that you are allowed to use for commercial purposes.

 When in doubt, ask the image's owner. If that isn't possible, always assume the image *isn't* free unless you can find somewhere that says otherwise. Fortunately, there are a number of websites with open source textures. Our favorite is CG Textures (cgtextures.com) where you can find pages and pages of amazing textures in high resolution.

2. Open a page you want to add textures to.

3. Open the texture you would like to use. Select All (Ctrl/Cmd+A) and Copy (Ctrl/Cmd+C).

4. Click back on your main image. Go to your Flats layer, get your Magic Wand tool, and select the area you want to add a texture to.

For this image, let's add a brick texture to the wall.

Look for straight lines in the drawing that ▶ you can use to align the perspective of your texture. Here, we're using the lines where the wall meets the ceiling and the floor.

5. Click Edit>Paste Into (Shift+Ctrl/Cmd+V). This will place the texture into a Masked Layer above your current layer. Click the little chain link between the layer thumbnail and its mask to unlink the two, and then move your texture around until you get it where you want it.

6. Click Edit>Free Transform (Ctrl/Cmd+T) and transform your texture to properly fit the object you're adding texture to. In order to keep your transformation proportional, hold your Shift key while pulling at the corners. Use the Alt and Ctrl/Cmd keys to skew and distort the image in perspective. You can click Edit>Transform>Warp and see grid lines appear on the selection. You can move these control lines around to manipulate and twist the selected area.

 If none of these steps are quite enough, try going to Filter>Liquefy and playing around with all the tools that bloat, distort, ripple, and smoosh there. Liquefy can be a lot of fun and is one of the few filters we use with any frequency.

7. Once the texture is where you want it, *desaturate* it either by going to the Hue/Saturation adjustment panel and dropping the Saturation slider to 0, or simply by typing Shift+Ctrl/Cmd+U. Then change the texture's Layer mode to Overlay, rendering your texture semitransparent while also allowing the color and tone of the object underneath to come through. Reduce the Opacity to prevent it from being overpowering—frequently somewhere in the range of 50% to 70% is best. Now your texture should be set!

▲
◀ Set the Texture layer to Overlay mode, desaturate it, and adjust the layer's Opacity until it blends nicely with your existing tone.

Color Shifts

Sometimes you need to shift the color of an entire panel or page toward one hue or another, whether to add moodiness to an image or to highlight some special effect happening in that panel. Maybe you need to tint a night scene with blue, or tint red when a volcano erupts, or green for characters walking under a thick canopy of leaves. These are generally done though a variety of

Notice how the same characters in the same room can have different moods just by the color of light used in the scene. ▶

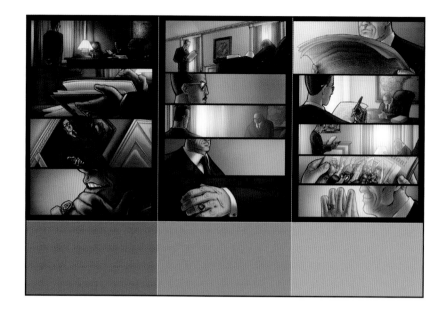

This scene was tinted with a layer of blue set to Color mode. It helps the scene feel like it takes place at night.

▼

separate layers with modes that affect your image's color directly. There are two Layer modes that we find do the job best.

Overlay: Overlay is a great catchall for shifting your image's color when you want to keep a range of colors in play and not just turn the whole thing monochromatic. It's also great for adding splashes of color to show the effect of bright lights and glows on a localized area.

Color: Color mode maintains the tones of the image while replacing its overall hue. Color is a good mode to use when you want to dull/change the general overall color of an image or shift all its color to a completely different hue. We like using Color mode especially when we do night scenes or areas with very dim light.

In either case, create a new layer and either fill it with the color you want or paint the specific area you want to tint. Change the Layer mode to Overlay or Color, and reduce the layer's Opacity until you reach the level you want. If you aren't sure what color to use, start with any color, and after you've found the opacity you want, use Image>Adjustments>Hue/Saturation and slide the hue bar around until you find a color that gives you the effect you like.

LIFE AS A COLORIST

As a colorist, color must become part of your waking life. Everywhere you go, look at how light changes and how color changes. Go out at night in the winter and look at how streetlights affect the snow. Watch a sunset or thunderstorm and see how the colors change. When you watch films, pay attention to how color is used to set the mood for a scene. Learn to soak in color information any time your eyes are open.

Colorists have a curious place in the hierarchy of most comics creative teams. They're often both the last to get their pieces of the book to work on and the ones most backed up against the deadline. Things vary if you're somebody who both draws and colors your book or are strictly coloring over somebody else's drawings, so we'll approach both separately.

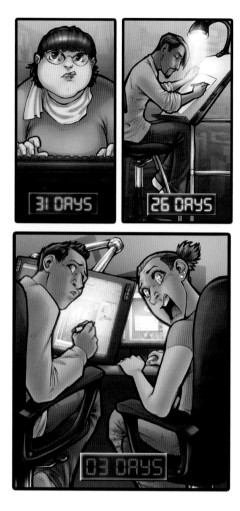

The Strict Colorist

Welcome to the second-least respected job in comics (letterers hold the top spot). When it comes to comics, the pencillers tend to get higher billing, better pay, and more gushing fans running to them at conventions for autographs. Unfortunately, far too frequently the color on a comic is thought of as a splash of flair to pretty up those awesome drawings—as a garnish on the plate rather than as an essential part of the meal. This is reflected in the job description in a few ways.

First, you've got very little time to get your work done. Nothing can go forward without the writer, and she'll generally set the pace. The penciller is expected to finish about a page a day, but that's flexible and people might give her more time if her work is exceptionally good. While it's awesome to be coloring over the pencils of a really great artist, the deadline generally does not change much. If the penciller takes too long on her part, then you're expected to make up that lost time. Depending on who the project lead is or who your editors are, it can get rough.

Second, expect to make less money. Colorists make substantially less, on average, than pencillers will. Self-publishing is a tough road to get started on. It can take years before a self-published book takes off, if it *ever* does. In those lean, early years, there's very little money to go around. The team lead (usually the writer/creator) and penciller will get the lion's share. You get a small slice of a tiny pie. If there's an inker, you'll split your piece with that person, too.

▲
The clock is always counting down. No matter what time everybody else takes, the colorist and letterer are expected to make their deadlines—period.

When things get crazy, work is due, and the ▶ rest of the team seems to be dropping the ball, a great colorist remains the calm at the center of the storm—doing his job well and swiftly so that the book stays on schedule and everyone can breathe more easily.

But there are advantages to all this as well. The most prominent is that your work generally doesn't take as much time overall. We spend more time on our color because we *do* see it as an essential part of the recipe for comics art. But even we readily admit that we can color four pages in the time it takes to draw one—more than that if the pages don't require much detail or effects work. This means you have options: you can hire yourself out to multiple projects, coloring many books at a time, or you can settle into another job to pay your bills and still be able to be a professional colorist in your spare time. Eventually, you may garner enough comics work to make that your only job, but if you have another occupation that brings you joy and fulfillment, you can often do both without losing a step.

The best traits you can possess as a colorist are promptness, reliability, and an easygoing demeanor. You've got to let stress roll off your back (or at least make it seem like you do), and always be there when your team needs you. A good colorist is the pressure-release valve of a comics-creating team—writers get behind, pencillers get *way* behind, and then the colorist comes in to save the day.

Don't try to be noticed; color should be something that simply *is*. If it stands up off the page and slaps a reader in the face while screaming "LOOK AT THE COOL STUFF I DID!" then it becomes garish and annoying. When a choir sings together, no one voice should rise above the rest. Be part of the choir, build a harmony with the rest of your team, and the product you create will be beautiful.

PRO TIP

JON ALDERINK: DEALING WITH DEADLINES

How much work is expected of a colorist?

It varies, but to be an effective colorist you must be able to do one to three pages a day minimum. We are often the last in line of the production process, and at times, we are asked to do anywhere from ten to twenty pages in a weekend . . . maybe even in only twenty-four hours. It happens—more often than you may like. How do we make it all work?

Be prepared! Read the script and glean color notes from it—for example, changes in costume color, special effects, day or night, and so on. If you're unsure of something, *ask*!

Get good flatters. Make sure they are reliable, and reasonably quick. It's best to have a small stable that you can call on. When you need to color twenty pages in twenty-four hours, they are the ones who are going to make it even remotely possible.

Don't panic! Remember your *Hitchhiker's Guide to the Galaxy*, kids.

Take breaks. Your eyes and your brain will thank you.

Jon Alderink

Colorist on *JLA 3000*, *Marvel Superheroes Storybook Collection*, and *Spider-Man 5-Minute Stories*
twitter.com/jonalderink

◄ Overdone color is bad color. Be part of the artwork, not a layer of film on top of it screaming "Look at me!" The best colorist work flows with the mood of the scene and the artwork.

The Complete Artist

If you're somebody who does the drawing *and* all the coloring, you've got a much bigger job. Make sure you are honest and up-front about the amount of time it will take you to complete your work—not just with your team, but also with yourself. It doesn't do you any good to presume you can always work as quickly as you have under the tightest deadline. Nobody can maintain that pace forever, and eventually you'll find what your *real* page-per-week ratio is. If everybody knows how long this will take going in, nobody will be unpleasantly surprised later on.

Some people like the idea of an artist who does the entire job herself, others don't. Some see it as a way of getting a unique aesthetic, a complete voice from a single contributor. Others see it as a liability—putting all your trust into one person, hoping she doesn't crack under the pressure or fall hopelessly behind schedule without anyone there to help her pick up the slack. In any case, don't expect that being a penciller-colorist raises your stock in the market. It can help, but it can also hurt.

The rates here are approximations, and some are pretty generous. Odds are you'll be paid even less when just starting out. Be ready for lean times in the early days! If you stick it out, though, your value will build with time and exposure. ▼

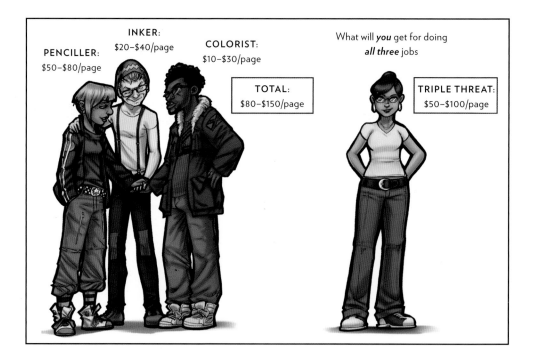

PENCILLER:
$50–$80/page

INKER:
$20–$40/page

COLORIST:
$10–$30/page

TOTAL:
$80–$150/page

What will *you* get for doing *all three* jobs

TRIPLE THREAT:
$50–$100/page

Finally, don't expect to be paid the rate of a penciller, inker, and colorist combined. You might get a little extra, but it won't be anything like what all those individual creators would have earned separately. It's actually what some project leaders see as a major benefit of hiring a penciller-colorist—the ability to get both jobs done at a lower cost than hiring two people. Sadly, as artists we have

to expect that we'll rarely if ever be paid what our time is worth. Instead, ask yourself what's the minimum fee you'd be comfortable with and shoot for that.

If you're a total-package illustrator, you have a lot to carry on your shoulders, but you also have more power to ensure that the final product is exactly what you wanted to see. You get to realize your artistic vision in a way few in comics can. Pride in your work is an invaluable asset. Make sure you're keeping your team leader as happy as you're keeping yourself, and you'll be golden.

In *Critical Millennium*, artist Daniel Dussault was able to add a painterly flair to his work that would have been nearly impossible to do if he were working only as colorist. There are huge artistic benefits to being able to draw *and* color your own pages. (*Critical Millennium* by Andrew E. C. Gaska and Daniel Dussault, published by Archaia)

5. LETTERING

LETTERING IS THE IGNORED ART OF COMICS. WHILE comics wouldn't be what they are without the words on the page, few people ever really pay attention to the nature of word balloons, caption boxes, or sound effects. How the words are arranged on a comics page blends typography, graphic design, and illustration techniques. The legendary comics letterer and founder of lettering studio Comicraft, Richard Starkings, said that this blending of techniques required the letterer to become a kind of art ninja. A great letterer ensures that his presence is always felt but never seen, for great lettering enhances the reading experience but doesn't stand out to distract from the art or the story.

In this chapter, you'll learn about the art of lettering. First we'll walk you through what makes good (and bad) lettering and why it's so important, how it impacts the reading experience, and how it can enhance the artwork by becoming a symbiotic part of the page. Then we'll introduce you to the program you'll use to do the job and walk you through the lettering process. It's a skill that's easy to learn but that can take years to master.

UNDERSTANDING LETTERING

As a letterer, you carry a vital responsibility in a comic's production. Don't think you're just slapping words on a page—you are an artist and your medium is typography! Just like every other artist working on this comic, you are a storyteller. Your work is just as important as theirs.

Something many people who've read comics for a long time can forget is that reading comics is a skill. To somebody who doesn't know comics very well, it is easy to get lost or frustrated when trying to follow the pictures and words on a page from panel to panel. Your primary job as the lettering artist is to alleviate that struggle, to be the soothing touch that gently guides readers on a painless, fun journey across each page. Reading comics takes work, but that work can be either a conscious effort or an unconscious breeze. It's the letterer who makes all the difference.

Controlling Eye Path

Eye path is the way our eyes flow over an image when we look at it. In Western cultures, we read text from left to right and top to bottom on a page (in Eastern cultures, it's right to left). That means that, when reading, our eyes will naturally want to flow in a specific direction. Sometimes, however, the artwork of a page can mess with that natural flow. The panel layout itself or the images inside those panels can lead the eye somewhere you don't want it to go, thus skipping over whole pieces of the story and winding up reading out of order.

When this happens, the act of reading the comic becomes a conscious effort, which is what you're trying to prevent. The more readers have to think about what they're doing, the less they're letting go and losing themselves in

the story. So your lettering has to step in and ensure that, no matter what the artist may have done, the viewer has an effortless reading experience.

Here's an example of a page that, while not drawn poorly, presents problems for the reader:

◀ The unlettered page

Note the big diagonal column in the second panel on the page above. Diagonal lines are like train tracks for the eyes—you lock onto them and follow them from one end to the other. It's hard to force yourself to get off those lines and look around the page. In this case, that diagonal line leads you from panel one through panel two and into panel four, skipping panel three entirely! This is a case where we (as letterers) have to save ourselves from the problems we (as artists) have created.

Below is the page with lettering. Note how the flow of the lettering guides you from important element to important element on the page. The lettering starts in the top-left corner and draws you into the second panel, but it then

The lettered page ▶

PRO TIP

CHRIS SIMS: PREPARING A SCRIPT FOR LETTERING

When it comes to lettering comics, the same things that apply to everything still apply here: Communication is key. If you're a writer and there's a specific look that you want for a certain character's dialogue, make sure you talk to the letterer about it, and indicate in the script when it should be used and when it shouldn't—especially if it's going to be the type of thing that tips off a reader about something that's going on with how that character speaks.

That's the key thing to keep in mind, both with lettering and writing for your letterer. It's not just about putting words on the page; it's about giving a completely silent medium a "sound," whether it's through bolded words that reflect the cadence of a character's speech, throwing in coughs or stutters, or even just in how they break up the dialogue into different balloons.

Always try to make your scripts as clear as they can be, and if anything seems odd, don't be afraid to talk it out. Comics are a collaborative medium, after all, and the most important thing about them is whether your reader can actually read it. When it comes to dialogue, it's the letterer's job to make sure they can!

Chris Sims
Cocreator and writer of *Down Set Fight!* and *Subatomic Party Girls*
Staff writer for comicsalliance.com
twitter.com/theisb

pulls your eyes down and guides you into the third panel instead of skipping over it by mistake.

This is the letterer's job. Whenever you look at a page of art, the first thing you should do is look for problems in the eye path and think up ways to solve those problems without overtaking the art. After all, it's the pictures people want to look at, not the words.

Fonts

The nature of reading comics is that we're always trying to work out sounds in our heads to match the action on the page. Which fonts you use for your lettering become the first and most dominant things readers will use to determine what they think things sound like in your book.

Picking fonts is as much about style as substance. There are a lot of options out there, but since you have to purchase the right to use fonts for commercial projects (that is, anything you're making money off of), money becomes a factor. For this reason, we strongly recommend blambot.com, a site dedicated to comics lettering that offers a large selection of fonts free for use by self-publishers. They also offer a variety of excellent pay fonts, and their prices are a fraction of what the competition charges. While you might pay upward of $70–$100 for a single comics lettering font from some sites, Blambot charges an average of $25.

You can also peruse the website dafont.com, which aggregates fonts from all over the Internet. It also lists whether a font you like is free (anyone can use it for any reason), a pay font (with a link to buy it), or if there is some other kind of license you may need to use it.

◀ Dialogue balloons and fonts give a specific feel to the sound of these characters—one dark and aristocratic, the other mechanical and robotic.

GETTING COMFORTABLE WITH ILLUSTRATOR

Just as Photoshop is the standard coloring program in the world of comics, Adobe Illustrator is the standard program for lettering. And, just like Photoshop, Illustrator is a big program with a lot of power that can do a whole lot of things. It can be intimidating when you first open the program, but there's good news: the vast majority of the bells and whistles of Illustrator just never come up when lettering. We're going to show you the only bits you'll need to use.

The Main Menu

Located along the top of the program, these ten menu tabs contain overarching controls for a wide range of actions. We'll talk more about using specific commands when we get into the lettering process, but here's an overview of what you'll find:

THE MAIN MENU

Adobe Illustrator

File Edit Object Type Select Filter Effect View Window Help

File	Contains the typical commands most programs will have: open, save, print, etc. The one unusual command you'll use is *Export*, where you duplicate your current file as a flattened image in some other file format.

Edit	Contains a lot of the same commands as Photoshop: cut, paste, copy, undo, etc. Also contains commands for *Find and Replace* to search for specific words in text (and replace them with different words, if you choose), the *Check Spelling* command, which does just what it sounds like, and the very helpful *Paste in Front* command, which you'll use frequently.
Object	Contains various ways to edit and adjust a selected object. You'll mostly use the *Arrange, Group/Ungroup, Lock, Path,* and *Crop Area* commands.
Type	Various ways to edit and adjust selected text. Most of the commands you'll use are obvious. There's a *Type* window you'll have open that will do most of this stuff more conveniently. The ability to quickly grab *Recent Fonts* is useful, though.
Select	Ways to select objects for editing and adjustment. You won't use this menu often, though you'll do a lot of selecting with different tools. Selecting *Next Object Above / Below* comes in handy sometimes, though—and when it does, it's the best tool for that job.
Filter	Contains a lot of Illustrator versions of Photoshop filters. You won't use any of these.
Effect	Special effects that you can apply to words and shapes. You'll use *Distort & Transform* most frequently, but *3D* and *Warp* have some neat effects you could use for logo design. Ignore *Photoshop Effects*.
View	Contains different viewing options for your document, but we rarely use any of them other than turning on the rulers at the edge of the page.
Window	Contains a list of all windows you can have up at any given time in your workspace. If you're looking for a specific window tab (*Appearance, Color, Stroke, Pathfinder*, etc.) click this menu to find it quickly.
Help	Takes you to Illustrator's help page. In our experience, you're better off going to Google for help. (Just our opinion.)

PRO TIP

JEREMY BASTIAN: LETTERING BY HAND

I hand letter my comic because it adds to the overall effect I want to have on the reader. I find that hand lettering makes it feel more like a crafted art piece, it makes it more personal.

In the days prior to computers, all comics were hand lettered; the letterers had kerning, leading, and penmanship perfected to a science. The way I do it is more influenced by the political caricaturists of the eighteenth and nineteenth century like George Cruikshank and James Gillray. My lettering is a bit more chaotic and more natural.

The reason I think my lettering works well in my comic is that it matches the style of the art and adds to the experience of reading it. That is key in lettering any comic. Whether it is a font you are using or lettering by hand, lettering should complement the art and style of what you are working on. The negatives of doing your lettering by hand are that it takes extra time and it can look unprofessional and sloppy if you are not practiced in it. Lettering can be an art in itself, but let's not forget the reason you need to letter: information. It needs to be legible. Don't go overboard; you need the reader to be able to understand what you are saying.

Jeremy Bastian

**Creator of *Cursed Pirate Girl*
Contributor to *Mouse Guard:
Legends of the Guard*, vol. 1
jeremybastian.blogspot.com**

Windows of Importance

Illustrator has a lot of windows you can flip through. In Illustrator versions CS3 and above, these windows naturally rest in tabs along the right-hand side of the program. You'll only need a few of these regularly, but those few will get a lot of use.

WINDOWS OF IMPORTANCE

1. *Color*	Where you'll pick and mix your colors for your text, balloons, captions, and sound effects. You'll work in CMYK (Cyan, Magenta, Yellow, and Black), adjusting the sliders to get different colors for the body color and for the outline/stroke color.	
2. *Swatches*	If you use a few colors all the time, you can store them here as little color swatches you can use over and over.	
3. *Stroke*	Sets the thickness of the outline around an object. One of the most frequently used windows, more versatile than you think.	
4. *Gradient*	Adds a gradient color fill to an object. You can adjust the colors that make up the gradient in the *Color* window.	
5. *Transparency*	Adjusts how transparent an object is. The lower the percentage, the more see-through it becomes.	
6. *Pathfinder*	Contains different ways of merging objects. You can use it to combine objects, subtract a shape from another, remove any part of multiple shapes that don't overlap one another, or remove only the parts of multiple shapes that do overlap. Gets used all the time, so get comfortable with where it's at on the tab bar.	
7. *Character*	Primary window for adjusting text. Here you can pick your font, font size, and font style (bold, italic, etc.). You can adjust the leading (the space between lines of text) and the tracking (the space between letters), as well as the height and width of letters.	
8. *Paragraph*	Sets the justification for your text so that it all lines up to the left or right or is centered in your balloons and captions, and lets you decide whether to hyphenate long words by cutting them in half. (Pro tip: Never use hyphenation to split words onto multiple lines. It's pretty ugly looking.)	

Tools of Interest

The tools palette sits on the left-hand side and is vaguely similar to the Photoshop tools palette. As with Photoshop, you can click and hold on these tabs to find extra tools hidden within. Here you'll find the most thrift in Illustrator maneuvering—you'll hardly use any of these!

A quick note on terminology, just so we're all on the same page: When you're working in Illustrator, we'll reference Objects and Paths a lot. *Objects* are just anything that isn't text—word balloons, caption boxes, even sound effects once they've been converted from text to a shape, are all objects. *Paths* are the outlines around those objects.

These are the tools you'll use in lettering comics:

ILLUSTRATOR TOOLS

	1. *Selection Tool ("Black Arrow")*	Selects object or grouped sets of objects. Pretty straightforward.
	2. *Direct Selection Tool ("White Arrow")*	Selects only specific control points on object paths. When you see an object or path, you'll notice little dots at intervals around its edges—those are control points. You can use this tool to select and manipulate those points. Also lets you select individual objects out of groups.
	3. *Pen Tool/Add Anchor Point Tool/ Subtract Anchor Point Tool*	Used to create paths and objects one control point at a time. The *Add* and *Subtract* tools can add or delete control points on existing paths.
	4. *Type Tool*	Allows you to type text. Click and drag the tool to create boundary boxes that text will fit to when typed.
	5. *Rectangle Tool/Ellipse Tool*	Used to draw boxes or circular shapes.
	6. *Pencil Tool*	Used to draw object paths freehand rather than point-by-point as with the Pen Tool.
	7. *Eyedropper*	Used to duplicate colors from one object to another. Select an object, grab the Eyedropper, and click on the object that has the color you want—the selected object becomes the same color as the one you clicked on.

Key Commands

Key commands are every bit as essential for lettering as they are for coloring, and their use will save you a lot of time. You'll notice many of these key commands are the same as in Photoshop. That's another advantage of using both Adobe products—the similarities between them make switching back and forth much easier.

MOST-USED KEY COMMANDS (GENERAL)

New	Ctrl/Cmd + N	*Paste*	Ctrl/Cmd + V
Open	Ctrl/Cmd + O	*Paste in Front*	Ctrl/Cmd+F
Save	Ctrl/Cmd + S	*Group*	Ctrl/Cmd + G
Save As	Shift + Ctrl/Cmd + S	*Ungroup*	Shift + Ctrl/Cmd + G
Print	Ctrl/Cmd + P	*Bring Forward*	Ctrl/Cmd +]
Undo	Ctrl/Cmd + Z	*Bring to Front*	Shift + Ctrl/Cmd +]
Redo	Ctrl/Cmd + Y	*Send Backward*	Ctrl/Cmd + [
Select All	Ctrl/Cmd + A	*Send to Back*	Shift + Ctrl/Cmd + [
Copy	Ctrl/Cmd + C	*Zoom In*	Ctrl/Cmd + Space, Left Click
Cut	Ctrl/Cmd + X	*Zoom Out*	Alt + Space, Left Click

MOST-USED KEY COMMANDS (TOOLS)

Selection Tool ("Black Arrow")	V
Direct Selection Tool ("White Arrow")	A
Pen Tool/Add Anchor Point Tool/Subtract Anchor Point Tool	P
Rectangle/Ellipse Tool	M
Pencil Tool	N

One very useful Illustrator trick to keep in mind is that, at any time, with any tool selected, you can hold the Ctrl/Cmd key to swap to whichever selection tool (black or white arrow) you used last. That can help you move more quickly by avoiding constantly swapping between selection tools and other tools.

HOW TO LETTER A PAGE

Lettering can begin at multiple points in the creation of a comic. Of course, the script has to be done, but surprisingly, the art doesn't necessarily have to be completely finished for you to start lettering. To give our editors and proofreaders plenty of time to read over our issues, sometimes when the art is going slow, we'll start lettering with just the penciled pages, or even using final roughs. When lettering over roughs, we know we'll have to adjust a lot later, when the final pages are finished, and when lettering anything in black and white, we know we'll have to adjust sound effect and text colors when the color of the final is in. But it helps us get review copies of our comics to the editorial crew as fast as we can.

In any case, once you're ready to get started with lettering, it follows a pretty simple process. Here's how it all works . . .

Building Your Lettering Workspace

Dialogue balloons and captions are the meat and potatoes of lettering. Ninety-eight percent of what you'll do comes down to placing these elements and filling them with text. The first thing you'll need to do is place the page in Illustrator and get your workspace ready.

1. Open a new document in Illustrator. It doesn't matter what size it is. (We usually just use the typical letter size of 8½ by 11 inches.) Set the Color mode to RGB and Raster Effects to high (300 ppi).

2. Place the artwork on the page by going to File>Place and finding the file you're going to letter. Select it, hit okay, and it will pop up in a blue box with a light "X" through its middle.

Select the page you're ready to work on, and ▶ it will be placed into the Illustrator file.

3. Drag the page to the middle of your workspace and lock it down by going to Object>Lock>Selection. This way, you don't have to worry about accidentally selecting and moving the artwork while you're lettering.

Lock the artwork in the middle of the page as shown.

▼

4. Now you need to make Crop Marks for the image so that, when you export it, it will only export the page and nothing else on your workspace. Grab the Rectangle tool (or hit the M key) and drag a square that's exactly the size of your image.

5. You don't want this Rectangle tool to have any color, so on the color palette at the bottom of the tool bar, first select Fill Color and then Stroke Color, and for each one click the white box with the red slash that's right underneath the color palette. This turns off all color, leaving you with a rectangular path that's effectively invisible.

It's better to place your crop box a fraction of a space inside the image than risk it being outside. If the crop box is bigger than your image, when you export the page it will have a sliver of white on its outer edge.

6. You can use the Selection tool to adjust the box so that it is an absolutely precise fit. We usually zoom in to the maximum closeness to ensure that the boundaries of the square match the page edges perfectly.

7. With the box selected, create a cropping mask by going to Object>Crop Area>Make.

◀ Having the script up in your workspace allows you to reference it as well as cut and paste within the same program without having to have another program up at the same time.

8. With your crop marks in place, when the page is ready to export, it'll trim your workspace down to just the page itself. Since that's the case, you might as well fill the outer edges of the workspace with useful junk, right? Right! Let's start by grabbing the Text tool and drawing a tall rectangle next to the page. With the script open in another program, copy the text for the page you're working on and paste it into the text box you just made in Illustrator.

9. Delete everything from the script section you pasted into Illustrator except the panel numbers and dialogue. Now select it all and change it to the font you're using, and set it to the correct Font size and Leading (space in between lines). Under the Paragraph options, set the text alignment to Centered. All this can be done either in the Type window or by selecting the Text tool and looking at the options bar along the top of Illustrator, under the Menu bar.

Word Balloons

With your workspace built and the script text imported and ready, it's almost time to place the lettering on the page. But first, you have to make your word balloons!

1. Grab the Ellipse tool and draw an oval. Go to the color palette and set the Fill color to white and the Stroke color to black.

PRO TIP

JAMAL IGLE: DRAWING WITH LETTERING IN MIND

I'm old enough, and have been in this business long enough, to remember when lettering was done directly to the original comics artwork. The times have changed, and technology allows for lettering to be done separately, but the basic principle is the same. Everything—including the lettering—on the comic's pages should be used to move the reader's eye from one panel to another.

When I lay out a page of art, or a sequence of pages, I make an effort to use the layout of the lettering to pull the eye along with the character direction of a scene. Since I tend to do my layouts at 4 by 7 inches, it gives me a better idea of how the overall page will look. I start by trying to make sure that the upper one-third of each panel is left open for dialogue. I'll rough balloons into the layout, as well as sound effects into the overall design of a page as well, using their placement to move the reader around the page.

Jamal Igle

Creator of *Molly Danger*
Artist on *Supergirl* and *The Terminator: Enemy of My Enemy*
jamaligle.com

▲

It might seem like a small difference, but the shape (in the image below) will make it much easier to fit the text inside nicely.

▼

2. In the Stroke window, set the size of the stroke to something you think looks right—not too fat, not too thin. We use a stroke of around 1pt.

3. Dialogue balloons aren't perfect ovals. Not only don't perfect ovals work well for containing text, they actually don't look very good. What you want is a slightly rectangular oval. To do this, grab your Direct Selection tool (the White Arrow, or hit the *A* key command). By clicking on one of the "corners" of the oval, you'll see the blue lines of its outer path light up, and all the Control points should be white. If any control point is blue (or if they all are), click away and try again.

4. With one of the "corners" selected, use the *arrow keys* on the keyboard to move the edges out and up one tap at a time. You don't want to make this balloon too boxy, but you want something more egg-shaped than perfectly oval.

5. Once you have a great balloon, duplicate it and keep a copy to the side of your workspace. Over time, we've built a small library of different balloon styles and shapes that we keep. This way, any time we want another creepy dialogue balloon or robotic dialogue balloon or something, we can just copy it and paste it on the page where we want without having to build it from scratch!

Placing Balloons and Text

With your script copied in a box next to your page and a nice dialogue balloon shape under your belt, you can finally get to work lettering your comic. Here's the simple step-by-step process for lettering.

1. Select your balloon shape with the Black Arrow and hit Ctrl/Cmd+C to Copy it. Look over the script you have and hit Ctrl/Cmd+V to Paste the

number of balloons on your page equal to the amount you'll need for the dialogue. Remember that you may have to break up big chunks of dialogue into multiple balloons.

2. Move the balloons around on the page to approximately where you'll place them. They won't look right yet, but at this point you're just getting a feel for how the flow of the page will work and how you'll manage eye path from panel to panel.

◀ Arranging the balloons without words in them lets you focus only on how the reader's eye will move on the page.

▼

**NATE PIEKOS:
PLANNING YOUR APPROACH**

The first thing to consider when lettering a comic is developing what I call, a "style guide," based on art and genre. A good letterer is a graphic designer first, and strong design sensibilities play a huge part at this step. Your choice of fonts, the way you approach titles and credits should complement the artwork, and never—ever—be distracting. Bad lettering can pull a reader right out of the experience.

Some things to think about right from the start are: Is the artwork organic and painterly, or perfectly clean and precise? In the former, you might want to use calligraphic strokes on the dialogue balloons, and imperfect outlines on sound effects. In the latter case, balloons that are very symmetrical and fonts with clean, strong horizontals and verticals may work best. As always, access to a library of hard copy and digital reference materials should always be in your arsenal! For instance, if you're lettering a crime noir comic, look at as much design work from the period that you can find and let it influence your approach.

Nate Piekos

Letterer on *The Umbrella Academy*, *Wednesday Comics*, and *X-Force*
Founder of Blambot Comic Fonts
blambot.com

3. When the balloons are all laid out, select them all with the Black Arrow by clicking and dragging across the page.

4. Hit Ctrl/Cmd+C to copy them, then Ctrl/Cmd+F to paste a copy in front. While it doesn't look like anything happened, you now have duplicates of each balloon directly on top of the other balloons.

5. With the Text tool, go to the script you've got beside the page to select and copy the first line of dialogue.

Select the text you want to paste into your first word balloon.

6. Still using the Text tool, hover over the edge of the first dialogue balloon on the page. You'll notice when the cursor moves over things, it changes slightly. When it moves over the edge of the balloons, the box around the cursor turns into a circle. Clicking on the edge of the balloon changes the balloon into a boundary for the text, forcing it to stay inside that shape.

7. Paste the text you copied into the bounding box and you'll see that the balloon shape fills with words. That's why we wanted two balloons, one on top of the other—so the duplicate becomes the border of the dialogue inside!

8. If you set the alignment of your text box to Centered earlier, the pasted text should also be centered. If it isn't, go to the Paragraph window and do that now.

9. Now you're going to adjust the size and shape of the text to get the best fit for your dialogue balloon. If there's more text than can fit, you can select

Make sure that your text is set to a centered alignment in your word balloon.

SIMON BOWLAND: WHO SPEAKS FIRST?

It's really important to remember that the lettering needs to blend into the background of a comics page so, although readers can still see the lettering, their attention is focused primarily on the artwork. Because of this, it's essential that the dialogue balloons are placed in a way that matches how we naturally read a page—top to bottom, left to right. It also needs to be clear as to the order in which the dialogue should be read—as soon as readers have to stop and think about the reading order, they're focusing on the lettering and not on the artwork. Even if the artist hasn't drawn the characters in speaking order, it's still the responsibility of the letterer to fix the problem (unless there's time for a script rewrite) and ensure that readers clearly know which balloon should come first. It's also worth bearing in mind that comics are a visual medium, so the lettering should be unobtrusive and cover up as little of the artwork as possible.

Simon Bowland

Letterer on *Red Sonja*, *Kings Watch*, and *2000 AD*
twitter.com/simonbowland

Your words are in the balloons— ▶
congratulations! Now on to the
final process.

the text shape with the Black Arrow and adjust the size of the bounding box to fit it all in. You might need to edit the text itself down to fit the space better, or possibly cut some out and paste it into a new dialogue balloon.

10. Finally, use the White and Black Arrows to adjust the fit of the balloon to the text so that it surrounds the words comfortably—not too much space around the edges, but not too little. The space around the text should be pretty close to even all the way around the circle.

And that's it. Repeat this process for all the balloons on the page, arranging them as you go, for the best look and feel. Don't worry about balloon tails or connectors until the very end when everything's in place. In fact, we don't add the tails or connectors until after we've both had a chance to read over the final edits for the lettering and agree we like what's there. It's much easier to edit the text in this stage of the lettering than when everything's done.

Adding Tails and Finishing the Bubbles

With the balloons in place, it's time to add the tails and connectors and then merge them all together into final shapes.

1. Using the Pen tool, click a point inside the dialogue balloon near the edge toward the spot where the tail will point.

2. Balloon tails should always point to the mouth of the speaker, so click (and hold) again about halfway or so toward the mouth of whoever is speaking and drag the cursor to bend the line you've just made. Give it a nice, even curve that directs the tail toward the mouth even more clearly.

3. Click again on the end point you just made to cap it off. If you don't do this, Illustrator will try to make the next curve for you rather than you choosing it yourself.

4. Click back inside the balloon a short distance from your first point, dragging the cursor again to match the curve of the first line. You're looking to create a nice, even taper from the balloon to the point.

Fear not—your text didn't disappear! Merging objects moves them to the top of the image, over everything else. Eventually, you'll move them back down where they belong.

Send the balloons to the back, and then ▶ move them forward one level so that they sit above the art but below the text.

If you're connecting two balloons, do so by creating another tail just like before. This time, put the tip of the tail in the center of the balloon that's closer to the speaker. If there are several balloons chaining together, link them by tails where each tail points to the next closest balloon.

Now, let's connect those balloons and tails into single shapes!

5. Use the Black Arrow to select a talk balloon and its tail (or all the balloons and connectors that will be part of one continuous shape). Make sure you don't have the text selected! You can hold the Shift key to add to or subtract from a selection group.

6. Go to the Pathfinder window and click the Add to Shape Area button. Your selected pieces will merge, but they'll be brought to the top of the page, covering the text.

7. Continue merging the balloons and tails one by one until your page is finished.

8. Select all the balloons you've created and tap Shift+Ctrl/Cmd+[to send them all the way to the back. They'll disappear because they're now beneath the page art. Click Ctrl/Cmd+] to move them forward one level and they'll reappear above the page art.

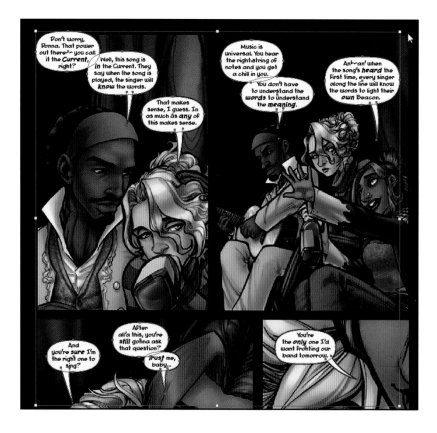

Caption Boxes

Now let's go over caption boxes quickly and you'll be done. Caption boxes are even easier than dialogue balloons.

1. Use the Rectangle tool to make a box where your caption will go.

2. Copy the box and hit Ctrl/Cmd+F to paste a duplicate in front.

3. Copy the text from your script, and use the Text tool to paste it into the duplicate box.

4. Adjust the size of the box (and the text itself, if necessary) to create a nice, even rectangular shape for the text. Try to balance the width of each line so that you don't have huge gaps on the edges.

5. Frequently, letterers use colored caption boxes to further separate them from dialogue balloons. In the case of captions used to show the thoughts of characters or the voice of a narrator, using color can denote which person is narrating/thinking at which time. If you're going to use a color outline, make sure it stands out from the page art enough to be visible. If you're using a color fill inside the caption box, make sure the text is still legible. You might need to alter the text color to ensure maximum readability.

Here, we've given the caption box and text a magenta color, with a pink box behind, to denote that the narrator is Donna from *Rainbow in the Dark*.

And that's it. You're done. After your first page is done, you've got a lot of the setup work out of the way forever. Next go to File>Save As . . . and create an Illustrator file called "Lettering Workspace." Now, whenever you're starting a new page, just open up the Workspace file, click Object>Unlock All and delete the page art and dialogue, replace it with the new page you'll work on, and relock the art. Then go to Object>Crop Area>Release and adjust the box to fit the new page, clicking Object>Crop Area>Make when you finish. The rest of the workspace remains as templates and layout tools. Any time you add new balloon shapes or caption styles or whatever, place them on the right side of your Workspace file so that they'll be easily accessible forever.

The most important thing to remember is to always, always, *always* click File>Save As . . . (Shift+Ctrl/Cmd+S) first, changing the name of the file before you continue on. You do *not* want to risk saving over something and losing all your work. In fact, this is a fine time to remind you that you should be saving multiple copies of everything you do. We have two desktop computers and two additional external hard drives, which have *all* our files on them just in case something gets lost or accidentally overwritten. Look into online cloud storage options like Dropbox.com for further protection against losing your hard work through accidents or disasters. There's no such thing as being too cautious when it comes to saving files.

As a final note, avoid the temptation to select and merge all of your dialogue balloons at once rather than one at a time. It may seem like a time-saver to just grab them all and merge them in one fell swoop, but if you do it that way, they will all become a single object so far as Illustrator is concerned. This means that if you want to make changes later (after your editors give you notes, for instance), you won't be able to manipulate the balloons individually unless you use the White Arrow to carefully select each piece of the one balloon you want to mess with. This becomes a *huge* hassle, and will cost you much more time than you saved by merging all those balloons at once.

Progress may seem slow at first, but you'll get faster and better with a little time. (*Gronk* by Katie Cook)

SOUND EFFECTS

Sound effects stand alone as one of the exemplary items that make comics what they are. Sound effects must be read as words, and yet they must also blend with the art to become part of the illustration. They have to seamlessly enter the artwork, and yet not fade back so far that they aren't recognizable as text. You have to be able to read them, yet they aren't intended to be read as words, but rather to be "heard" as a sound in your head. It's a very delicate balancing act that makes the creation and application of sound effects the hardest part of a letterer's job.

Before starting, we suggest restraint when it comes to sound effects. Remember that you don't want to overexplain things to the reader that they will fill in for themselves. If your artist is good enough, the reader will look at one character punching the other and they'll hear the crack of skin on skin, bone on bone, without you putting a big, obnoxious "PUNCH!" sound effect over it. The first rule of thumb in sound effects is this: only use them when they add something significant and/or necessary to the storytelling.

Speech as a Sound Effect

The first thing we'll teach is the kind of effect we use most often. The skills you'll learn here will be useful for creating many other kinds of sound effects later on.

Imagine a panel in which a character is talking and is suddenly taken by surprise. In the middle of her dialogue, maybe even in the middle of a word, she suddenly screams. Simply varying the text inside a dialogue balloon is an effective way of creating different sounding speech.

The first option is to take a single word or exclamation (*Graagh!*, *Nooo!*, and so on) and make it bigger inside the balloon. You can select individual letters in the word and use the Character window to adjust each letter's size, width, rotation, and baseline shift to create a word that puts a specific sound in the reader's ear. You can also make characters whisper just by reducing the font size a point or two and leaving a bit more space between the text and the stroke of the balloon than normal. Of course, changing the font to something more dynamic, jagged, or specific to the exclamation being made is another simple option.

The second method for using speech as a sound effect is to use the balloons themselves. One of the classic, archetypal visuals in comics is the starburst "screaming" dialogue balloon. It's actually quite simple to make.

1. Create a balloon like normal, and fill it with text. Create a tail, but don't connect it with the balloon yet.

2. Convert the balloon itself into a guide by clicking View>Guides>Make Guides (Ctrl/Cmd+5).

3. With the Pen tool, click on one end of the tail. Then click points around the guide you created, varying the length and width of the jagged outline for visual excitement and an explosive appearance.

4. Make sure that all the points you create radiate out from the center of the guide. Use the White Arrow to correct them if necessary. The tail should always be the longest point.

It can take a lot of practice to get an explosive balloon that looks good. When you get a good one, save it on the side of your workspace! It's a good idea to have a few varieties saved so that you don't use the same one over and over.

Breaking the Balloon Boundary

Here's a fun trick that will bridge into more elaborate sound effects. This is for when a word gets so big and wild that it breaks out of a dialogue balloon.

1. Create the balloon and text as normal. Select the word you want to enlarge, and cut-and-paste it so that it's separate from the rest of the text in the balloon.

2. Click Type>Create Outlines (Shift+Ctrl/Cmd+O) to convert the word from text to a shape. Now you can manipulate each letter of the word on its own using the Black and White Arrows to get the big, expressive sound effect word you want.

Convert your text to Outlines. This allows you to change the shape and orientation of each letter with far more freedom than you'd have when trying to manipulate type.

3. Select all the letters of the word, and group them together by clicking Object>Group (Ctrl/Cmd+G); then send them behind the art (Shift+Ctrl/Cmd+[) and then forward once with Ctrl/Cmd+].

4. Give the letters a thick black Stroke (8–10 pt.).

▶ Set the black stroke nice and thick. It's going to be the new outline for your talk bubble soon.

5. Copy and paste in front (Ctrl/Cmd+F), and then Bring to Front (Shift+Ctrl/Cmd+]).

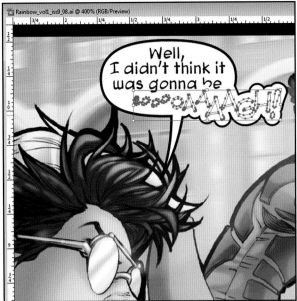

6. Give this group a thick white stroke, slightly smaller than the black stroke behind it (5–8 pt.).

7. Copy, paste in front, and bring to front again, and this time give the group a black fill with no stroke.

Try to make the white stroke thick enough that the black outline is approximately the same thickness as the stroke on the talk bubble.

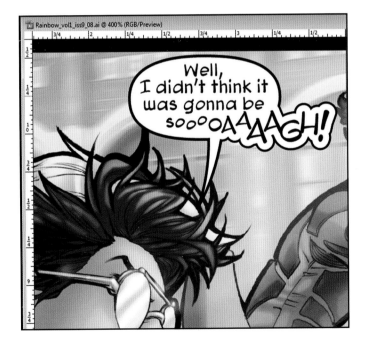

The final effect makes it look like the words are stretching the talk bubble.

Now you have a word that has transformed into a sound! This method of alternating layers of a duplicate group of text, changing the stroke colors and thicknesses to create multiple outlines, is something you'll use frequently in creating sound effects.

JOEL ENOS: STRADDLING THE NOISE DIVIDE

An oft-undervalued area in officially adapted manga is the partnership between the letterer, translator, and editor on the sound effects (SFX). Japanese manga uses sound descriptives to help flesh out the drama in the story, noise words like *smile*, *loom*, or *shin* for the sound of silence. But in the United States, we use onomatopoeia (words that sound like the noise) like *slam* or *whooosh* for a door opening (not *open* as you find in manga). Balancing the best SFX method (staying true to the technical word used or staying true to the intent using pop culturally adaptive onomatopoeia) can spark intense debate on a team. My own pet peeve? *Step*—takes you right out of the action. Though I realize not every footstep can constitute a *wham* (*tmp* is a cop-out, but I still use it!). Many a translator has responded to my edits with "... but what IS the sound of leaning?" I sound out everything out loud at my desk. My letterers will attest that pretty much all my last-minute edits are on SFX.

Joel Enos

Editor and adapter of *Naruto*
Former senior editor for *Shonen Jump*
Writer of *Ben 10 Omniverse: Parallel Paradox*
joelenos.com

Creating Sound Effects

Now it's time to put the "Biff! Bam! Pow!" into your comics. When making sound effects, you want to keep in mind the source of the sound, what it sounds like, and how that sound feels when you're there in that moment experiencing it. Big sounds make big sound effects. Ringing echoes might make hollow sound effects. The sound of a door closing in a scary place, trapping the protagonists in a nightmare, might need a creepy-looking sound effect style in order to convey the eeriness of the moment in a way that a simple "slam" might not get across.

First we'll look at how sound effects are made in Illustrator. Then we'll look at some ways to create different impacts and effects in your comics.

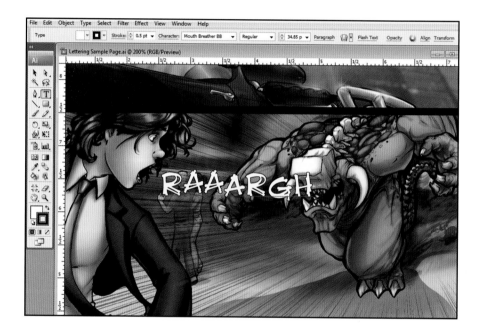

▲

Selecting the right word to use for a sound effect can be a challenge. When in doubt, try to make the sound yourself, and listen to your voice and the consonants and vowels you use; then try typing that out and see how it looks as a word.

1. Pick the font you want to work with, and type in the sound effect text. Big, chunky fonts tend to work easiest, but each situation will have its own requirements.

2. Click Type>Create Outlines (Shift+Ctrl/Cmd+O) to convert your text into an object. Then click Object>Ungroup (Shift+Ctrl/Cmd+G) to ungroup the letters so that you can manipulate them individually.

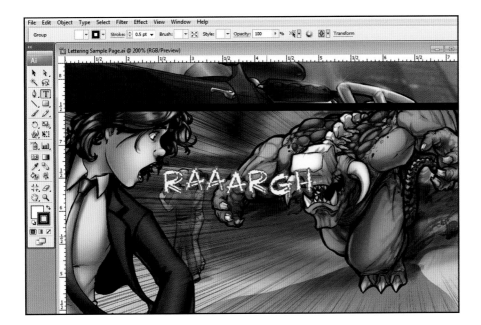

◀ Convert the text to outlines; then arrange and shape them to get the look you want the sound to have.

3. Adjust the size, stretch, and rotation of your letters to create the proper shape for the sound effect. It is helpful to imagine at what point in the word the sound would be loudest and make that the biggest part of the sound effect. For example, you might emphasize the "OOO" in BOOOM or the "POW" in Ka-Pow!

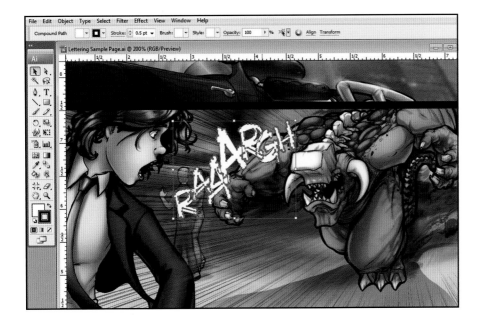

Just like before, the black stroke will be the ▶ outline for the sound effect.

4. Once your shape is set, use the Bring Forward and Send Back commands (under Object>Arrange, or using Ctrl/Cmd+] and Ctrl/Cmd+[) to arrange the letters so that the first letter sits on top and each subsequent letter sits one level below the previous.

5. Group the letters together again by selecting them all together and clicking Object>Group (Ctrl/Cmd+G).

6. Set a stroke color of your choosing. Give the group a thick stroke (8+ pt.).

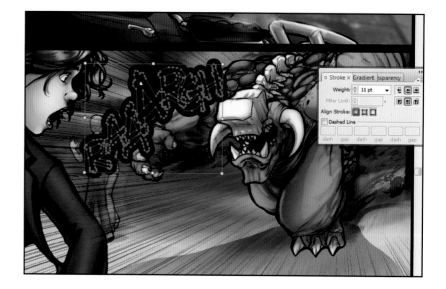

7. Copy the group and Paste in Front (Ctrl/Cmd+F). Give the new group a thinner stroke (5–6 pt.) in a different color.

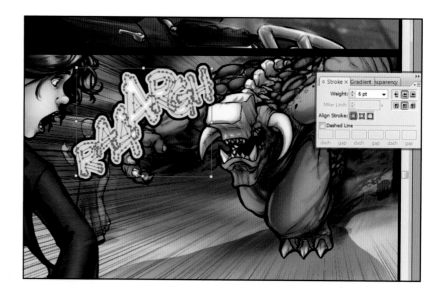

8. Copy/paste again, and set a very thin stroke (0.5–1 pt.). Set the color for the stroke and the fill.

◀ Pick colors that will work with the colors of the page but don't get lost against the art. How much the sound effect's color should stand out will depend on what the sound is and what's making it.

9. Create varied effects by using the Copy/Paste in Front method a few times, each time changing the stroke thickness and color. Alternately, you can use gradient colors or move the positions of underlying copies to create drop shadow or 3D effects. Play around and see what else you can do.

10. Create hollow sound effects by turning off the Fill color for each group! Be sure to open the Stroke window and set the Cap and Join buttons to "Round" so that your corners don't get flat or jagged. Unless, y'know, that's what you *want* for that particular effect.

This basic method is all you'll need to make any sound effect you can imagine. The trick with sound effects is not in how they are made, but in how they are *used*. It helps to study graphic design, typography, and illustration techniques to find anything that can be used in creating your effects.

LIFE AS A LETTERER

When you're the letterer of a comic, you're often the forgotten cog in the machine. Few readers recognize your contributions. There are even some professionals who might not respect your time or opinions. But the truth is, while you have the least control over the content of a comic, you have the most control over how it's read.

The Professional Letterer

Letterers get the least amount of time to do their job and are always expected to meet the deadlines given almost without exception. Even colorists receive more deadline forgiveness than letterers. If you are supposed to have five days to get your book lettered but the art doesn't get to you until you're down to the last two days, you're still expected to turn your work in on the original date.

Fortunately, once you master your workflow, lettering doesn't take a tremendous amount of time. You can easily maintain work on several books at once, and it's fairly easy to hold another job while lettering on the side, if needed. Understanding how to letter seems like it could take a lot of time and experience, and it does, but it also quickly becomes second nature. As with any art, once you start getting a handle on the major concepts of the craft, they start to become rote and you don't need to actively think about them all that much. You'll find that looking for a good eye path, thinking of panels as planes of space, and finding clever uses for different fonts and balloon shapes become reflexes rather than struggles.

Give it time and you'll be that magic combination of fast *and* good! Then all those deadlines will roll off your back like water. ▶

Average pay for letterers isn't great, but it's better when you consider the per-hour rate of production. Big companies typically pay $30–$50 per page for lettering; small publishers or individuals putting out work on their own might offer as little as $10–$15. But when you consider that you could potentially be lettering half a dozen pages in an hour, that money can add up.

You may be contacted out of the blue with sudden jobs that need fast turn-arounds. "We need these twenty pages by tomorrow morning!" "Here are twelve pages—we need them this afternoon!" It isn't uncommon, and the days when you could charge extra for rapid production are long over. Try to take it in stride—this is the job you signed up for, and there are great personal benefits. Typography is a fascinating art form, and comics allow you to explore that art in a completely different way from any other illustration or graphic design work would do.

Why Self-Publishing Writers Should Also Be Letterers

If you're writing a book you intend to put out yourself, we highly recommend that you letter it. For one thing, you won't have to spend money you probably don't have on a letterer (or find one who will work for free). But more

important, it gives you the final say on how your words will be read by your audience.

A lot can change between the script and the final page. Sometimes you get pages back and the way the artist drew certain panels makes you reconsider the dialogue you intended for them—the expressions are a little different, maybe you don't need to say as much because the art says it all, or maybe the art is confusing and you need to clarify it via dialogue. Space is also a concern, either because there isn't enough room for all the dialogue you've written, or because there's *too much* space. If you're working with a letterer, you'll need to create a new script for them to work from, and even then you'll find changes you want to make. If the letterer can do them, you've just created more work for them. If they can't, you're stuck with work you know could have been better.

Then there are the logistical issues of whether your dialogue works well in a balloon shape, whether you need to divide a speech into multiple balloons, or all the myriad little tweaks and adjustments that you might want to do as you read over the lettering on the fly. If you're lettering yourself, you're in control of all those adjustments. You can do whatever you think needs doing as you go along.

The best part of lettering your own books, and the reason we will likely always be our own letterers, is that it gives you total control over your words. When things need changing, you make that decision and you make those changes. Think you can do better? Do it! No middleman, no having to explain yourself, no asking an already overworked partner to stretch himself even thinner—you just take charge and make the book the way you want it to look and read. You can't beat that, provided you have the drive to become a good letterer yourself. If you don't have it in you to learn that craft and really dig into the work you'll have to do, you might be better off having somebody else take over. Better to deal with an extra team member than to do a bad job yourself and make your comic suffer for it.

It isn't worth lettering your own comics if you can't deliver the quality the book deserves.

▼

6. PUBLISHING

SO, YOU'VE CREATED A COMIC. CONGRATULATIONS! You've accomplished something that few people ever do. Take a moment to bask in how good it feels to have gotten this far. But your work is just beginning, friends. Now it's time to take your work and publish it for readers everywhere.

Thankfully, as we've said, you live in the golden age of the self-publisher, and the very act of publishing comics has become much easier since the black-and-white indie comics boom of the 1980s. Whether you're making American-style comics, manga, or webcomics, now is the time to step out into the major leagues and get that comic of yours out into the hands (or onto the screens) of your potential fanbase!

In this chapter, we'll walk you through all the things modern comics self-publishing entails. We'll talk about how the business has changed and what this new world means for you as a creator. You'll learn all about the wonderful world of digital publication and how cheap and easy it is to create and sell digital comics. Then we'll walk you through how to work with printers and distributors, and what to do to make the process of publishing your comic as painless as possible.

Traditionally, publishing has been known as the act of printing and releasing a product to an audience. In this day and age, it can be as simple as putting a webcomic up on the Internet, or as complicated as doing a run of five thousand physical copies of a hardcover graphic novel for international distribution. We used to need publishers to handle everything from editorial review to dealing with printers to managing relationships with comics shops and the press. But as the times change, we as creators have learned to do those jobs for ourselves.

When you make the decision to make your own comics, you have to be aware of everything, from what publishers actually do (and what they used to do) to the different weights and coatings of paper, what average graphic novel sales figures are, where the major markets for comics buyers are, and which online comics distributors will get you the most readers. It's a big job, but it's not an impossible one.

The Way We Were

Comics publishers once provided a wide variety of production services. They would assign an editor to oversee your project. Their marketing departments would look for ways to popularize your work in the public eye. Publishers would take care of printing and distribution of the comics, and if a comic became especially successful, they might arrange for you to have signings or appearances at conventions and handle multimedia tie-ins and adaptations.

But all those things cost money and time, and require risk on the publisher's part. As the publishing industry began to struggle, publishers began taking on fewer risks. They may still offer editorial assistance, and might cover the initial

▲

A rosy re-creation of how we often think of a time when studios existed and publishers had employees and not just freelancers.

printing costs, but creators are expected to do more of their own marketing, advertising, and audience building. Some publisher deals require the creators to pay back the print costs as well, only earning a profit after that initial debt is paid.

The advent of digital comics has changed everything for comics publishing. Like the music industry before it, the comics industry has had to adapt rapidly to a complete change in the way its audience wanted to consume its product. Publishers struggled to figure out how to handle the digital market and changing desires of their audiences, and in the face of that struggle, they had to tighten their belts even further, taking fewer risks and expecting creators to make a name for themselves somewhere else before they would be given a chance to pitch to any serious publisher. Which brings us to today . . .

Why Choose Self-Publishing

We live in a time when most comics publishers are offering less than ever before. If you're a creator with a big name and large fanbase whose comics regularly sell thousands of copies just because of who you are, publishers will leap at the chance to support and advertise you all they can. They want the world to know that you are working with them—they benefit from the prestige you bring their label, and from the money your work will bring their company.

If you do get picked up by a publisher but don't have an established name, you often get little to nothing to start. Sure, it's possible that your concept could get the publisher so excited that they'll work hard to see your comic find success,

PRO TIP

JIMMY PALMIOTTI: THE CHANGING BUSINESS OF COMICS

In the past twenty years, creators have taken a step away from the big publishers and have started to explore the word of self-publishing to hold on to their rights and at the same time connect directly with their audience. Things like webcomics and crowdsourced funding options like Kickstarter slowly have been changing the way we deliver the stories to people. A lot of creators like me with the paperfilms.com site have been offering direct digital downloads to people while cutting out the middleman. There was a time when this would be next to impossible, but now fans can feel like they are supporting a creator's work directly. This connection has also helped broaden the genres being offered. Comics are no longer a superhero platform but, like book publishing, offer personal and genre-breaking stories and characters that would have never been able to sustain an audience in the past. It's a really exciting time.

Jimmy Palmiotti
Cocreator of *Painkiller Jane*
Writer of *Harley Quinn* and *G.I. Zombie*
paperfilms.com

◀ When you make your own comics, you'll frequently feel like an outsider even among your peers. Traditionally, it's only been wild success that can catch the attention of some people. But take heart, the times they are a-changing. You are not nearly as alone as you may think you are as a self-publisher.

PRO TIP

NINA MATSUMOTO: MERCHANDISING

When creating comics merchandise, I generally stick to merchandise I'd want. When a certain piece of merch catches my eye, I ask myself, *Why?* (Same goes for stuff I don't feel compelled to buy.) For example, I choose subtle designs over logos to avoid feeling like a walking advertisement—so that's what I create.

Conventions are great places to get ideas. Look around and see what people are buying or wearing. If you have friends who do convention tables, ask them what their best-selling items are and what's been harder to sell. When dealing merch at your table, bring things that don't take up too much space; bulky items are harder to carry, keep in stock, and display. Make sure you cater to every price range, from $2 pins and stickers to $25 T-shirts. Don't go overboard, though—too many items means more decisions and more confusion, which can overwhelm the buyer and lead to no sale. Keep it simple, and it'll make things easier for both you and your fans.

Nina Matsumoto
Creator of *Yokaiden*
Penciller for Bongo Comics
T-shirt artist for Meat Bun,
Fangamer, and Yetee
spacecoyote.com

All you need is your skill, your determination, ▶ and lots of gumption! Being a self-publisher can be scary—but you can do it!

but that's rare. Most times, signing with a publisher requires you to hand over a large chunk of your ownership rights for the comic you're creating (especially media rights, meaning the publisher can sell your comic idea to Hollywood for movies or television without your approval and will get most or all of the money that comes from it) and means they will receive a sizable portion of the profits your book brings in. In return, you may be expected to repay printing costs, you will probably have to do your own marketing and pay for your own advertising, and will have to hit the streets to build your own fanbase while attending conventions on your own dime.

Some publishers have better deals. Some even have *very* good deals. But generally, the better the deal you get from a publisher, the harder it is for you to get that publisher to take a chance on you without already establishing yourself as a "big deal" creator. This reality belies a fundamental shift in the publishing world today:

You don't *need* publishers anymore.

The major services a publisher still provides today are printing your comics and working with a distributor to get them into stores. Since you're already doing everything else, you may as well recognize that you can do both of those things as well. The biggest advantage to a publisher is that they front the cash for printing, but in return you typically lose a lot of your profits. If you can afford to take the risk of paying for your own printing, you can reap all the rewards. And with the advent of digital comics, you can publish comics online for free—no risk, all reward.

Moving forward, self-publishing has become not just a possible strategy but almost a necessity! As fewer publishers give new creators a chance (and some of those who will might take terrible advantage of those new creators), you almost have to do it yourself first to prove yourself. The joy for us was discovering that, once we'd begun self-publishing, we had no reason to give up our freedom for traditional publishing.

The Three Barriers: Availability, Convenience, and Price

There are three barriers to getting people to buy your product: availability, convenience, and price. Your job as publisher is to break down these barriers and make your comics as appealing to customers as possible.

◀ The more places your comic can be found, the more people are going to find it.

Availability means that people can find the comic somewhere. Is it available where the customers are looking for it? Comics struggle with availability because there aren't a lot of places to find them anymore. The Internet is changing this, thankfully, but there are few traditional stores left that sell comics—and even fewer that sell single issues of comics. You need to get your comic in as many places as possible, online and off, to ensure that your potential audience has the opportunity to find it.

Convenience means people can get your comic the way they want to read it. Some people don't like buying single issues but love trade paperback collections. Some people hate digital comics, while some won't get anything else. The more options people have for reading your comic, the more people will try it. More than that, it also has to be easy to buy your comics. People might see tons of ads or hear a lot of word of mouth about your series, but if they can never find it, they can't buy it. Let them buy your comics in whatever format they want, and let them do it easily and quickly.

▲

The more ways your audience can read your comic, the more likely they are to buy it. Don't let arbitrary blockades get between you and your readers!

Price is obvious—don't overcharge. You're in a competitive market! Why would readers pay more for your comic than they would for a comic by a creator they know or starring characters they already love? Sometimes you don't have a choice; the costs of printing or production might force you to charge more than you want. But as much as possible, you need to undercut your competition. If Marvel and DC charge $19.99 for a graphic novel, you need to charge $14.99 or less. If they're charging $3.99 for a digital download, you need to charge $0.99 or go free (provided you have some other way of making up the loss of giving away digital issues or pages).

Remember that you're competing against major, established series. Every dollar the audience spends on you is a dollar they can't spend on *Spider-Man*,

Batman, *One Piece*, and so on. Most comic fans will bemoan the higher prices of comics these days, and we have heard this exact complaint: "I really want to support indie comics, but everything costs so much that I have to make choices. And if it comes down to getting *Thor* this week or trying something new, I have to get *Thor*." They feel more comfortable with the old, reliable books they've been reading forever.

The biggest thing to remember is that you have to charge enough to make a profit for your work, but not so much that customers blanch at the sticker price. If it comes down to lower profits in order to price competitively, that's what you'll have to do. Hopefully, you can make up the difference in volume.

If you can overcome these three barriers, your book will stand more on its own merits. That's all any of us want, right? All that should matter is whether the comic is any good. The fewer hurdles for your readers to jump, the more the content of your comic will rise to the top.

The Value of Forward Thinking

This book exists in a moment in time. At this moment, we're giving you the best advice we know to get you started on the path to being a successful self-publisher. However, time changes all things and what's good advice now might change later on as new technologies and new trends arise. The most important thing you can do is continue looking to where comics, manga, and webcomics are going, not just where they've been and where they are.

It can't always be all about what *you* want. Look to your audience and ask yourself what *they* want. Better yet—find a way to ask *them*!

▼

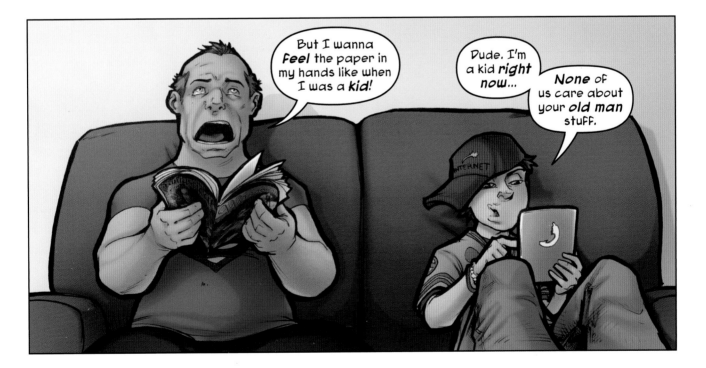

As an example, digital comics are now everywhere, and people who might have earlier complained about how they would hurt the experience of reading comics are now jumping on the bandwagon so that they can reach a wider audience. We've sold digital comics since we began self-publishing, and they've consistently outsold physical issues the entire time. Because we saw this trend coming, we were able to jump on it early and take advantage of the new technology as soon as it appeared.

Think of the future as a huge wave coming, while you're standing on the beach. You can shake your fist at it, you can try to make a sand wall to stay safe, but you can't stop it, and when it hits you're going to be underwater. Instead, you can find a surfboard and ride that wave into whatever comes next. We're trying to be surfers, and you can, too. Nobody wants to be the poor guy trapped underwater after the wave hits.

PRINT PUBLISHING

When most people think of publishing comics, print publishing is what they think about—sending files to a printer and getting a shiny new comic book back for fun and profit. Everybody wants their comics in bookstores and spread across their tables at conventions, but there's a lot more to printing comics than you might think. Before you jump into the big world of publishing in print, there is much for you to learn and consider.

Offset Printing vs. Print on Demand

There are two primary ways of getting your book printed, and which you use will determine a lot about your costs and your options for selling the comic. Offset printing is the traditional print method most people think about when they imagine how a comic gets printed, while print on demand is a relatively newer, faster, and more accessible way to do the job. Each has benefits and drawbacks.

Offset printers use massive machines that print multitudes of pages at once on vast sheets of paper, running off thousands of those vast sheets rapidly. The great advantages to offset printing are that you can get very high-quality comics printed with a wide range of options in paper stock, binding, and fancy cover styles. Plus, because they print so many pages at once, the more copies you have printed, the cheaper each unit costs. So your graphic novel might cost $5.50 per copy for one thousand copies, but $4.25 per copy for two thousand copies.

But there are downsides. In the beginning, the biggest and hardest for you to handle is that you have to pay the whole price up front. Maybe it only costs you $4.25 per copy for those two thousand copies, but you have to fork over $8,500 immediately to buy them all, and that's no small amount of pocket change when you're printing your first comic. Also, the fewer copies you print, the more expensive it gets. If you only want or need a few dozen copies, it's going to cost you a ton of money because those printers are not designed to print such small quantities.

By contrast, print on demand (POD) is a term for digital presses that print small runs of books cheaply and quickly. These printers are far, far smaller (comparable in length to a long dining room table), and they print one entire book at a time rather than tons of pages on one sheet of paper. The big advantage here is that you can get small quantities for much less money than you'd pay an offset printer. That one benefit creates a range of other upsides for start-up self-publishers.

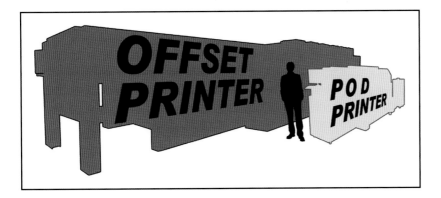

◄ Approximate scale difference of an offset printing machine and a POD printer. Some offset printers are significantly larger than this, and some POD printers are even smaller.

First, and most important, you don't yet know how well your comic is going to succeed. You don't want to wind up with thousands of copies of a comic that won't sell filling up your house! With POD, you can order a dozen copies to take to a convention and see how it goes from there. If you do well, order more for the next show. You can always have exactly the stock you need when you need it. Second, if you won't have the money for a huge print run yet, POD makes it affordable to dip your toes into print publishing without committing tens of thousands of dollars right at the outset.

No matter how much space you think you ▶ have, it's easy to overextend yourself and wind up with a house full of boxes.

But there are also downsides to print on demand. While the per-unit cost is much lower than it would be to get a comparable quantity of comics printed from an offset printer, that doesn't mean it's cheap. Our trade paperback collections run an average of 120 pages or so, full color, and they cost us around $15 each after shipping (you'd never get such a great price from an offset printer for a small print run) and we sell them for a cover price of $19.99. The problem is that retailers require a minimum of a 50 percent discount off the cover price if they're going to carry your comics. If you go through Diamond Distributors (the largest comics distributor in North America), they take 60 percent of your cover price to cover both their costs and the retailer discount. So, if we had tried to distribute

our comics while using POD, we'd lose money on every sale. We could be the highest-selling comic of all time and be bankrupted by our success!

So, POD is really not designed for large releases. Where it works best is where you'll be in the beginning: selling small quantities at conventions and online. The great thing is that most POD services also have online stores. We use Ka-Blam for our POD needs, and they have a store site called IndyPlanet.com. Anything Ka-Blam prints can be offered on Indy Planet at no charge to you. You can link to Indy Planet from your website; your customers buy directly from them; Ka-Blam handles all the processing, printing, and shipping; and you receive your cut of the profits. It's a very easy way to get started in print publishing.

Eventually, with a little luck and a lot of hard work, you may reach the point where you're selling so many copies of your comics that POD no longer makes sense. When that happens, it's time to consider switching to an offset printer. The per-unit costs are far lower, but you have to be able to fork over all that cash up front.

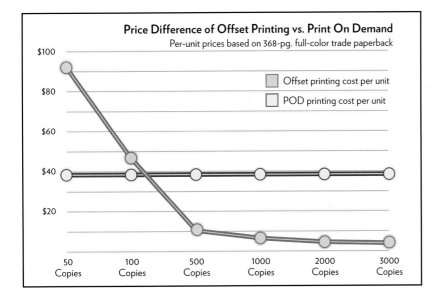

These are the prices we were looking at when printing our *Rainbow in the Dark* omnibus collection. Clearly, it's as ridiculous to get small runs from an offset printer as it is to get large runs from POD.

The cost of our omnibus editions went from $35 per copy to less than $5 per copy—but we had to pay $10,000 all at once to do it. We were then able to cut our cover price on the omnibus editions from $45 to $29.99. We distributed through Diamond, and even though we only get 40 percent of the cover price, have to pay for shipping and printing, and make slightly less profit per book than before, we're selling hundreds of copies at a time instead of just dozens. With our comics available in far more outlets than before, and at a discount of one-third off the prices we had to charge when using POD, our sales numbers will only increase with time. For smaller trade paperback collections, the difference becomes even more stark, and our gains become much larger.

**BARRY GREGORY:
CREATING WITH THE PRINTED
PRODUCT IN MIND**

If you're actually putting in the effort to create a comic, then presumably you want others to read it—which means that your pages have to be reproduced somehow. Mostly likely, that's going to include print.

As the cofounder of a comics specialty printing service, I see dozens of new comics every day. The most common mistake I see is the failure to account for how the work will appear on the printed page.

It's not necessary to understand all the minute technical aspects of print technology, but there are definitely things to keep in mind while creating. Simple things . . . like page structure (knowing the ratios, getting the dimensions right) with proper margins and bleeds, and confining word balloons and captions to the page's live area. Color density is a big concern, also. Your monitor's backlighting can trick you into thinking colors are brighter than they actually are. Don't just eyeball it. Always check your CMYK values.

Barry Gregory
Cofounder of Ka-Blam Digital Printing
Writer/Colorist/Cocreator
of Gallant Comics
ka-blam.com

Don't be afraid to ask questions about ▶ things you don't know. It could save you a lot of trouble down the road.

We recommend starting with POD to get your feet under you and figure out your publishing strategy while you build a fanbase and get the word out about you and your comics. Then, once you reach a point where your sales climb higher and your costs reach comparable levels to an offset run, make the switch to printing large runs and start looking at wider distribution. It took us five years to make that switch, and we were tremendously lucky to be able to do it so quickly. But we did do it, and so can you.

Prep for Print

Prepping your comic book for print is the process of adjusting the files that make up your book so that the printer can do what it needs to do to give you the end product you want. Any POD printer worth its salt will have information on its website on how to prep your files, and will frequently have downloadable templates you can use to make sure you do it right. Offset printers will have someone serve as your contact with the company who can talk you through what is needed from you. If there's anything you're not totally clear on, make sure to ask about it right at the start. Better to admit you don't know everything than have to deal with big problems at the eleventh hour.

Some companies offer prepress services and will take your files and set them up for the printer for you—for a price. The upside is that you don't have to worry about making any mistakes; the downside is you have to pay for the privilege, and often it isn't cheap. We prefer learning the process ourselves so that we're always in control over how our comics are handled. Also, we're cheapskates. (When you self-publish, you kind of have to be.)

You should prepare your comic for print throughout the entire production process. In the concept stage, you should choose your comic's format and size (width and height). If you want to use a POD printer, you need to pick a format they can handle. When drawing the comic, you need to know how big the bleeds are (the area the printer will cut off the edge of the pages when compiling the book) and where the trim area is (the zone so close to the bleed line that anything put there *might* get cut off). When lettering, you should check that your text balloons and sound effects don't get cut off by those bleed edges, or that they aren't so close to the center of the book that the text will be buried in the spine of the comic. Prepress is a long, measured, sometimes tedious process, but you're making sure the printing process won't muck up the art you're creating.

The next thing to know is that the images you see on your computer monitor will not be what you see in print. Ink handles color completely differently from monitor screens, and it's highly likely that your pages will print dark and overly saturated with color unless you prepare the images for the printer first. It can be hard (maybe impossible) to know exactly how your printer will handle color. Here, too, is a great benefit of POD printers: you can make a single proof copy of your book very cheaply.

When we printed our first comic ever, we set up four different levels of color correction (one with almost no correction, one a little brighter and less saturated, one a lot brighter and less saturated, and one ridiculously brighter and less saturated). We alternated correction schemes so that every four pages we'd run through correction sets 1, 2, 3, and 4, then cycle back again for the next set of four pages. When we got the proof copy back, we could decide which level of correction gave us the best balance of color depth and light. Once that decision was made, we recorrected the issue using just the one color correction set and had total faith that the comics we printed would look the way we wanted them.

PRO TIP

BRIAN MILLER: THE IMPORTANCE OF PREPRESS

As a comic book creator, you may think prepress is not part of your job. Penciller, inker, colorist, and letterer each have specific prepress duties ensuring the finished comic book prints correctly. The pencil artist must be aware of page dimensions, live area, and bleed when drawing. The inker must scan the finished artwork and resize it to perfectly fit the publisher's template. The colorist must know the publisher's specifications for maximum ink density to create the color separation and trapping. The letterer, too, works from a template knowing where the safe area is for lettering and sound effects. Once the initial lettering and coloring are done, the letterer will composite the files in a layout program and color the sound effects to complement the colored artwork. If all have done their jobs, the files will mesh seamlessly and the comic book will be ready to print. If any one of the comics creators made a mistake along the way, it can cause headaches, poor printing, or a comic book that ships late!

Brian Miller
Founder of Hi-Fi Color Design
hifidesign.com

▲

Four different levels of color correction. The differences might look slight, but you can never be sure how a printer will handle the color you send them. Slight differences here could mean huge differences from the press.

Preparing images for print isn't difficult. We use Photoshop's Actions feature to do ours, and it makes the whole thing a breeze. Actions are prerecorded sets of steps for a process. Say you want to perform the exact same correction on every page in your comic; you simply perform it once while recording it as an action, and then on subsequent pages you can open that action, press Play, and it will automatically do the whole process instantly.

To create Actions for prepping your pages for print, once your pages are exported from your lettering program (Illustrator), bring them back into Photoshop and perform the following steps:

1. Bring up your Actions window in Photoshop (or its equivalent in the image-editing program you're using) by going up to Window>Actions.

◀ Make sure to name your Actions clearly so
that you always know *exactly* what they do.

2. Press the New Action button at the bottom of the Actions window. Give
 your Action a name like *Printer Prep: Page Correction 1*—something that
 will make it easy to know what this action does. Remember, if you're taking
 our advice and creating a proof copy of the book first, you'll make three
 more of these actions!

3. Press the Record button to start.

4. Go to Image>Adjustments>Brightness/Contrast.

PRO TIP

JEREMY TREECE: SEEING IT FOR THE FIRST TIME

In October 2005, my art was published
in a book called *Hero@Large* through
Speakeasy Comics. I had slaved on the
book and was excited to see it featured in
Previews. However, when I noticed my work
had been credited to the wrong artist, the
excitement faded and I felt like someone
had kicked me in the gut! After receiving
emails with congratulations on the book
and news that it had sold out at Diamond,
I was determined to gain back some bragging
rights. It was on my way to the comics shop
that I realized I had forgotten to preorder
my own book. When I got there, the guy
behind the desk told me they had just sold
out. I was bitterly disappointed. I felt like a
failure and needed to complain to someone
I knew would listen . . . my parents. After
whining a while, my father (who never
stepped foot in a comics shop before)
informed me that he had gone and proudly
bought all the copies he could find. That
was truly validating.

Jeremy Treece

Creator of *Fearsome as the Night*
Cocreator and artist of *Hero@Large*
Artist of *Marvel Zombies:
Christmas Carol*
jeremytreece.com

5. Increase your Brightness a bit by moving the slider +1–5.

6. Bring your Contrast down by -5.

7. Go to Image>Adjustments>Hue/Saturation and bring your Saturation down by -5.

8. Go back to your Actions window and click the *Stop* button on the bottom left. This will end the recording and save your process as an Action that you can now play whenever you like.

9. Do this three more times, each time increasing the amount of correction you use (Brightness +15–+20, +25–+35, +40–+50; Contrast -15, -25, -35; Saturation -10, -20, -30).

Finding the right degree of color correction for a printer is a bit like chemistry, adding a little of this or that until you find the right balance. Once you do, though, you'll have it recorded as an Action and will always be able to trust that, no matter what you've created, running that Action on your pages will net a printed book that looks the way you want.

Just remember, always ask questions of your printer, and do your best to follow the printer's instructions and requirements to the letter. They know what they're doing, and it's their job to give you a book that looks the way you want it to. They want you to succeed! They know that, if you do, you'll give them more business! So listen and learn, and do your best to communicate your needs. If the printer is a good one, you'll be in good hands.

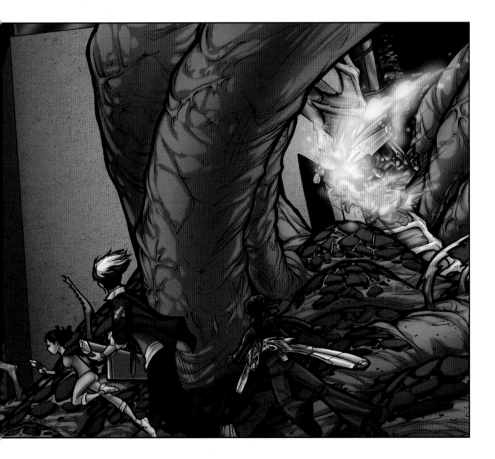

◀ This kind of panel only prints well with good prepress. If we didn't carefully prepare our pages for the printer, the colors wouldn't pop nearly as nicely or have such detail.

DIGITAL PUBLISHING

Digital publishing should be your first outlet as a self-publisher. We always tell people looking to make their own comics that they need to focus on digital. It gives you the widest reach, the most potential readers, the cheapest and easiest entry into the market, and the least risk on your part. Paper publishing is nice, and well worth using as a secondary release method, but it won't be your biggest concern for a while.

The digital comics landscape is constantly changing, and does so quickly. We can give you the best information we have for right now, but like we said,

The world of comics publishing is topsy-turvy ▶ right now. Nobody knows for sure where we'll end up, so you have to keep moving forward.

the future is a wave coming at you. Watch for the changes, build your surfboard, and ride it toward tomorrow.

Making Digital Comics

Digital publishing is the simplest process in which you can engage. The primary file format you'll be working with is PDF. Making a PDF is pretty straightforward, and you don't need to own Adobe Acrobat software to do it. There are several freeware options for creating PDFs that are just a Google search away. They don't require much, so even the simplest of them will probably work perfectly well. Some digital comic stores (such as Comixology) have their own proprietary formats, so you'll have to look into each outlet you want to use and see what they require.

You'll want your files at a nice high resolution—crisp and clear and beautiful at any size. Don't be afraid of people downloading your files and printing them out themselves—so few people will bother that it won't take money out of your pocket, and you'll sacrifice far more potential income by offering a lower-resolution file that readers find less attractive or (in the worst cases) harder to read.

You also need to consider how large your digital files will be. If you plan to post pages to your website for online reading, you'll need to keep in mind that (currently) the average monitor resolution is around 1366 x 768 pixels. Since scrolling up and down isn't a problem but scrolling side to side is annoying, you want to keep your page resolution between 1000 and 1200 pixels wide in order to comfortably fit on a screen and leave room for other web page info on either side (just in case). Any larger than that and average netizens may need to constantly scroll left and right to read each page, and that becomes a headache quickly.

◀ Low-resolution files might deter illegal reproductions of your comics, but they're also cruddy to look at and hard to read. It will do more harm than good to your ability to turn a profit.

PRO TIP

KEVIN BOLK: MAKING MONEY ON A FREE WEBCOMIC

Okay! Business hat on!

The revenue model for free online comics mirrors the radio model that has worked successfully for decades. Radio stations make money by selling advertising space during peak listening hours, and webcomics creators can leverage web traffic and their reader demographic to interested advertisers. Just as musical groups benefit from increased public awareness of their albums on the radio, comics artists reap the rewards of online popularity. As your work spreads, an increase in sales of books, merchandise, and digital downloads follows. The comic may be out on the airwaves for free, but you're actually building up equity in your website, your comics brand, and your creator reputation.

For best results, you must constantly drive readers to your corner of the Internet: your own web ads placed on related sites, guest strips with other popular creators, URL watermarks on your images to take advantage of social sharing, posting your comics "one week behind" in other receptive corners of the Internet with a link to "the most recent" comic on your site, and making sure that all books, merchandise, and convention flyers carry your site address.

Business hat off! Who wants cookies?

Kevin Bolk
Interrobang Studios
interrobangstudios.com
kevinbolk.com

Publishing Online

Publishing your digital files online is just as painless as creating the files themselves. There are now dozens of sites that sell digital comics, each with their own setups and stores. You want to be on all of them! The more places your comics are sold online, the more opportunities there are for people to find them. The advent of digital publishing has made it easier than ever for self-publishers to create and release their comics, but it also means there is more competition for the audience's dollars than ever before. You aren't just a small fish in a big pond, you're a piece of kelp in the ocean!

Any place that you can get your comic in front of the most eyes as possible is good. But you still need to be a little cautious. Never accept a deal that includes exclusivity, meaning you can only sell your book on that one website. Few webstores include this clause in their contracts, but some do, so look out! You never want to limit where your comics are sold, and exclusivity requirements are frequently signs of crummy service. Never accept a deal that doesn't allow you to set your own prices. It is essential that you control how much your comics cost! If the website demands the right to determine your pricing, walk away immediately.

Otherwise, look for every possible store you can get into. Most will have submission guidelines, but generally it's a matter of uploading your comic, filling out a brief form, and waiting for that particular digital comics distributor to review the comic and see if it's worth selling. Find out what formats they require your files be sent, in and prep your comics accordingly before submitting.

You won't have the time to promote every site your comic is on, though, so pick one or two of the biggest webstores—the ones with the most customers, broadest reach, and simplest interface—and link to them on the store page of your website. The simple interface of stores is important, because you don't

Don't discount potential readers just because they aren't web-savvy or are lazy. You never know who your next superfan might be.

▼

want to force your potential customers to go through a big hassle just to buy your comic. A rule of thumb is that the more clicks it takes to make a purchase, the fewer people will make that purchase. You may even lose as many as 10 to 30 percent of your visitors with every click they have to make! So, if they go to your homepage and have to click the "Store" button, that's at least 10 percent gone already. If they followed a link from another page, you lost 10 percent before they even got to you! So you're looking at a minimum of one-fifth of your potential customers who've quit before even getting to your store page. The simpler it gets from there, the fewer additional customers you'll lose.

A Brief Note on Piracy

Internet piracy is a touchy subject for a lot of creators and publishers. People have a knee-jerk reaction to the idea that there is a vast community of—essentially—thieves taking creators' works for free. These creators look at the numbers of illegal downloads and see all the profits they aren't making. They feel it undermines the value of their work, stands in the way of their financial success, and is a drain on an industry that's already struggling in so many ways.

But the truth is that pirates are here to stay. Every time an industry tries to attack them or eliminate them by force or legal action, they fail and suffer, and lose a lot of money and goodwill in the process. We're going to tell you right now: there is no point in trying to fight the pirates. That genie is out of the bottle and will not be put back in again. But there is good news, too, because you don't have to fight them! What very few people seem to realize is that the pirates are not your enemies, but are in fact potential allies.

Study after study has shown that people who pirate media spend far more money on said media than those who don't. The American Assembly, a public policy forum affiliated with Columbia University, published a study in 2012 that

PRO TIP

MIKE NORTON: WHY I DID IT!

I chose webcomics because I was scared. I had never done anything on my own completely before *Battlepug*, and the idea of finding a publisher for my project was pretty daunting. Add to that a lengthy production schedule for print and high personal expense, and the project became less and less appealing.

None of that applies when putting your comic online. Expense is minimal and reaction is immediate. There are as many different methods of formatting your comic as there are creators publishing. With all these barriers removed, fear was eliminated and I became a much more confident creator. I feel I've grown more as a creator in the three years that I've been doing *Battlepug* than I have in the entire seventeen or so years that I've been working professionally.

Mike Norton
Creator of *Battlepug*, *Revival*, and *The Answer!*
battlepug.com
fourstarstudios.com

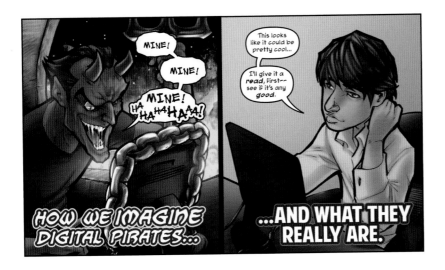

◀ Don't fall into the trap of assuming digital pirates are automatically selfish, entitled villains. At the end of the day, they're just normal people—our friends, neighbors, and sometimes even ourselves.

found that US and German file sharers spent an average of 30 percent *more* buying music than those who didn't pirate. In 2012, Ofcom, a telecommunication regulatory body in the United Kingdom, published a study that found that 10 percent of the most prolific music pirates in the UK also accounted for 80 percent of all legitimate music sales. The highest-pirating 20 percent spend 300 percent more on music in the UK than those who don't pirate. Research also shows that ripping and borrowing CDs accounts for nearly half of all music piracy, and people were doing that with cassette tapes long before Internet piracy even existed.

What does this have to do with comics? It means that the piracy situation isn't as black and white as you might think. Ripping CDs is a lot like trading comics with friends. Have you ever read a great comic and loaned it to a buddy so he could check it out? And how many times have you read a comic a friend loaned you and then started buying it yourself?

Try-before-you-buy is one of the oldest and most successful ways of getting new customers. Today's Internet piracy is essentially the new radio; you listen for free, and if something really grabs you, then you are more likely to buy it. Pirates are passionate about the things they love. Pirates love to talk with one another about what's great. They share, they write about their passions, they blog about them; they're the superfans you're looking to get on your side.

Piracy technically includes reading comics off the rack and sharing your favorites with friends. It's the way many of us found our favorite comics!

▼

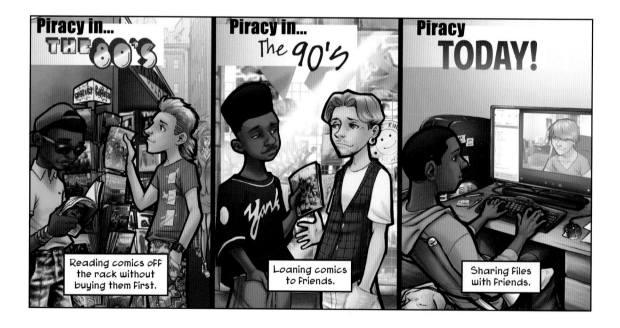

In 2010, American comics artist Steve Lieber (famous for such comics as *Whiteout, Detective Comics, Superior Foes of Spider-Man*, and *Hawkman*) found that people on the website 4chan.com were pirating his graphic novel *Underground.* Instead of getting angry, he joined the thread discussing it and talked with the posters. It turned into a whole Q&A, and a very positive experience where he gently encouraged that if people liked it, they consider donating a couple bucks or just, hey, buy the book. Here's the important part—the day after this exchange, sales on his book skyrocketed. He posted a graph charting his sales, and pictures speak far louder than words:

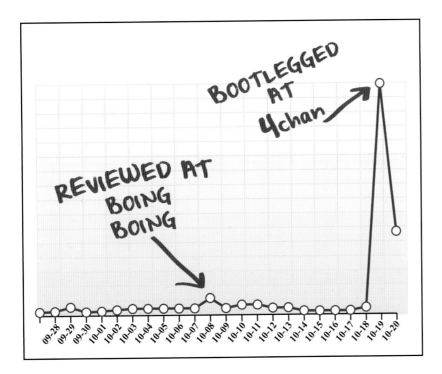

While Lieber didn't share specific sales numbers, with a sales jump like that the numbers almost don't matter.

Pirates aren't evil. They're people just like you and us. They're living in a world where there's less and less money to spend on products that are getting more and more expensive. We're transitioning into a reward-based economy in which we expect to try things for free, and if we really enjoy them, we'll reward the creator with money. For a self-publisher, obscurity is a bigger problem than almost anything else, and pirates spreading your book around, talking you up, becoming fans, and encouraging others to try you out is a potentially valuable way to beat that obscurity problem.

So don't shake your fist at the changing world, and don't try to fight the pirates. Instead, try to find ways that you can use pirates as part of your publishing strategy.

DISTRIBUTION

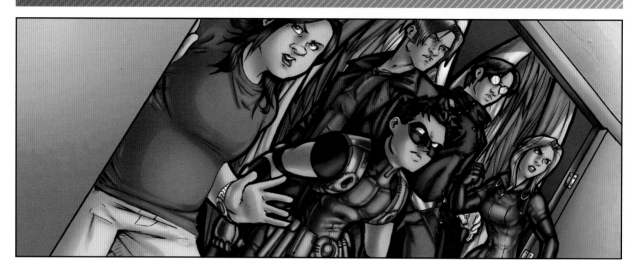

Distribution is the process of getting your books—printed or digital—into stores so that people can buy them. Distribution takes a lot of thought, coordination, preparation, and determination. It isn't easy to navigate and isn't a short process. Once you begin, you'll always deal with distribution in some fashion, if you want your comics to continue being available after their initial release.

Venturing into the world of distribution is a crucial step for a self-publisher, and much like most of what we've talked about in this chapter, it isn't something people put much thought into. Let us be frank: at one point or another, you're going to wish distribution wasn't your problem. As an old man in a pointy hat once said, so do all who live to see such times. Take heart! As we've said with just about everything in this book, while time-consuming, once you get the hang of it, distribution isn't all that bad. It's at its worst in the very beginning and gets easier as you progress.

Early Distribution

So, you're a brand-new creator with a gorgeous first issue on your hands. This must be the time to submit to a distributor and get your comic into stores every-where, right? WRONG! Time for Distribution Lesson #1: Distributors don't want you (yet).

You have to accept that, as a new creative voice with a relatively insignifi-cant fanbase and all but zero experience, you're a tremendous risk for distribu-tors. They want to make money. They need you to sell a lot of comics for that to happen. Even if they like you personally and think you have a good comic, if they don't think it can sell in solid quantities, it isn't worth their time to try

Sorry, kid—he's gonna say no. Try again later, when you're *really* ready.

to get you out there yet. To be a real prospect for serious distributors, you need to have either a major name that draws attention, a big following that will show up to buy your stuff, a comic of such good quality (either in terms of content or price point) that it basically sells itself, or some combination thereof. Be honest with yourself—in the beginning, you probably have none of those things.

But that's okay! You live in a magical age in which you have options outside the traditional brick-and-mortar bookstores and comics and manga shops. Rather than busting your hump to look appealing to huge distributors before you're ready to make that leap, focus on the two most effective distribution outlets for the up-and-coming self-publisher: the Internet and conventions. For all intents and purposes, you are your own distributor during this period. You're contacting websites to host your digital comics, you're working out the particulars with your POD printer and their online store, and you're going directly to the consumers to sell to them face-to-face.

There are valuable gains happening during these early days of putting out your comic. Buying comics from someone's personal website, from a creator at a convention, or even from a smaller indie online store creates a different kind of relationship between fan and comic. It feels like a more personal buying experience than just picking up a random comic from a store or a big conglomerate like Amazon. Buying your comics becomes an experience, and that experience connects readers to you and your work in a deeper way.

It's a lot like being an indie rock band. You aren't well-known yet, but by putting yourself out there in person, you build a fanbase that loves you. You're a rare, special little flower that they discovered, and that discovery makes them feel special for having found you. Take the time to cultivate these early fans, form relationships with them, and earn their trust and loyalty. They'll be some of the most valuable fans you'll ever have.

PRO TIP

SINA GRACE: GETTING PUBLISHED IS ONLY THE BEGINNING

What folks really want to know is, what is the next project for me? They don't realize that the real "next" part of getting published is promoting your work, promoting yourself, and finding money to keep on following your dreams.

That's the issue a lot of up-and-comers must learn—fast: being published doesn't take away the numerous pressures involved with the long-term efforts to get your work recognized and to continue building momentum on your brand. A published comic does not ensure interviews, decent shelf placement in bookstores, or audience awareness. (It also doesn't guarantee a book deal!)

I don't find the extra work cumbersome or distracting. Taking charge of your career allows you to dictate what exactly is next for you. The moment you're wrapped with a project, make sure you map out your own efforts to publicize the book, and try to have a follow-up of some sort ready. You never know, the person asking what's next could be your future publisher!

Sina Grace

Creator of *The Li'l Depressed Boy*, *Not My Bag*, and *Burn the Orphanage*
sinagrace.com

◄ Some of those early diehard fans an indie band gains stay with the band for life. The same is true for the early fans of your comic.

There will come a time when you need to move to proper distribution. You'll be big enough, have enough sales and enough fans, and have enough material for a full-size trade paperback collection (TPB) or graphic novel that will have a real chance in the market. When that day comes, you can graduate to the next level. Don't rush, though, lest you make a big stumble early on that costs you the whole game. Slow growth is good growth.

Working with Your Distributor

The next step is working with a large professional distributor like Diamond or Titan, the largest distributers of comics in the United States and Europe. Unlike with POD printing or digital distribution of PDFs, you can make mistakes in full-scale distribution that can damage your career for a long time to come—even up to effectively ending the run of your series in the mass market. We're going to try to walk you through the minefield so that you can avoid those kinds of tragedies.

First, you need to be certain that you can actually make money with a large run of your comic. Work out what your expenses are, how many copies of your comic you can realistically expect to sell, and what you'll actually wind up earning with the set cover price. As mentioned, distributors and retailers will take a minimum of 60 percent of the cover price of your book, so if you're selling a TPB for $20, you'll only earn up to $8 per unit sold. After the cost of printing and the cost of shipping (because you will always be the one who pays for shipping), you might be down to earning as little as $3 to $5 per unit sold. Now, how many units do you need to sell to make enough money to cover your costs and the expenses of the rest of your team? Do you think you can honestly sell that many?

It's important that you make a good first impression with your distributor. Treat your potential distributor as somebody you're trying to sell your comic to—how can you present it in the most impressive way possible? If things go well, they'll have a number of questions for you, and you'll likely have questions for them. Answer everything they ask fully and in detail, and don't shy away from admitting what you don't know and asking them your questions in return. The more involved you seem, the more they'll trust in your professionalism. They need to believe you're a serious publisher in order to have enough faith to carry your book.

If the distributor agrees to carry your comic in their catalog, your next step is to get the word out about preordering so that people who like your comic realize they can order from the catalog before it's actually in stores. The higher your preorder numbers, the more of an asset you will appear to be to your distributor and the more they will extend themselves for you. If you look like a potential hit, then your success is their financial gain.

PRO TIP

STEVE GEPPI: WHAT DISTRIBUTORS LOOK FOR

A creator's work must be clearly saleable in the market the distributor represents. Distributors look for products that retailers can purchase with confidence. For the diverse comic book specialty market with stores ranging in size from mom-and-pop comics shops, to large stores in major metropolitan areas, to Internet retailers with worldwide reach, all retailers purchase books on a nonreturnable basis. This makes it imperative that preordered books arrive on time and that fans respond enthusiastically with immediate purchases. With this in mind, distributors look for creators who put together a full package: a sharp cover, an interior that contains quality artwork, professional presentation, and a compelling story. Distributors also look for creators who can print and ship on time, have a plan for putting out more than one book, who can support each book with marketing efforts that target retailers and their customers specifically, and those with a professional demeanor that indicates a commitment to becoming not just a comic book creator but also a publisher and an ongoing partner.

Steve Geppi
President and CEO of Diamond Comic Distributors
diamondcomics.com

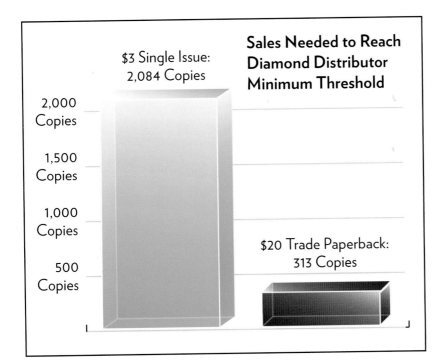

Sales Needed to Reach Diamond Distributor Minimum Threshold

$3 Single Issue: 2,084 Copies

$20 Trade Paperback: 313 Copies

2,000 Copies

1,500 Copies

1,000 Copies

500 Copies

◀ This is the reason so few self-publishers do large runs of single issues. It's just too hard to make your minimums compared with trade paperbacks.

PRO TIP

CAMERON AND CHRISTINA MERKLER: BUILDING A RELATIONSHIP WITH COMICS AND MANGA SHOPS

Comics shops want to carry a diverse amount of titles to appeal to a broad spectrum of customer tastes, but there are many options available.

A good way to set yourself apart is to reach out to the shop before your product is offered for preorder. This gives the creator an opportunity to "sell" the title to the shop and gives the shop a chance to talk to customers about it and get feedback and orders. If the shop receives orders for the title and good feedback, the shop is more likely to order the creator's subsequent titles.

Many comics shops operate primarily on a preorder model, so promoting your comic after the preorder period may fall on deaf ears. Preorders also help retailers determine the amount of shelf copies they will order. Sending customers to the shops that do order from you will help you build a lasting relationship for future projects. Don't be afraid to approach as many comics shops as possible, because they want to work with you.

Cameron and Christina Merkler
Owners of Discount Comic Book Service, InStockTrades, Tales of Wonder, and MyDigitalComics
dcbservice.com

Also, many distributors have minimum sales numbers in dollars that a comic has to hit before they'll actually distribute your comic. So let's pretend that minimum dollar figure is $6,000. This means that, unless your comic receives $6,000 worth of preorders, they will not ship your books to the stores. Even if you're just a few hundred dollars short, none of your comics will ship unless you hit the minimum threshold. This is another reason why it's a bad idea to try and self-publish single issues of your comic—when your book sells for $15 to $30 instead of $3 to $5, you have to sell far, far fewer of them to hit that threshold.

To ensure you hit your preorder threshold, you've got to mobilize your fanbase and get them to go to their local comics and/or manga shop and pre-order your new comic. You're going to call stores on the phone (yes, actually using your phone as a phone rather than as a text machine) to let them know who you are, what your comic is, and get them interested in stocking it in their shops. You must do anything you can do to get people to preorder! It's hard, grueling work. You're going to be tired and exhausted by the end of it, but it's work that must be done, and it can lead to huge dividends for you.

7. MARKETING

MARKETING IS THE WAY YOU LET PEOPLE KNOW you exist, and it is the single hardest part of self-publishing. It's a great big world out there and you're just one little comics self-publisher. What's more, you're one little comics self-publisher fighting against established brands that have been around since early in the twentieth century. You're trying to get attention in an industry where a large portion of readers refuse to try any comics, manga, or webcomics other than their longtime favorites, and where getting exposure with new readers is perhaps harder than it's ever been.

In this chapter, we'll talk about modern marketing philosophies and strategies. How to refine your approach for the audience you want, and how to build and manage a robust online presence to increase your visibility. Finally, we'll talk about the importance of comics and anime conventions in building grassroots support for you and your comic. Marketing a book is hard work, but it's the number one thing you'll do to help your book gain the success it deserves.

PRO TIP

ED CHAVEZ: THE TOTAL PACKAGE

In the increasingly competitive world of comics, creators, whether or not they are attached to a publisher, cannot let up when considering their own personal marketing. And the concept of publicity goes far beyond simply connecting with the public through social media.

Creating the total package starts from the ground up. It means doing the legwork on a consistent basis. Improving your portfolio regularly as your skills improve is critical. Attending industry events to do portfolio reviews (when available) and to connect with members of the industry is highly recommended. Connecting with the public and with other artists, in person and through media, allows for greater exposure.

While many of these steps, specifically the publicity, can be done by a publisher, providing redundancy is ideal. As a creator, you know your audience best and you may know how best to communicate with them.

Finally, even once some level of success is reached, creators should not neglect the steps that got them to this level. Maintaining that and building on that through experience should take new talents to even greater heights.

Ed Chavez

Marketing director for Vertical, Inc. Translator of *Chi's Sweet Home,* *Velveteen & Mandala,* **and** *Morning International Manga Competition* vertical-inc.com

YOU ARE YOUR PRODUCT

A common misperception many creators have is that all you have to do is make a great comic, get it out there, and talk about it wherever you can to build buzz. The truth is a little different. Quality certainly matters, but people aren't interested in being sold products. We're all tired of advertising, and of being advertised to, yet we still need to be sold on something before we'll buy in.

To begin marketing a self-published comic, manga, or webcomic, you need to recognize that, in many ways, your comic is not your product; *you* are your product. If they like you, if they care about you, they'll want to support you. This is how you grow your audience in today's market—by being a cool, interesting person who others can care about and want to see succeed.

The End of the Funnel

The loyalty of your fanbase is tremendously important. They are the most valuable advertising you could ever get, because word of mouth is the only advertising that really matters anymore. It used to be that the only way to find new comics was to go to a comic shop or peruse a rack of comics at a corner store. Since the publishers knew their audience only had those sources to use to find comics, they could both control which comics people could see and tailor content for a very narrow group of readers (those who actually went to comic shops).

◀ Publishers were the wide end of the funnel, deciding what got in, and specialty comics shops were the narrow end, feeding us the single stream. Those days are done.

PRO TIP

CHANDRA FREE: CREATING YOUR PERSONA

Think presentation, presentation—presentation!

First impressions make lasting impressions, and your appearance says a lot about you! When presenting yourself on the convention floor, you can craft your appearance to give that lasting impression right along with your work. You want to brand yourself so that people have a face to connect to the work. Think of this as the icing on the cake.

Things to think about: makeup, grooming, suits, dresses, nice clothes, corsets, fun jewelry, brightly colored hair, hats, ties—whatever suits your personality, but bump it up to 11!

When it comes to my own personal style, I try to evoke both how I like to dress as well as what my characters wear. I adorn myself with corsets, wild and dark makeup, fancy dresses, and I keep my hair freshly dyed a vibrant color (usually red). It makes me stand out on a crowded convention floor, and people can identify me and my artwork as a unified brand identity.

If you stand out, fans will remember you for years to come, and seek you out.

Chandra Free
Creator of *The God Machine*
spookychan.com

Those days are past. The advent of the Internet and the digital age meant we suddenly didn't have to go to comic book stores to find comics. They're all over the place, in all shapes and styles. This change led to chaos in the industry, but it was also freeing. We became a more savvy audience, able to avoid or ignore things we didn't want to buy—able to make our own decisions about what we wanted.

◀ We are so bombarded by advertising all our lives that we become immune to the obvious attacks on our senses.

PRO TIP

LORA INNES: MAKING A COMIC THAT MATTERS

Walk around Artists Alley at a convention and you'll see every trick in the book when it comes to selling comics. Some tactics are rather effective. Others are cringeworthy. But none of it means a thing if you don't have a great product to sell.

Showmanship and gimmicks might get a customer to buy your comic once. But not twice—not if the product doesn't live up to the promise.

Building your reputation as an established creator happens over time by producing work that people care about. Can a reader get lost in your world? Do they wish they were one of your characters? Can they identify with the deeper themes of your hero's journey?

Your hero must grow in a way readers can identify with; he starts out one person and ends another. Your characters must have something to learn that your reader can identify with as well.

So do you want to be a salesman or a creator? Spend your energy on the right things and you'll turn one-time customers into lifelong readers.

Lora Innes

Creator of *The Dreamer*
thedreamercomic.com

What that means for comics today is that traditional advertising doesn't work anymore, at least not very well and certainly not reliably, and there's no one place you can go to make sure the world can discover your comic. What matters now is word of mouth—friends telling friends about this thing or that thing they've discovered that they thought was cool. If you see an ad or product placement on TV, it doesn't mean much, but if a friend of yours tells you that the product is pretty great, then you might listen.

Make It Worth It

The single most important thing you can do is produce an excellent comic. You don't just need to be as good as the competition, or even just "better"— you need to blow them out of the water. If everything goes as planned, you're going to share shelf space with the biggest comics on the market. To stand out, you need a comic that commands attention.

We've talked a lot in this section about the power of word-of-mouth advertising, but all of that means nothing if people get convinced to pick up your comic and come away disappointed. Whatever it takes, make that comic worth their money. Make it beautiful and powerful and exceptional any way you can. Leave your readers smiling and they'll keep coming back.

You want to make a comic people cannot wait ▶
to read. The more excited they are to curl up
with your comic, the more likely they'll be to
share their enchantment with others.

TARGETING YOUR AUDIENCE

The shattering of the "funnel" we talked about in the last section has led to an interesting market. Rather than one main stream that attempts to attract the broadest, most diverse audience possible, everything has fractured into niche audiences. It's hard, perhaps even impossible, to create the next *X-Men, Fullmetal Alchemist,* or *PVP,* with all the scope and power those entail, but it's easier than ever to build the comic you want and find an audience that will love it.

So, when planning your marketing strategy, don't think of how to get the biggest possible audience. Instead, think of how to get the most impact with the niche audiences most inclined to enjoy your comic. Create small circles of fans for your work, and then look for ways to link these circles into a bigger ring of support for your work. It takes time and is by no means easy to manage, but it's the best way to develop a following in the modern age.

Seek the Congregation

There's an old saying that, if Mohammed won't go to the mountain, then the mountain must come to Mohammed. If there's no single perfect way to bring fans to your comic, you have to find ways to put your comic in front of them. Early in your creation process (ideally, while building the concept of your comic), figure out who your target audience is. Who are the people most likely to enjoy the kind of comic you're creating? Once you begin marketing, the question becomes how to get the comic in front of them, so they'll pick it up and try it.

The Internet has made this process much, much simpler. There are online groups for pretty much everything these days. No matter how niche your audience, they congregate somewhere online. Forums, message boards, blogs,

news sites—anywhere that people gather around a common interest is a potential place for you to present your comic. Go out and find them! This is direct marketing—talking directly to your audience and informing them about you and your comic firsthand. It will do you good. As Dale Carnegie said, "You can make more friends in two months by becoming interested in other people than you can in two years by trying to get other people interested in you."

It's vital that you not go into these communities to advertise. Nobody likes the used-car salesman who constantly pitches you on his product. We as a people generally hate advertising! There's always "that guy" whose Facebook page only updates with ads for his CD or his books or whatever, or who joins a web forum and immediately starts blasting off about how great his comics are. People don't like "that guy." Don't be him. Instead, join these communities to be part of the group. Interact with the members. Show that you're a real human being interested in the things they're interested in.

The old "used-car salesman" style is more likely to drive people away than draw them in. ▷

Look for conversations that you have something to add to. Where can your commentary enhance a discussion? Where are people asking questions you can answer? Be helpful, be interested, be charming, and be enchanting. We'll say it over and over again—learning to be an enchanting person is crucial to success in the modern age of self-publishing.

Then, once you've made some small impression, you can casually start to mention your work. But do it subtly and without coming off as Internet spam, or you'll turn off the very people you're trying to attract.

Every post you make should include a link to your site as a small ad for your comic, usually as some kind of user tag or signature. It's inoffensive, unobtrusive, and can draw people in: "I like what this guy's talking about—maybe I oughtta check out his comic . . ." Don't try to turn every conversation into a discussion of your book, but if there's a casual way to drop it in where a mention is actually relevant to what's being said, go ahead. Avoid anything that comes off as bragging, and be careful of overdoing it to the point where it looks like you're only joining conversations so that you can plug your comic again. Remember, direct marketing like this has to use finesse. Be a scalpel, not a sledgehammer.

Using the Media

Comics media can be incredibly helpful for you. Getting approval from a voice the audience trusts is one of the highest recommendations you can receive. There are a wide variety of comics podcasts, review and news websites, and blogs. Remember what we mentioned about finding your target audience, and look for media outlets that talk directly to that audience. If you're doing a fantasy comic, a Marvel/DC exclusive podcast might not care about your story. Even if they did, their audience might not. Pick your targets carefully before you start.

It really helps if you can meet these people in person at conventions. Many podcasts set up tables at conventions, and a website's reporters often roam con floors. If you can, make a personal connection with them and give them a copy

◀ It's important to focus your marketing on people who will actually be interested in what your comic is about. Getting creative is good, but you still have to target the right audience(s).

JOHN SIUNTRES: WHAT MAKES A GOOD INTERVIEW

Obviously, you are there to promote your work, but for the people who conduct the interviews, they may want more than the basic five Ws—who, what, when, where, and why. What were your inspirations that helped define your style? Specific artists or writers? An era or time period? An art style? Interviewers want to know what's behind your creative process. Why do you approach your work the way you do? Has your approach changed from where it started? Interviews are an opportunity to let your audience know more about you as well as your work. When they discover you like the same things they do (movies, music, books, and so on), they feel more connected to you, and may want to support your work that much more.

John Siuntres
Host of *Word Balloon* podcast
wordballoon.blogspot.com

Sitting down for a single interview with ▶ a well-heard podcast can give you a tremendous bump in recognition.

of your book. This will go a long way toward encouraging them to be open to and supportive of you.

Podcasts are like Internet radio and can be incredibly helpful. We were able to make early connections with several comics podcasts: Comic Geek Speak (CGS), Comic News Insider (CNI), and Around Comics, among others. They gave us a lot of support when we were just getting started, and CGS in particular became a major booster for us. We still get people who come to us because they heard our interviews on CGS or CNI.

The other specific benefit of podcasts is that your personality gets to come through on the air. Like we said, you are your product. Listeners able to hear you conversing with podcast hosts feel a stronger connection to you, as if they really got to know you in that brief moment. Be fun, be charming, be *enchanting*, and people will remember that.

MASTERING YOUR WEB PRESENCE

It's impossible to be a successful self-publisher without some kind of Internet presence. You have to be able to create and maintain a website that can act as your hub online—the place to which you can direct anyone and everyone who has even a passing interest in what you do.

Building a good website is only part of the process of designing your web presence. We aren't simply talking about what you're doing with CheckOutMyComicBro.com; we're talking about your Internet persona as an offshoot of your comic, your professional reputation, and the relationship you're trying to build with the fans you want to have.

◄ Even if you have a reason for choosing CheckOutMyComicBro.com as the URL for your comic, it still might not be the *best* choice unless it is specifically reinforcing something about the style or tone of your comics or you as a creator.

Branding

Your "brand" is like a label you apply to yourself that involves both how you present yourself as a person and the graphic design you use to promote yourself. It encompasses who you are, the kinds of comics you create, and the feeling people get when thinking about you and your comics. When designing your brand, you have to have an understanding of what sort of persona you want to be known for, how that applies to your comic (and how the content of your comic applies to that persona), and how to create that look and feel through graphic design and Internet communication.

Sounds complicated, huh? It isn't as bad as it seems. For starters, if you're just doing one comic, your job is much, much easier. Start by looking at your comic and breaking down what it's about, what its themes are, and what the general mood and attitude of the comic is. If you're doing slick sci-fi action, you'll want to build a brand around yourself and your comic that feels futuristic, exciting, and techie. If your comic is about a bar, your website, blog, store page, Twitter page, Facebook page—everything you do online—should carry some kind of bar theme and aesthetic in the imagery and design you choose.

On the other hand, if you're building a website for yourself as a creator of multiple projects, you need to think less about the content of any single comic you're creating and more about the overall style of all your comics together. We encountered this problem after we branched out from *The Uniques* to create *Rainbow in the Dark*. We had built a website for one, but it couldn't support both; we needed a new, singular website that could encompass all things Comfort and Adam. For *The Uniques*, we had used design that felt a little space-agey and a little retro with a lot of curves, circles, and shades of blue. That didn't work at all for *Rainbow in the Dark*, which was an urban fantasy story. When we looked at both, and at the list of stories we intended to create over the coming

Early website designs for UniquesComic.com and RainbowInTheDarkComic.com. ▶

Initial ComfortAndAdam.com design: It still needed adjustment and finesse to get where we wanted it to go, but it was our first stab at branding identity for "Comfort and Adam" as a unit.

years, we were able to find common threads in the styles of stories we write and art we enjoy. We also realized that we'd already been cultivating a brand as the hard-working, do-it-ourselves married couple.

So, our unified brand then became about fun, adventure, and creation: bold fonts, comics panels incorporated into the imagery, ink splashes, and bright colors dominated by blue and gold. Once settled, the aesthetic carried through all our graphic design easily. Furthermore, the aesthetic of "fun, adventurous creators" extends to how we interact online. We always try to stay positive, rarely criticizing without also having something upbeat and hopeful to say at the same time. We talk a lot about our creative process, and you'll almost never see us anywhere that we aren't hard at work on some project or other. This makes our role as creators a cornerstone of who and what we are. We're always together, so the fact that we're a couple that works as a unit is emphasized to the point that people rarely think of one of us without thinking of us both.

We even dropped our last names from all our branding. "Comfort Love and Adam Withers" is a lot of information to remember. It makes our relationship unclear (people still expect spouses to have the same last name) and people would tend to only remember one or the other of us. "Comfort and Adam" rolls off the tongue, sticks in the mind, and is quick and easy to say. It's also less formal and more fun, another aspect of our brand that we try to emphasize.

The name change worked on practical levels, too. Putting Comfort's name front and center makes sure people recognize her as an equal and essential part of the creative duo, something sadly still necessary in an industry that continues to be dominated by male creators. Finally, Comfort (being the more unusual name) is more often remembered and recognized. Always lead with the most memorable thing you've got!

The equivalent of "rough drafts" of our Comfort and Adam logo. The first couple here are just horribly designed and feel too stuffy and pompous. Once we settled on a font we liked, it was just a matter of playing with the orientation of the words and color palette. We settled on the one at the bottom right as our favorite.

Once you choose a brand for yourself, avoid anything that would subvert or confuse your brand. We couldn't suddenly start using grungy spatter-graphics in our design because it doesn't fit the rest of our aesthetic and would confuse the feelings we're trying to engender in our audience. Everything you say and everything you design and post online speaks to who you are and how you are perceived—take care that you don't do anything to muddy or damage that perception.

Your Website

The beauty of creating a website as a self-publisher (as with all other aspects of self-publishing) is that you have total freedom to make your site whatever you want it to be. That can be excellent and liberating, but it can also be terrifying. When you can do anything you want, you may experience creative blocks and struggle to find good ideas.

For that reason, when starting to concept a website, your first step should always be to check out the sites you really like: How have they been put together? How do they look? What features work really well and which ones annoy you? Put together a list of things you want to see on your site and a list of Internet bookmarks to sites that inspire you. Reference these sites often when you run out of ideas or find yourself stuck. Remember not to copy them too literally—your website still has to reflect your own unique brand! Just because your favorite webcomic site uses a lot of cute little frogs and birds and things in its design doesn't mean those frogs and birds are a good fit for your urban crime thriller comic.

◀ You want your web design to match the mood of the comics you create. Then again, we hope there's a world in which this panel is from a comic about cute little frogs and birds.

PRO TIP

TINA PRATT: SETTING UP AN ONLINE STORE

The design of your online store is just as important as your comics site. It should be an extension of your site, not a new experience for your readers. Even if your store links off from your main domain, make the transition visually seamless. Customers are more comfortable with the familiar, and the more comfortable they are, the more apt they are to buy.

For product listings, I find it best to stick to two ideas: simplicity and entertainment. Order the products in your store by type (for example, books, T-shirts, prints). You want customers to easily recognize and find what they're looking for and, perhaps, find similar products they didn't know they wanted. Clarity of what each item is in photography, title, and description is essential. However, that doesn't mean it has to be boring. Your comic is entertaining, and your readers are looking for more of the same attitude from your products. Don't be afraid to have fun with your product photography and descriptions.

Tina Pratt
Creator of *The Paul Reveres*
paul-reveres.com

When starting your website design, keep these important things in mind: First, the two places the eye immediately goes to when opening a new webpage are the top-left corner (because English speakers read left to right, top to bottom) and dead center. For that reason, you'll want your most important pieces of info in that corner and centered on the page. Typically, that means your logo will go in the corner and some splashy art advertising your comic (or the comic itself if you're posting pages/strips online) will go in the middle.

Second, all the most important information should show up on the page without requiring any scrolling. Newspaper lingo uses the phrase "above the fold" to describe the top half of the newspaper. When folded in half, any articles or headlines that are above that halfway point will show up in newspaper vending machines, newsstands, and anywhere else people buy their papers. The idea is that you want the catchiest stuff "above the fold" so that people passing by will see it and be intrigued enough to buy the paper.

Websites have a similar concept called "above the scroll." This is all the information that can be seen without having to scroll down. Just like newspapers, you want to keep all the most important and interesting stuff "above the scroll." If viewers have to scroll down on your page first, they might never see or find the thing that could hook them on your stuff.

Next, you want to keep viewers on your page as long as possible, and keep them coming back for more. The longer people stick around and the more often they come to visit, the more likely they are to become the kinds of superfans who will actually buy stuff when you release it. The best way to accomplish this is to have a lot of different kinds of content to look at. You've got your comic, sure, and that's good, but you can also have a blog to read (which should update

All the most important information on this website can be found immediately, no scrolling required.

as frequently as you're able—the more you update your blog, the more value it will give you), videos, galleries and backgrounds on your characters and your world (maybe even a wiki, if you can organize one), articles you've written . . . whatever stuff you can come up with to include on your site, do so. The more frequently it updates with new, different, interesting stuff, the more time people will spend checking you out. They'll get hooked and, in turn, will turn their friends on to you. That's the cycle of fan generation and retention you want to get started.

Leave room in your design for advertising. It might not be something you set up right at the start, but in time you'll want to consider it. You can pick and choose which companies or products advertise on your site, so choose those that you feel good about supporting. We recommend connecting with the site Project Wonderful, which represents a consortium of webcomic creators and allows you to select from all their comics to advertise on your site. This way you're using your comic to advertise other comics you like, and everybody wins. Ads don't have to be bulky or annoying or represent you selling out to The Man. Set aside a small strip to the right of your page, maybe some real estate at the very top and very bottom, and you can make decisions about how to use it (or sell it) later.

Finally, be sure that your site is easy to navigate, requiring as few clicks as necessary to get to the best stuff. As we've said, every time you make a viewer click a button to get somewhere, a percentage of your visitors quit and leave. Place big image links to any comics people can read on the website right at the

◀ An easy-to-spell and easily remembered URL is absolutely essential.

center of the page, and ensure your store is just a single click away. Also, make sure that your navigation buttons are clearly labeled, easy to find, and easy to use. Nested buttons (when clicking a button opens a drop-down menu of options) are okay to save space, but avoid overnesting (having menus within menus within menus over and over again). Too many nests clutter the screen and become a hassle.

With your site design under your belt, you'll need to buy a domain name. Picking a domain name can actually be a pretty fun process. Everybody wants a cool website name! Keep in mind, though, that your name should be both cool *and* easily marketable. Your domain name needs to be easy to spell and easy to remember. Things like H1k0ryD1k0ryD0ck.com or ThoroughlyFrouFrouGaity.com might seem cute, but if you speak them out loud to somebody, they're not likely to get the spelling right. Meanwhile, things with dashes or special characters like One-Two-Three.com require extra explanation and extra steps for the audience; avoid them if possible.

While we're at it, the .com extension is the best one you can get. Others like .org and .net are both gaining ground, but it will always require the viewer to make an extra mental step: "Hold on, was their site ComfortAndAdam-dot-com or dot-net?" Since dot-com will always be people's first reflex, use it whenever possible.

Finally, research website URLs to find out if there are other websites with names close to yours that you wouldn't want to be associated with. The last thing you want for your action-plumber webcomic GuysSwingingPipesComic.com

PRO TIP

ROBERT PORTER: MANAGING YOUR ONLINE PRESENCE

In this day and age, making a presence on the Internet is a must if you want to be noticed for your work or project. Obviously, we need time to create the work, but there should definitely be time allotted for speaking with your audience. It shows that you are passionate and devoted to your work, and that can be contagious!

I like to take at least an hour out of a day to socialize on Twitter. And on my personal blog on Tumblr, I try to post at least one thing every day, maybe even multiple times a day. It keeps you relevant to your audience's interests.

Also, test the waters among various social media sites. For example, if you post the same content on Twitter and receive a flock of a response, and Tumblr produces tumbleweed, great. But if the response is vice versa with different content, then you'll know what site works best for the type of content you wish to share. Tailoring your content per site will definitely give you an edge!

Robert Porter

Cocreator and artist on *Cryamore*
Artist on *Marvel vs. Capcom*
and *Empowered*
robaato.deviantart.com

Be very, very careful about how similar your URL is to other websites you wouldn't want people navigating to accidentally. ▶

is to discover there's a GuysSwinging*Pipe*.com out there doing the sorts of unsavory things that would shock and disturb accidental web travelers. It always pays to spend that little extra time hunting out potential problems before the site launches, because after it's up and out there, it becomes much harder to fix.

CONVENTIONEERING

As for so many who have come before us, comics and anime conventions have been a cornerstone of our careers since the very beginning. Long before we had comics of our own to sell, long before we were struggling, aspiring professionals, we were just a couple of college kids running a sequential art club, putting out

a yearly anthology and selling it and some stray art prints at local conventions. Since we were young, we've built a reputation through conventions. By the time we were self-publishing our own comics, we already had a small but loyal fanbase interested in our work.

Conventions are a big deal. The technology that was supposed to bring us closer together has also made us feel more separate, more alone. The act of meeting people face to face and physically shaking their hand has more impact than ever. You can connect with people on a personal level, and that connection will leave a stronger, more lasting impression because of its rarity and its connection to the event itself. This is how you'll find your biggest supporters; we've made many fans and sold a lot of comics online, but we met the majority of our super-mega-fans first at conventions.

Managing Your Space

When it comes time to plan out your own table, you have some decisions to make. You'll have to look over all the notes you've taken and figure out the table setup that's right for you. Luckily, we're here to help you past some of the tricky stuff and to guide you away from some easy mistakes you could make.

First, a sad note: All you writers out there are going to have a much harder time making conventions a major revenue stream. Artists have it easy—they can

Yes, conventions mean you have to step out into the light sometimes. Deal with it, you nocturnal types.

Chin up, writer. There's plenty else you'll be able to sell as time goes on.

SEAN E. WILLIAMS: BEING A WRITER AT A CONVENTION

Conventions can be hard if you're a writer, especially if you're just starting out. There's no income to offset your expenses, since you don't have wares to sell like artists do. So are they worth going to? *Absolutely.*

As a writer, you need to meet as many people as possible, be they artists, editors, or publishers. They're going to be your partners for the rest of your career, and getting to know each other is the only way to make those lifelong connections. As an added bonus, some will even become your closest friends!

So how do you meet these fine folks? If you've interacted with them online, introduce yourself in person: buy their books and chat with them in Artists Alley. But the best place is away from the convention floor, at the hotel bar. Find someone you know already, and gradually you'll be introduced to more people than you can work with in a lifetime.

Without these collaborators, it's impossible to succeed in comics, and conventions are the best place to do it.

Sean E. Williams
Creator of *Artful Daggers*
Writer of *Fairest* and *The Vampire Diaries*
seanewilliams.com

make art prints, sell commissions for tidy fees, and sell comics and merchandise right along with it. If you're a writer who can't draw, all you've got to start with are some comics and your sunny personality. Having less to sell makes it harder to make as much money as your illustrator counterparts, but that doesn't make conventioneering any less essential for your marketing and the gathering of your fanbase. So just keep going with us and use anything you can, understanding that there's a bit more direction needed for artists who will, by their nature, have more stuff to manage on their tables than you will.

Backdrops

We'll start by talking about what you hang behind you at a con. You've probably seen quite a few different kinds of backdrops while attending conventions, but they generally break down into these five types: The Nothing, The Art Student, The Comics Pro, The Wide Splash, and The Drive-Thru. Each has benefits and drawbacks, but some are more clearly advantageous, while others might seem to be until you look closer. So let's look closer!

The Nothing has no backdrop ▶ whatsoever.

The Nothing: No backdrop at all. It's the cheapest (because there's nothing there), easiest to transport (because there's nothing to transport), and fits any table size (BECAUSE THERE'S NOTHING THERE). The downside is that you have no backdrop. You want a backdrop behind you because it catches attention. With something big and colorful behind you, people can see your art from across a great distance, and may be drawn to check you out without having to stumble across you first. And when people do walk around the con, they frequently look up and behind the artists more than down and across the table. Having a nice backdrop is necessary for a successful convention, both professionally and financially. The Verdict: Do not use The Nothing.

The Art Student: Usually consists of one or two easels set up behind the table with art resting on them, but it can vary a bit. What it boils down to is that, in lieu of having money to spend on an expensive professional backdrop, and being intimidated by the concept of building your own, you went to an art or hobby store and bought what you could find to display work standing up. These setups can work early on, but the big drawback is that they can get heavy and cumbersome to transport, and they're very flimsy and easily knocked over. You'll have a lot of other creators moving around in the space behind your table, and you yourself will be coming and going over the weekend of the con. You don't want a backdrop that is constantly getting knocked down. The Verdict: Can work early on, but you're much better off investing a little time to build yourself a more ideal backdrop.

The Comics Pro: These are standing display signs made by companies who specialize in convention displays. Some of them can look extremely nice, and most of the big shots at comic cons will use them. They're a bit pricey but make up for it by being light, compact to transport, and fast and easy to set up and take down. The drawbacks are twofold, and both come from the fact that you're just getting started. First, your work is likely to improve greatly over time, and that means whatever art you have printed on this will be useless in a year or two. This can be offset by some sellers who offer to replace banners without having to buy an entirely new display, so be sure you know what services different sellers offer. The second drawback is these displays emphasize your name and one picture. You don't yet have a name that sells comics on its own, and until you do, it might take more than one picture and your name in big letters to draw attention. However, these drawbacks hardly affect writers at all, since switching around artwork isn't likely to be something they do that often. The Comics Pro is thus the ideal backdrop for all writers going to conventions. The Verdict: Expensive but convenient backdrops great for all writers and worth considering as an artist once you've become a larger, established pro.

The Wide Splash: Consists of a large, wide backdrop where art prints, large posters, or a combination of both are hung. The benefits are that your backdrop is even more eye-catching at a distance and that you can cycle the art you use as you get newer and better pieces to hang. It's also pretty cheap but requires construction. We built ours out of PVC pipe, gray felt, and foamcore board (like cardboard but sturdier) for less than $50. It's modular and can break down into a small space for travel. The downsides are that they take a long time to set up and break down at each show, and they can be heavy in your luggage (ours weighed just over thirty pounds). The Verdict: The most versatile and eye-catching backdrop you can use as an artist; well worth the extra work it takes to construct and transport. Highly recommended early in your Artists Alley adventures.

The Art Student is a style of backdrop that's cheap, easy, and okay when you're just starting out.

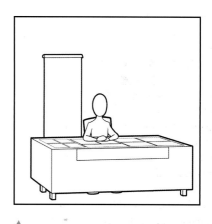

The Comics Pro is great for all writers and big name comics/manga/webcomics professionals. But, as an artist, it may not be ideal for you early on.

The Wide Splash is what we'd recommend most to any artist in the early part of their careers.

▲

The Drive-Thru seems cool until you realize that it cuts you off from the fans, and cuts visibility to your fellow Artists Alley neighbors.

The Drive-Thru: The most deceptive of backdrops, this one seems pretty cool until you think about it in practical terms. This setup consists of a large frame of PVC pipe or plastic crates constructed on your table on which art is hung in a huge array, leaving only a small window through which fans and customers can interact with you at the table to make purchases. More of a "front drop" than a backdrop, The Drive-Thru is certainly eye-catching. Unfortunately, it has two huge drawbacks. First, you want to be able to interact with people to build a reputation and a fanbase, but The Drive-Thru turns the convention experience into one of plain, dull retail. Being hidden behind your table setup, you seem unapproachable and antisocial. People won't want to interact with you, and it becomes difficult to do so even if they try. Second, you're really screwing over your table neighbors. By putting all your gear way up front on your table, you're making it hard for people walking the aisles to see the creators on either side of you. It's bad form and unfair to your fellow Artists Alley peers. You should have better con etiquette than that. The Verdict: Deceptive setup that seems cool but creates a wall between you and fans, and gives the shaft to anyone with a table next to yours. Do not use The Drive-Thru.

The Tabletop

On the table itself, you'll want to display your comics well. In the beginning, they may be virtually all you have. Try to get your hands on some kind of standing tabletop display so that you can have a few copies raised up and facing the attendees as they walk by; it looks more attractive and catches more attention. You'll want to have some kind of art prints or posters, usually 8 by 10 inches or 11 by 17 inches in size. If you aren't an artist, you can use the cover art as prints, or commission other artists to do pin-ups for the book that you can also use as prints. They might not sell well in the beginning, but it helps to have a diversity of items at the table just to make your space look nicer. The more attractive your table space, the more people will want to stop and look.

Artists, you'll want to create as many prints as you can to start with. These should cover a wide range of subject matter, representing both characters from your comic and others. Do not look down on the idea of doing prints of characters you didn't create yourself; fan art can be valuable to a portfolio, at least in the beginning. People are always looking for characters they recognize to hook them in—use that to draw them to your work, make them fans of your art style, and slowly turn them into fans of your original material. Over time, you'll transition away from fan art to focus more on your original characters and comics, but in the beginning it's a nice way to get a little more attention.

You'll want to keep as organized behind the table as you are in front of it. Develop a system for storing comics and merchandise so that, once somebody

Within the diagram:

PRICE LIST & SKETCH SAMPLES

TRADE PAPERBACKS

11"×17" PORTFOLIO

11"×17" PRINT SAMPLES

COMIC RACK

24"×9 1/2" SCROLL PRINT

POSTCARDS

chooses one from your display copies on the table, you can quickly retrieve a fresh copy from the back, sign it, and sell it. Simple cardboard boxes can make nice storage for comics, shirts, or whatever. You may want to invest in (or construct your own) dividers for smaller items so that your variety of pinups, buttons, and stickers are organized for your convenience. The cleaner and more structured you keep your setup behind the table, the faster and smoother your business transactions will be. You'll appreciate it when you reach the point where you've got a lot of customers bugging you for stuff at once.

The process of developing your table setup never really stops. Continue looking around you for ideas or inspiration for how you can better design your convention setup. Be willing to try anything, but always look closely for how it's working with others before jumping in yourself. Several convention staples (like, say, The Drive-Thru backdrop) seem like a good idea when you're just looking at them, but the more you think about them, the more you realize what bad ideas they actually are. Be creative, but be smart.

Working the Con

Conventions are a way to create new fans and increase your professional profile, but only if you work them right. Once you become an actual part of conventions by having table space in Artists Alley, you can't look at cons as vacations anymore. They're part of your job and need to be treated as such. Be at the show every day when it opens, ready to greet the early attendees. Even if a show looks like it'll be pretty empty in the opening hours, you need to be there! The first people through the door are usually the die-hards, and those are the people you want on your side. Besides, if other creators are skipping out because they're sleeping in, that's more business you can take for yourself.

When working your table, resist the urge to holler and call attention to yourself. Your art and table display should grab the attention for you—calling after passersby like a carnival barker is just annoying, and it drives people away. It also angers other artists in your region whose sales are being hurt by your bullhorn schtick. A big rule of working a convention: nothing you do, whether it's how you set up your table or how you draw in customers, should hurt

▲

An example of a typical setup for our table. Note that all the prints and comics on the table are display copies—we keep fresh copies of everything for sale behind the table where they won't get damaged.

This is a dramatization of *actual events.* ▶ We weren't even that close to a guy acting like this at a convention, but he was so loud we had people walking away from *our table* just to get farther away from him.

PRO TIP

JIM DEMONAKOS: GETTING STARTED AT CONVENTIONS

Conventions are a great way to get yourself new fans, sales, contacts, and more. For me, there are three things you need to do to have a successful presence at a show:

1. Get yourself a pop-up banner to put behind your table. Usually your name is printed on the front of a table, but even two people talking to you means others walking by will have no clue who you are or what you are doing. Make sure the banner features a single image, very clear and easy to see— show people the artwork and toss your name at the very top—legible, but not huge. Banners tend to run around $200 and are worth every penny.

2. Have a giveaway. I don't mean a key chain or something like that; I mean a postcard. You can print these incredibly cheap online, and it gives you something that you can hand to every single person who gets within arm's reach of your table. Use that as the tool to get them to your table, and then try to sell them on your product. If it doesn't work, they can look you up later, and if they even considered your stuff, they will.

(continued on next page)

the ability of other creators around you to do their jobs and make their own sales. People who go into this business with an attitude that says "Screw those other guys—I'm in this for ME!" are people the rest of us want nothing to do with. While that self-centered attitude might get you more sales in the short term, it will turn people off from you in the long term and leave you without friends or allies when you inevitably need their help later. It's simple—if you wouldn't want the person next to you driving *your* business away, don't use that sort of behavior yourself. Success at conventions doesn't have to be a zero-sum game.

When people come to your table to peruse your products, engage them casually. Don't try to press them to get their money, just talk to them conversationally. Ask about their day, how they're enjoying the show, whether they've been to other conventions before—get them talking with you about whatever. You want to bring their guard down so that they aren't nervous about opening up with you. This allows for the personal, human connection you can make with them that turns customers into fans. Remember, the more they like you and connect with you as a person, the more they will want to support you and talk you up to others.

In that vein, you also want to try to work as many conventions as you can. The more people see you, the more real you seem. They'll start to recognize you, even if they've never talked to you before. "Oh, yeah—I've seen that guy around at cons." We do around fifteen conventions every year, and for a while we were doing almost twenty. You don't need to do *that* many, but the more you can do, the faster you'll have that air of recognition about you. This business is a lot about perception. Published creators have the perception of importance and validity because a publisher gave them their seal of approval. Self-

As you produce more work to sell, your table layout will evolve. Keep it classy and clean, and always utilize all the space you have as best you can.

publishers like us have to craft that perception on our own. Being so omnipresent that they recognize your name or comic without ever having read it is a major step toward that goal.

Finally, one of the most important parts of working a convention is the ability to make professional contacts. Networking is invaluable to your career—we wouldn't be where we are without the help and advice of friends we made who knew more than we did. You might even be lucky enough to find a guru who will mentor you through the struggling early days. There are two main ways to network; the first is just by walking the con floor when you have a moment and talking to people. Introduce yourself, have brief conversations, and just be friendly and personable. The second is what comics writer Bryan J. L. Glass calls "the show after the show."

Nearly all conventions have a hotel where most of the pros stay. After the con is over, you'll frequently find everyone gathering at the hotel bar or lounge at night. The atmosphere varies depending on the convention, but it's usually

(continued from previous page)

3. Engage. This should probably be #1, but unless you have the most amazing product, #1 and #2 are what will help you with #3. You need to be engaging. You have no idea what a turnoff it is to see creators at their table, playing on their phone, or too busy talking to their table-mate to pay attention to the person in front of them. I've seen it happen countless times, and the amount of lost potential sales/interest is astounding. Stand up. Make eye contact. Smile. Say hello. Invite people over. Make sales.

Jim Demonakos
Convention director of
Emerald City Comicon
twitter.com/technogreek

PRO TIP

MORGAN KOLLIN: THE VALUE OF BEING ON A PANEL

Creators have the fantastic ability to be able to bring their imagination and visions to life, but there is a lot more to these works than can be contained on pages alone. Panels and presentations are a integral outlet that allows creators to connect with not just fans of their works, but also to let others learn firsthand about them and to see the process itself. To hear and see in person how a creation comes into existence, and to discuss points about their works directly with the creator and others is a powerful thing. It's this connection that can only happen in person, as a blog can only say much. Just as with their creation, the panel takes time to develop into a format where panelists can convey their process to an audience. At this stage, the creator is able to work with event staff to arrange time, space, and technical requirements to properly facilitate the panel, and really show their followers the true magic of their creation.

Morgan Kollin
Chairman of Youmacon
and the Midwest Media Expo
youmacon.com

somewhat laid-back. Note that this is not the "con party." Some shows host an actual party of their own, but those are noisy and most of the pros won't be there anyway. Instead, try the hotel bar or lounge. It's a nice, casual atmosphere to meet people and chat. Some people will spend all night there, having drinks and friendly conversation.

Start conversations with people when you can. If you see somebody you talked to at the con hanging out, reintroduce yourself just to say hello in a more casual atmosphere. Let them see that you exist outside the convention! Don't try to butt into conversations if you aren't invited; just say a quick hello and move on. The last thing anybody wants during their relaxation time is to have somebody forcing themselves on them awkwardly. And if there's nobody to talk to, fine! Just be there and smile and be sociable with anybody who comes by. Just being seen is useful to you, regardless.

If you're an artist, a great way to meet people is to find yourself a nicely lit area close to where everybody's hanging out, and start drawing. You might have commissions from the show to finish for people to pick up the next day,

but even just casual sketching is fine. People will want to see what you're working on, and it becomes a conversation starter. You can meet other pros, get casual onlookers interested in maybe buying a commission from you the next day at the show, and make yourself look like a hard worker all at the same time.

Finally, remember this: you don't know who is important. Instead of looking up to the big, established superstars, look around you. The people in the trenches with you, those from your generation of creators, they will be the ones with you when you hit it big. Don't assume you can write somebody off or burn that bridge just because you don't think they're a "somebody." Treat everyone as well as you can, because today's nobody may become the somebody of tomorrow who can make (or break) your entire career.

PRO TIP

KATIE COOK: STANDING OUT IN ARTISTS ALLEY

The benefit of having your own unique style when exhibiting in Artists Alley is that it sets you apart from the other artists around you. You might be in the middle of a row of dozens of other creators, and if your work doesn't stand out then people aren't as likely to stop and notice you. It's easy to follow a crowd, but it can be hard to be your own person— even when it's to your benefit.

So use the style you love to draw in, not one you think everybody loves to look at. By drawing in a style that comes naturally to you, you'll develop your own artistic voice. It's worked for me personally because there isn't somebody else doing what I do right now, in the way that I do it. If people are interested in the kind of work I have, I'm the only one who can take care of them. So be a unique individual. Draw the way you enjoy drawing, be your own person, stand out, and take charge in Artists Alley.

Katie Cook

Creator of *Gronk*
Artist of *Fraggle Rock*
Writer of *My Little Pony: Friendship is Magic*
katiecandraw.com

◀ The "show after the show" can be as simple as a bunch of creators sitting together around a table and hanging out. It doesn't have to be intimidating, and can become the thing you look forward to most at a convention.

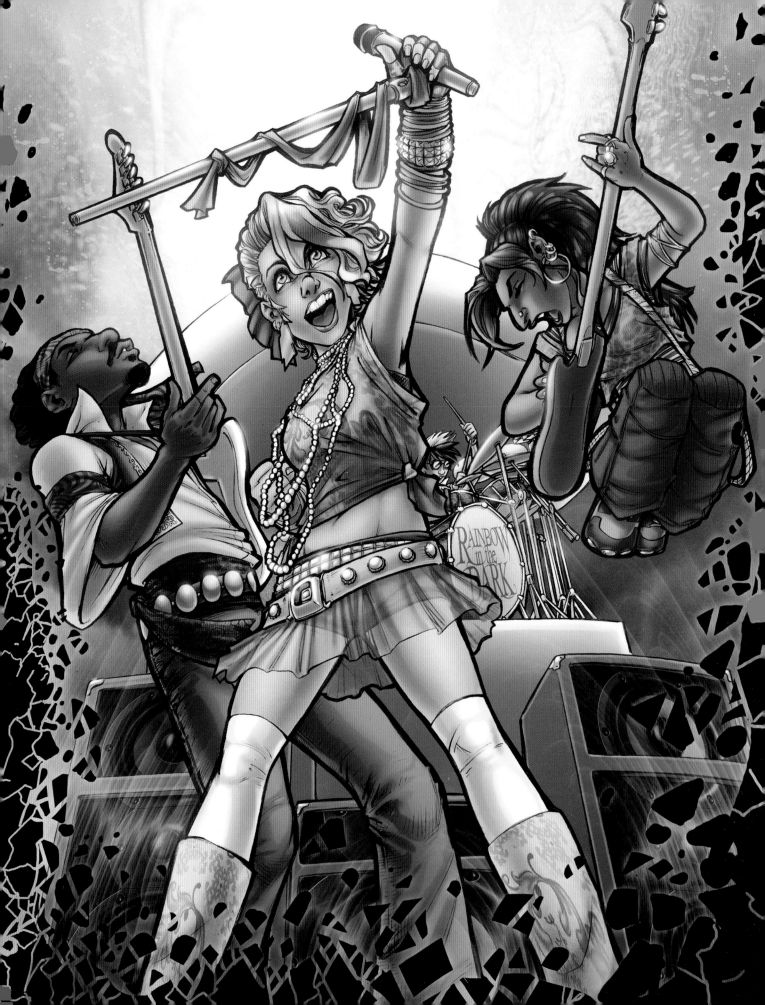

AFTERWORD

AND SO WE COME TO THE END OF OUR JOURNEY, fair readers. Now you have an idea of how much goes into creating your own comic—the blood, sweat, and tears you'll have to invest to make your hobby a career. It will never be easy, it will require a lot of sacrifice, but it will be glorious. The two of us work ten-hour days, seven days a week. We don't get holidays, we don't get sick days, we don't get pensions or retirement options, and there's nobody to cover for us if we need a day off. We do this because our work is our passion. It's because we're doing something that matters to us, and we hope it matters to other people. It's because this job, this life we've chosen, is meaningful to us.

Be proud of the work you do and the effort you put in. Don't let anybody tell you this isn't a "real job." Those people will never understand how much you've struggled and sacrificed. It's okay, because you'll know, and that's enough. We're better people because of the work we've done. Our time creating comics has been the most beautiful of our lives. We spend our days telling stories, supported by wonderful friends, family, and peers. We've seen our creations nominated for awards beside some of the greatest comics of our generation, and you can't imagine how that feels until it's happened to you. And it can!

If we leave you with nothing else, it's this: You *can* live this life. You *can* do this job. If we seemed harsh at times, it's only because we want you to be

prepared for what life as a self-publisher can be like. It's easy to be ready when things go well; it's when things get hard that people tend to freak out and run. It's like Thomas Edison said: "Many of life's failures are people who did not realize how close they were to success when they gave up." Do not give in to despair. You are capable of the exceptional if you're just willing to work for it.

This is your time. We'll say it again: it has never been cheaper or easier to create your own comics than it is right now, and it will only get easier as the years progress. There is no reason to hold back. If you are somebody who is truly called to create comics, nothing you can do will be as rewarding. For all the hard times you will have, when readers come to you with that special look on their face because they can't wait to tell you how much they loved your comic, it will be magical. There's nothing like it, truly.

So be bold, be daring, and begin. Arm yourself with all the knowledge and training you can amass, but don't trap yourself by waiting to be "ready." We've improved our skills so much since we started releasing our comics, but if we hadn't started when we did, we wouldn't have come nearly as far in this time. Nothing teaches you how to do this job like *doing this job*. Trust yourself, trust your partners, and plunge in.

We hope to see you on the convention circuit, and to see your comics, your manga, and your webcomics on our computers or in stores. Your success is good for all of us; the better any comics do, the better it is for everybody trying to make comics. It's more fun to share this feeling, anyway. We want to see comics become a vast brotherhood (and sisterhood) that welcomes all and has room for any who have the skill and the grit to survive this job. Your voices are important. We all look forward to hearing them someday.

Comfort and Adam

THANKS AND GRATITUDE

THIS BOOK MAY HAVE BEEN OUR BABY, BUT NO MAN (or in this case, no husband and wife duo) is an island. What you hold in your hands would have been impossible without the hard work and dedication of so many others. We wanted to take a moment to give special thanks to the people who came together to help make this book happen.

Our editors kept us grounded, kept us honest, and pushed us to work harder at every turn. This was our first experience with a book like this, and they made sure we gave you the best we could give.

From Ten Speed Press, Patrick Barb and Jenny Wapner provided primary oversight for the project. Ian Levenstein and Kris Naudus edit our comics and came on board for this project as well. Comfort's parents Kathi and Steven Love were instrumental for their non-comics perspective. Finally, Dave Jablonski, Chris Karath, and Jennifer Oslund stood in as our pre-readers. Trust your editors, people. They're essential pieces of any project.

Artistic support was provided in the form of our Fightin' Flatsmen and a pair of stellar backup artists for the cover. Flats were led by Travis Perkins and Jason Winter, with additional help from Jared Brokaw, Sasha Hayes, Kyle Schetzel, and Andrew Varcho.

The Manga and Webcomics panels from the cover illustration were created by Del Borovic and Corinne Roberts respectively. They're trusted collaborators of ours, and we're very thankful they were willing to contribute to this project.

Our design team took our text and illustrations and helped arrange them in a way that was both attractive and easy to follow. Special thanks to Senior Design Manager Chloe Rawlins for managing the whole process, and to Daniel Lagin, who handled layout design for the interior pages.

To each and every person on this list, we are in your debt. To everyone out there reading, thanks for taking the time to see a little of how the sausage gets made.

THE ADVENTURE CONTINUES ONLINE

YOU THINK THAT WAS EVERYTHING? OH, NO— there's so much more! If you want to see even more fully illustrated guides to self-publishing, head to comfortandadam.com to read them all free. Sections include such topics as choosing a format for your comic, Using culture in your settings, prepping art for color, distributing online, and more!

Go, read, and continue your journey into the life of a comics creator.

INDEX

A

Abrams, J. J., 46
Achromatic, definition of, 90
Action lines, 80–81
Action sequences, 73
Adlard, Charlie, 40
Adobe Illustrator
 building lettering workspace
 in, 141–45
 caption boxes with, 153
 important windows in, 138
 key commands in, 140–41
 main menu in, 136–37
 sound effects with, 162–66
 as standard program for
 lettering, 136
 tools in, 139
 word balloons with, 145–52,
 156–57, 158–61
Adobe Photoshop
 adding tone in, 107–12
 alternatives to, 95
 channels in, 105
 flats with, 102–6
 important windows in, 97
 key commands in, 99–100
 main menu in, 96
 preparing for print with,
 184–87
 special effects with, 113–25
 as standard program for
 coloring, 95
 tools in, 98–99, 100
Aerial perspective. *See*
 Atmospheric perspective
Afterlife Inc., 50
Alderink, Jon, 127
Analogous schemes, 92
Antagonists, 16. *See also*
 Characters

Aristotle, 37
Artists
 as colorists, 128–29
 compensation for, 51–52,
 128–29
 finding, 49–51
 professional, 83–85
 relationship between writers
 and, 52–53, 85–87
 teamwork and, 85
 writers as, 49, 53–55, 86
 See also Pencillers
Atmospheric perspective,
 94–95, 116
Audience, targeting, 8, 9,
 203–6
Availability, 175, 176

B

Bastian, Jeremy, 137
Batman, 22
Battlepug, 191
Bermingham, Leonard, 25
Blankets, 7
Bleed, 60
Blogs, 211–12, 213
Blurs, 118–21
Body language, 80–82
Bolk, Kevin, 189
Borovic, Del, 47, 112
Bowland, Simon, 150
Branding, 208–10
Breeden, Jennie, 59

C

Calafiore, Jim, 70
Camera, moving the, 72–75
Campbell, Joseph, 8
Caption boxes, 153
Character arc, 42

Characters
 antagonists, 16
 backstories of, 14–17
 body language of, 80–82
 body types of, 18
 costuming, 19–21
 designing, 13–21
 developing, 42–45, 46–48
 dialogue and, 43–44, 46–48
 drawing, 76–82
 expressions of, 77–80
 faces of, 18, 77–80
 importance of, 13–14,
 42–43, 46
 minor, 29
 personalities of, 15–16, 18,
 19, 48, 81
 protagonists, 14, 16
 questions for, 17
 simplicity and, 18–19
 utility and, 19–20
Chavez, Ed, 200
Chibis, 79–80
Chmakova, Svetlana, 79
Cho, Frank, 68
Chromatic, definition of, 90
Cibos, Lindsay, 51
Clark Jim, 24
Climax, 37–38
Color
 atmospheric perspective
 and, 94–95
 correction, 183–84, 187
 mood and, 108
 power of, 89
 schemes, 91–93
 separations, 106
 shifts, 123–25
 temperature, 93–94
 terms, 90–91

 theory, 90
 traditional use of, 98
 wheel, 92
 writing for, 109
Coloring
 flats and, 101–6
 process of, 101–12
 software for, 95
 special effects and, 113–25
 tone and, 106–12
Colorists
 artists as, 128–29
 communicating with, 109
 compensation for, 126, 128
 deadlines and, 125, 126, 127
 importance of, 89
 pace of, 127
 prepress duties of, 183
 in team hierarchy, 125, 126
 traits of, 127
Comics shops, relationships
 with, 197
Complementary schemes, 92
Concept
 building, 7–9
 character design and, 13–21
 importance of, 5
 research and, 10–13
 setting design and, 21–25
 sources of ideas for, 6–7
Conner, Amanda, 77
Contrast, 91
Convenience, 175, 176
Conventions, 214–23
Cook, Katie, 223
Corene, Cari, 108
Corsetto, Danielle, 44
Covers, 71, 164
Critical Millennium, 129
Cruz, Jeffrey, 24, 25

D

Dale, Jeremy, 84, 91
Dale, Kelly, 207
Deadlines, importance of, 83, 84
Death Note, 39
DeCastro, Nelson, 187
Delve into Fantasy, 47
Demonakos, Jim, 220–21
Dialogue
 camera angles and, 73–75
 character development and, 43–44, 46–48
 importance of, 46
 See also Lettering; Word balloons
Diamond Distributors, 180, 181, 185, 196, 197
Diaz, Aaron, 22
Digital publishing, 188–93
Distribution, 180, 194–97
Dodson, Terry and Rachel, 85
Downer, Steve, 91, 120
Drawing
 action sequences, 73
 characters, 76–82
 controlling time and impact with, 67–70
 establishing shots, 70–72
 experimenting in, 80
 importance of, 57
 improving, 66–67
 line weight and, 69
 moving the camera with, 72–75
 process of, 62–66
 simplicity and, 75–76
 See also Panels
The Dreamer, 11, 39
Dresden Codak, 22
Dussault, Daniel, 129

E

Editors, 34–35
Emotions, showing, 77–82
Enos, Joel, 162
Establishing shots, 60, 70–72
Exclusivity, 190
Exposition, 37
Eye path, controlling, 132–34, 145

F

Faces
 character design and, 18
 expressive, 77–80
Fades, 116–18
Falling action, 37, 38
Final Draft, 28
Final roughs, 63, 64, 66
Flats, 101–6
Fonts, 135
Free, Chandra, 90, 201
Freytag, Gustav, 37
Frog Prince, 41
Full bleed, 60
Funding, 51–52, 54

G

Gaiman, Neil, 49
Gaska, Andrew, 7, 129
Gaylord, Jerry, 80
Gaylord, Penelope Rivera, 219
Geppi, Steve, 196
Girls with Slingshots, 44
Glass, Bryan, 9, 14, 109
Glows, 113–16
The God Machine, 90
Grace, Sina, 195
Grayscale, 112
Gregory, Barry, 182
Guns of Shadow Valley, 24
Gutters
 definition of, 60
 panel borders vs., 59
 width of, 68

H

Ha, Gene, 71
Hard work, importance of, 3, 225–26
Hodges, Jared, 51
Hues
 definition of, 91
 examples of, 91
 warm vs. cool, 93–94

I

Ideas
 refining, 8
 sources of, 6–7
If It's Purple, Someone's Gonna Die, 108
Igle, Jamal, 77, 145
Illustrator. *See* Adobe Illustrator
Imitation, avoiding, 8
Impact, controlling, 67, 69–70

Inkers
 compensation for, 128
 prepress duties of, 183
 role of, 66
Innes, Lora, 11, 202
Inset panels, 60–61
Interviews, 206
Irwin, Jane, 63

J

Jackson, Ash, 50
Juno, 48

K

Kirkman, Robert, 40
Kollin, Morgan, 222
Kurosawa, Akira, 8
Kurtz, Scott, 48

L

Lee, Stan, 49
Letterers
 compensation for, 168
 deadlines and, 126, 167
 prepress duties of, 183
 professional, 167–68
 role of, 132
 in team hierarchy, 126
 writers as, 168–69
 writing for, 134
Lettering
 building workspace for, 141–45
 eye path and, 132–34, 145
 fonts for, 135
 by hand, 137
 as ignored art, 131, 167
 pace of, 167, 168
 planning, 148
 preparing script for, 134
 process of, 141–54
 software for, 136
 timing of, 141
 See also Caption boxes; Sound effects; Word balloons
Licensed properties, 7
Lieber, Steve, 193
Line weight, 69
Lock, Jon, 50
Logo design, 164, 210
Lucas, George, 8

M

Maihack, Mike, 208
Marketing
 branding and, 208–10

 at conventions, 214–23
 importance of, 199
 logo design and, 164, 210
 podcasts for, 205–6
 press packets for, 205
 quality and, 200, 202
 to target audience, 203–6
 web presence and, 207–14
 of yourself, 200–202
Martin, Laura, 105
The Matrix, 19, 39
Matsumoto, Nina, 174
Merchandising, 174
Merkler, Cameron and Christina, 197
The Mice Templar, 14
Mignola, Mike, 55
Miller, Brian, 183
Miller, Frank, 55
Miyazawa, Takeshi, 106
Molly Danger, 77
Monochromatic schemes, 92
Mood
 color and, 108
 establishing shots and, 71
 setting and, 24–25
Moore, Alan, 33
Moore, Terry, 19
Moore, Tony, 40
Morales, Mark, 66
Morals, 40–42
Mouse Guard, 43

N

Narrative arc, 42
Naruto, 14
Newton, Isaac, 92
Norton, Mike, 191

O

Oeming, Michael Avon, 9, 14, 44
Offset printing, 178–82
O'Malley, Bryan Lee, 22
The Once and Future King, 38

P

Palmiotti, Jimmy, 173
Panelists, 222
Panels
 borders of, 59
 controlling time and impact with, 67–70
 definition of, 59
 interrelationship of, 58–59
 size of, 68, 69
 space between, 60
 special, 60–61

Paradigm Shift, 18
PDFs, 189
Pekar, Harvey, 7
Pencillers
 compensation for, 126, 128
 pace of, 126
 prepress duties of, 183
 in team hierarchy, 126
 See also Artists
Petersen, David, 43, 86
Photoshop. *See* Adobe
 Photoshop
Piekos, Nate, 148
Pinchuk, Tom, 52
Piracy, 191–93
Planet of the Apes, 7
Plot
 character development
 and, 42
 definition of, 36, 37
 elements of, 37–39
 outlining, 38
 sequence of events in, 38–39
 story vs., 39–40
 types of, 37
Podcasts, 205–6
Porter, Robert, 213
Pratt, Tina, 211
Preorders, 196, 197
Prereaders, 34–35
Press packets, 205
Price, 175, 176–77
Print publishing
 offset printing vs. print on
 demand, 178–82
 prep for, 182–87
Proofreaders, 34–35
Protagonists, 14, 16. *See also*
 Characters
Publishing
 availability and, 175, 176
 changing nature of, 172–75,
 187, 201–2
 convenience and, 175, 176
 digital, 188–93
 distribution, 180, 194–97
 future of, 177–78
 price and, 175, 176–77
 print, 178–87
 self-, 173–75, 199
 See also Marketing

Q

Quiller-Couch, Arthur, 35, 37

R

Rainbow in the Dark, 19, 29, 31,
 33, 35, 36, 41, 59, 61, 82,
 181, 208
Random Veus, 25
Research, 10–13
Resolution, 37, 38
Rising action, 37
Rucka, Greg, 16

S

Santos, Victor, 14
Saturation, 91
Scanners, 65
Scott Pilgrim, 22
Screentones, 106
Scripts
 format of, 29–30
 lettering and, 134
 revising, 33–34, 35–36
 software for writing, 28
 See also Writing
Self-care, importance of, 87
Sermons, 40–42
Setting, 21–25
Simplicity, importance of,
 18–19, 75–76
Sims, Chris, 134
Siuntres, John, 206
Sizer, Paul, 164
Skyward, 91
Slow reveal, 71
Smash cut, 70
Smith, Kevin, 46
Snyder, Zack, 69
Software
 for coloring, 95
 for lettering, 136
 for script-writing, 28
Soma, Taki, 87
Sound effects
 as balancing act, 155, 162
 creating, 162–66
 hollow, 166
 speech as, 155–58
South Park, 41
Special effects
 blurs, 118–21
 color shifts, 123–25
 fades, 116–18
 glows, 113–16
 guidelines for, 113, 120
 textures, 121–23
Splash pages, 61
Splash panels, 61

Split complementary
 schemes, 93
Starkings, Richard, 131
Star Wars, 8, 40
Sterne, Laurence, 87
Stewart, Yale, 25
Story
 definition of, 36, 40
 morals or sermons in, 40–42
 plot vs., 39–40
 themes in, 40, 41
Style, finding your, 67, 223
Sunu, Steve, 205
Surmelian, Leon, 17
Sword in the Stone, 38–39

T

Team
 artistic, 85
 building, 49–53
 respecting, 52
 writing as a, 51
Teaser, 70–71
Tetradic schemes, 93
Textures, 121–23
Tezuka, Osamu, 55
Themes, 40, 41
Thompson, Craig, 6
Thompson, Jill, 98
Thumbnails, 62–66
Tiede, Dirk, 8, 18
Time, controlling, 67–69
Titan, 196
Tone
 adding, 106–12
 definition of, 90
Toriyama, Akira, 49
Treece, Jeremy, 185
Triadic schemes, 93
Tsui, Drake, 69
Twitter, 12, 208, 213

U

Underground, 193
The Uniques, 5, 12–13, 20,
 22–23, 25, 30, 32, 35–36,
 60, 78, 81, 208

V

The Victories, 44
Villains, 16. *See also*
 Characters

W

Wachter, Dave, 24, 65
Waid, Mark, 40, 83
The Walking Dead, 40

Warren, Adam, 73
Watchmen, 39
Watterson, Bill, 55
Websites
 advertising on, 212
 branding and, 208–10
 designing, 210–14
 domain names for, 207,
 208–9, 213–14
 importance of creating, 207
 multiple, 208
 online store on, 211
Williams, Freddie E., III, 64
Williams, Sean E., 216
Willingham, Bill, 11
Wood, Wally, 71
Word balloons
 adding tails to, 151–52
 arranging, 146–47, 150
 breaking boundary of,
 158–61
 leaving space for, 66
 making, 145–46
 placing text within, 148–51
 starburst, 156–58
Word of mouth, 202
Writers
 as artists, 49, 53–55, 86
 conventions and, 215–16
 as letterers, 168–69
 relationship between artists
 and, 52–53, 85–87
 as team leaders, 49–53
Writing
 character development and,
 42–45
 for color, 109
 feedback on, 34–35
 importance of, 27
 for letterers, 134
 over-, 32
 process of, 31–36
 re-, 33–34, 35–36
 as a team, 51
 See also Dialogue; Plot;
 Scripts; Story

X

X-Men, 40

Y

Young, Skottie, 67

Z

Zahler, Thom, 53